Chinoiserie

Oliver Impey

Chinoiserie

The Impact of Oriental Styles on Western Art and Decoration

Charles Scribner's Sons New York

Copyright © Oliver Impey, 1977

This book was designed and produced by
George Rainbird Ltd, 36 Park Street, London, W1

Designer: Yvonne Dedman

The text was set and the monochrome
illustrations originated by
Filmtype Services Limited, Scarborough, Yorkshire
The color plates were originated and printed by
Jolly & Barber Ltd, Rugby, Warwickshire
The book was printed and bound by
Redwood Burn Ltd, Trowbridge, Wiltshire

Printed in Great Britain

Library of Congress Catalog Number 75–46100
ISBN 0–684–14679–7

To Billy Winkworth

Contents

List of Color Plates

NOTE: *The page numbers given are those opposite the plates, or, in the case of a double page spread, those either side of the plate*

MAPS

Preface

I have divided the book into two parts. The first part is an account of the meeting of East and West. This division I feel to be necessary to the understanding of the mingling of oriental and occidental styles that makes up the complex of styles that come under the heading of chinoiserie. This account is necessarily both short, and selective: I have tried to summarize what seem to be the major events. In the second part of the book I have dealt with the visual arts: what was imported when from the various eastern regions, how it affected occidental taste and how it stimulated new styles. This part is divided into chapters based on different commodities – textiles, ceramics, furniture and so on. Naturally these categories are blurred at the edges, and in order to avoid repetition I may ignore one facet of the commodity if I have treated that facet elsewhere. When writing on interior decoration, for instance, it is impossible to avoid some discussion of the things discussed at greater length in almost all the other chapters of the book. Again, I have been forced to be extremely selective.

I have concentrated almost entirely on the visual arts, and have avoided discussion of the effects of oriental philosophy (or rather the European understanding of oriental philosophies) on Europe. These have been excellently discussed in various accessible books (Hugh Honour, Adolph Reichwein, *et al*) and seem to me to be beyond the scope of this work. They are, however, of great importance and should not be totally forgotten when considering the arts.

Names of persons and places have been spelled throughout in the best known way – not necessarily in the correct anglicized equivalent.

I am deeply indebted to the many friends who have helped me in the preparatory work for this book. No colleague in the Ashmolean Museum has been immune from my questions, but I must choose for particular thanks Simon Digby, Christopher Lloyd, Ian Lowe, Gerald Taylor, Bo Gyllensvärd, Daan Lunsingh Scheurleer and most of all, Mary Tregear. I am also particularly grateful to Henry Mayr-Harting, Kate Foster and Michael Webb, all of whom have read and criticized sections of the book. Janie Anderson, John Carswell, Tim Clarke, and Peter Miller have helped me over particular items. To all these I owe a great debt of thanks, while fully acknowledging that all errors and mistakes that may have slipped past their vigilant eyes are entirely my fault and responsibility.

The typing of my manuscript was expertly and expeditiously done by Margaret Goodall.

My wife has patiently read and criticized everything; without her help the book would never have been written.

O. R. IMPEY
1976

8

Introduction

In July 1753 Queen Louisa Ulrika of Sweden wrote to her mother, Sophia Dorothea of Prussia, describing her birthday present from the King:

'I was surprised suddenly to see a real fairy-land, for His Majesty had ordered a Chinese pavilion to be built, the most beautiful ever to be seen. The body-guard was dressed in Chinese clothes, and two of His Majesty's aides-de-camp as Mandarins of military rank. The body-guard performed Chinese drill. My eldest son [later King Gustaf III] was waiting at the entrance of the pavilion dressed as a Chinese prince, and was attended by gentlemen-in-waiting attired as Mandarins of civil rank. The Crown Prince read a poem addressed to me and handed me the keys of the pavilion with all it contained. If the exterior was a surprise, the interior was no less astonishing . . . There was a main room decorated in exquisite Indian style with four big porcelain vases, one in each corner. In the other rooms there were old Japanese lacquer cabinets and sofas covered with Indian fabrics, all in the finest taste. There was a bedchamber with Indian fabric on the walls and bed, and the walls were decorated with the finest porcelain, pagodas, vases and birds. A chest of drawers in old Japanese lacquer was filled with different curios, among them Chinese embroideries. In the wings tables were laid: one with a magnificent Dresden service and the other with a Chinese one. When everything had been admired. His Majesty commanded a Chinese Ballet . . .'

What was a 'Chinese pavilion' built in Sweden in 1753 like? What were 'Mandarins of military rank' supposed to wear, and what was 'Chinese drill'? What was 'exquisite Indian style' and what on earth was a 'Chinese ballet'?

The answer is, simply, chinoiserie; that is, the European idea of what oriental things were like, or ought to be like. So this charming birthday surprise was based on a European conception of the Orient gathered from imported objects and from travellers' tales. Apart from the genuine eastern objects (the Japanese lacquer, the Chinese porcelain, and possibly the Indian fabrics) these were European things – they were in 'oriental' style: chinoiserie.

Naturally the innumerable eastern objects either seen by travellers or imported by merchants were in a very wide range of styles from different eastern countries whose native arts (and

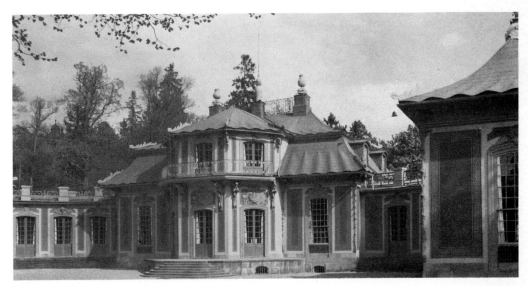

1 The Chinese Palace at Drottningholm, begun in 1763, was the successor to the temporary building described above. Like others of its type it is a European building dressed in fancy chinoiserie details.

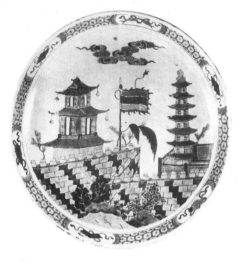

2 A Chinese *famille verte* dish made for export to Europe in the early 18th century, showing a pavilion and pagoda with upswept roof-lines.

3 A Delft dish by Koek, with designs based on Chinese porcelain, but the red and blue colour scheme imitates Imari ware (Japanese). First half of the 18th century.

4 Typically flimsy-looking rococo-chinoiserie designs on a cup and saucer of Vienna porcelain of *c.* 1730, reflecting the interest in the 'lotus land' Cathay.

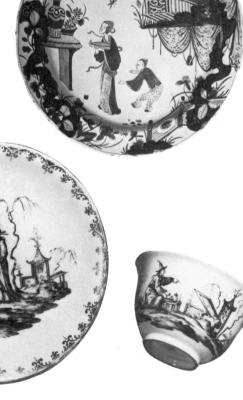

export arts) were markedly dissimilar. This resulted in a very wide range of chinoiserie styles in Europe, for not only were there these different styles to imitate, but the European craftsman was perfectly happy to mix together quite dissimilar ideas from quite distinct origins.

Chinoiserie is thus the European manifestation of mixtures of various oriental styles with which are mixed rococo, baroque, gothick or any other European style it was felt was suitable. But the oriental origins of the various chinoiserie styles that appear can always be seen, and can sometimes be traced back to their source. Thus the curved, upswept roof-line of buildings, so popular for garden pavilions in the eighteenth century, can be seen depicted on imported sixteenth- and seventeenth-century Chinese porcelain. Because it is not possible always to sort out the exact origins of chinoiserie things — they may be descended from a mixture of Chinese, Japanese, Indian or Persian styles, they may even be more than second or third hand in descent, as in textiles and porcelain (as we shall see in Chapters 5, 7 and 8) — the name has to be all-embracing.

This, of course, is confusing, and it would be very much easier if we were able to subdivide the word into categories. But this would lead not only to some horrible new words but also to some horrible confusion. So it is better to use the umbrella term and to particularize when necessary. The only exceptions I shall make to this will be to use the term rococo-chinoiserie for the Cathay-based designs of the 1730s to 1790s (though we shall see that the origin of this style is much earlier than the rococo), and the term *japonisme* for those styles dependent upon the influence of Japan in the later nineteenth century.

Chinoiserie starts, of course, by imitation, developing further and further away from its prototypes with time. This is not simple degeneration of motifs into meaningless symbols, but a much more complex process, for new materials for copying were continually being made available.

It is therefore important to know just what

5 English imitation (right) of the 19th-century Nankin blue-and-white export plate (left), though with a different border. Note how the boy has been transformed into a puppy, and the punt's cabin into a mere decorative element.

eastern objects were available for copying and when they first appeared in Europe. I have, therefore, traced, wherever possible, the history of the importation of objects or the importation of the knowledge of objects within the category discussed in each chapter.

We shall see that European copies are very rarely true copies: either the material is different (as in lacquer and japan) or the style of decoration unconsciously becomes a pastiche. It was usually quite impossible for a European craftsman to avoid putting the stamp of his own period, nationality or style upon an object intended to be in a true oriental style. Here the best examples are in ceramics, where European copies of, say, Nankin blue-and-white porcelain are readily identifiable, partly because the European painter has misunderstood the Chinese original.

One of the constant difficulties one has in discussing eastern influence is to define what one means at that moment by East. Clearly there is little problem with China and Japan (though even here there is some – see the chapters on ceramics) or even India (though see Chapter 5 on textiles). But what about the Near East? Byzantium, Constantinople or Istanbul – sometimes western, sometimes eastern – had a profound effect on Europe comparable to that of Egypt (another problem). Most difficult of all is Islam, extending westwards as far as Spain, which was to a varying degree an Islamic

country from the eighth to the fifteenth centuries.

Bearing in mind this very complex background, what are the criteria by which one can judge that something is chinoiserie? It is this that we shall examine chapter by chapter.

It will become apparent that much of the iconography of chinoiserie is relatively consistent, so that certain features can be used as diagnostic. In rococo-chinoiserie, for instance, upswept roof-lines, Chinese fret, pagodas, pagods, figures with pig-tails or conical hats, and parasols, singly or in combination, are not only diagnostic, but almost obligatory. But the

6 A late 17th-century Chinese blue-and-white plate showing a pavilion of two storeys, a type much admired in Europe.

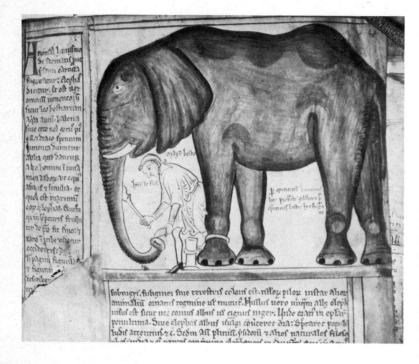

7 Drawing by the St Albans monk Matthew Paris (d. 1259) of the elephant presented by King Louis IX of France to King Henry III of England in 1255.

iconography of chinoiserie has not always remained constant. As certain objects became familiar to western eyes they no longer necessarily held an automatic eastern connotation. Elephants, for instance, were exotic and oriental in the fifteenth and sixteenth centuries, though the first Indian elephant to arrive in Europe only came to Lisbon at the beginning of the sixteenth century – all earlier elephants in Europe had been African. But by the eighteenth century the elephant was hardly associated with the Orient at all, but was more an attribute of classical history or mythology.

Another difficulty is whether or not a so-called chinoiserie feature really is chinoiserie. *Singerie* (see pp. 169–70), for example, was originally grotesque, and so was the hoho bird. This ungainly bird is often considered an essential of eighteenth-century rococo-chinoiserie; its very name is Japanese (*hō-ō*, meaning phoenix) though it comes from China to Japan. But it was

a commonplace in European design long before the eighteenth century, especially in grotesque designs in intarsia work (e.g. the choir-stalls of San Pietro in Perugia of 1535).

So far we have considered chinoiserie to encompass those things made in the West in some variation of eastern style or styles, but should not chinoiserie also include objects made in the East for the western market? We shall see that the Indian design of chintz was profoundly affected not only by Chinese (and even Japanese) design, but also by direct interference from the West. Not only was the Indian design modified or adapted by designers working for the East India Company but designs were actually sent to India to be copied. They were copied in a moderately inaccurate way, at that. In the same way, the Dutch sent models to be copied in porcelain at Ching-tê Chên and Arita. Logically, such copies[1] should be called chinoiserie, but this makes the question so complicated (for one could take it back as far as Scythian 'copies' of Greek objects) that it is usual to escape the difficulty by confining the term chinoiserie to western-made objects.

The term chinoiserie is sometimes used only to cover the eighteenth-century rococo-chinoiserie styles; while this is too narrow a definition, it does restrict the word to the intentional employment of the style. However, it would be more accurate to say that the intention to copy or to adapt eastern styles deliberately, began in the sixteenth century.

Since the sixteenth century the fashion for deliberate chinoiserie has waxed and waned, and we can roughly classify the period into three phases of the fashion.

Firstly the late sixteenth and early seventeenth centuries, then, leaving a gap, perhaps, in the mid-seventeenth century (always excepting ceramics) until towards the end of the century when there is a revival of the fashion that lasts until the early eighteenth century. Again there is a slight lull, and then comes another major change in the history of chinoiserie almost coincident with the coming of the rococo.

1. p. 103

8 A hoho bird from San Pietro in Perugia. This bears some resemblance to phoenixes on earlier imported oriental textiles (*see Chapter 5*) and continued as a motif in later times especially in English rococo-chinoiserie.

9 An unpainted Meissen centre-piece of about 1735. This extreme form of outlandish chinoiserie decoration is only just beginning to influence the overall shape of the object.

Whereas chinoiserie had been a decorative style for embellishing architecture, silver, furniture and so on, it now became the totality of an object. In silver, say, it was no longer a flat-chased picture on a normal European style object; it took over the European shape and adapted it much more drastically. The same is true of almost all the arts. It is in the 1730s–40s that chinoiserie first broke free of the constraints of its repetitive, almost formal frivolity.

Nowadays rococo-chinoiserie would be regarded as distinctly racialist: it has a faintly derisory air that is comparable to the patronizing attitude that has been so criticized recently in such books as *Little Black Sambo*. It is extremely unlikely that it originally had this intention. All the literary evidence suggests that China, in particular, was much admired (perhaps erroneously) as a haven of philosophical freedom, wise government and carefree existence. No one in seventeenth- or eighteenth-century Europe would have wanted to belittle that. Criticisms of the style abound — its absurdity, its frivolity or its lack of realism — but it was more the extremes to which the devotees took the

style rather than the style itself that aroused the fury of its attackers.

By the eighteenth century most people using chinoiserie styles for any form of decoration were well aware of its mixed parentage, but they did not care. What did it matter if it were a mixture of Chinese, Indian and gothick as long as it was pretty? Correctness is a nineteenth- and twentieth-century phenomenon.

The opening of Japan to the western world in the 1850s, the Opium Wars in China, and particularly the sacking of the Summer Palace in Peking in 1860, aroused western interest in Japan (the effects of this are *japonisme* and the influence of Japanese prints on the Impressionist painters) and in China. This is closely bound up with the start of the Aesthetic Movement.

A revival of interest in oriental art inevitably followed its 'discovery' in artistic circles. Some Chinese porcelain became millionaires' taste ('hawthorn' jars and *famille noire*), a few discerning collectors discovered early Chinese painting and even fewer (mostly American) discovered Japanese painting. The Chinese Exhibition in London of 1936 showed many people for the first time what Chinese art was really like: that is, what the Chinese themselves took seriously, not the stuff they considered suitable or had specially made for export to the tasteless barbarians of Europe. T'ang tomb figures (recently discovered when graves were uncovered in new towns and in railway workings, and immediately faked) became taken as seriously as Greek art, in spite of the fact that they are obviously mass-produced. (Mass-produced or not, they can be very beautiful.) Since the war of 1939–45 another revival of the taste for the oriental arts has arisen.

In the late nineteenth and early twentieth century the fervour for Japanese knick-knacks and japonaiserie wore itself out in greenery-yallery and art deco. Such chinoiserie as is made today (a surprising amount) is a survival of eighteenth-century chinoiserie styles, where it had become almost totally absorbed into general eighteenth-century taste.

Part I

The Meeting of East and West

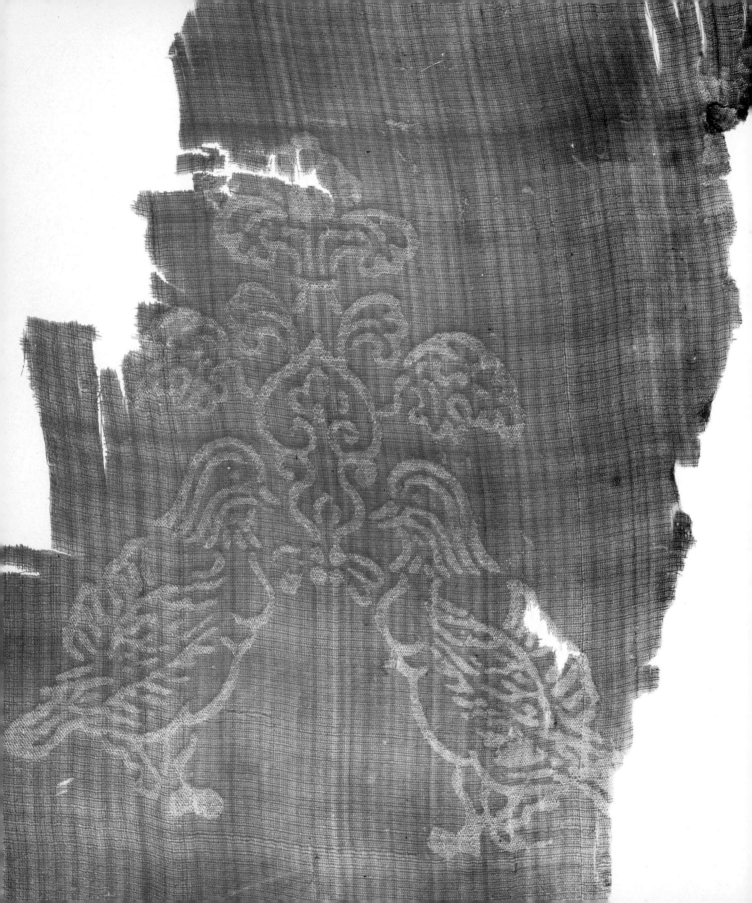

The Great Silk Road

It is probable that the peoples of the Mediterranean, of India, and of China developed their separate civilizations from the Palaeolithic to the Bronze Age in virtual isolation from each other. It was perhaps only in the seventh and sixth centuries BC that the great westward movement of the Scythians started any considerable exchange of knowledge, let alone of culture, between East and West. This movement ended, temporarily, with the Scythians occupying the area north of the Black Sea, while retaining trading connections across central Asia by the northerly route, north of the Caspian and Aral Seas, north of the T'ien-Shan mountains almost to China. For the Scythians had an insatiable appetite for gold, and their gold came from the Altai mountains. Herodotus, writing some two centuries later, knew about the westward migration of the Scythians, and did not believe the current story of their descent from Heracles and a woman who was half viper!

So Europe had indirect connections across the northerly route almost, but not actually, to China, before it had more than the remotest inkling of India. For between the Greek world and India stood the great Achaemenid Empire of Persia.

Darius the Great extended the Persian Empire eastward by annexing the Indus Valley in about 515 BC, and he sent a Greek officer, Scylax, to report on India. Scylax sailed down the Indus, and along the coast of Arabia, as Alexander the Great's friend and admiral Nearchus was to do some 200 years later. Scylax prepared a report on his journey, which had taken about thirty months, some of which we can read in quotations in later writers such as Strabo. Scylax set the pattern for so many of the Greek, and indeed later commentators on India or upon the East in general, by not being over critical of his sources, and including much fable and gossip among his own observations.

The northern route may have been taken by Aristeas of Proconnessus in the sixth century BC. Aristeas described this trade route in an epic poem entitled *Arimaspea* as running from the Scythians, north of the Black Sea, via other semi-nomadic tribes to the Argippaei, who lived south-west of the Altai Mountains, in modern Sinkiang and Mongolia and to the Issedones who can probably be identified from Chinese sources with the Wu-Sun. Beyond the Issedones Aristeas mentions the Arimaspi, the Hsiung-nu of the Chinese sources, who may be the people later called the Huns, and beyond them again, reaching to the sea, the Hyperboreans, the 'dwellers beyond the North Wind'. These must be the Chinese, the many small kingdoms now called the Eastern Chou, that were formed by the breaking up of the Chou empire. The name Hyperboreans arose because of the confusion of the extreme cold and high altitude of parts of central Asia, with northerly climes. Herodotus, writing in the fifth century BC believed the Arimaspi and Hyperboreans to live due north of the Black Sea, when of course they really lived east, and did not connect them in any way with his knowledge of Bactria, Sogdiana and the Indus valley. Herodotus was unaware of the Pamirs or the Himalayas, and called the Indians the most easterly of all the inhabitants of Asia, 'beyond them the country is uninhabitable desert'.

When Alexander of Macedon conquered 'the world' he, in effect, barely extended the old Achaemenid Empire, but his campaign in India in 326–324 BC opened the way to India to the Greek World. Few trading-goods had reached Greece from India before, because of the impassable barrier of the Persian Empire, though we hear of a few luxuries including peacocks and parrots, but now the way was open, and the trade in ivory and spice began. The trade in spice became one of the most important of all trades, and has lasted, with interruptions, ever since.

In India Alexander felt he had reached the end of the inhabited or inhabitable world, and the vague reports of 'islands' to the south and east given by Nearchus meant little to him. From the geographers' point of view, as the Scythian kingdom had fallen to the Sarmatians,

10 T'ang dynasty (8th century) self-coloured wax-resist dyed Chinese yellow silk excavated in Sinkiang in 1968. The confronted-bird pattern is similar to Sasanian design, but the mandarin ducks are completely Chinese. *See p. 63*

and the northern trade ceased, there was little chance of their being able to consider the two routes together to form a more real view of the shape and size of Asia. Indeed by the time Eratosthenes (*c.* 275–194 BC) was compiling his *Geographica* in Alexandria, it was even thought that the Caspian Sea was not enclosed, but was an inlet of a great Northern Ocean.

On Alexander's death in 323 BC, the Empire was broken up. Alexander's successor to the eastern part was Seleucus I, who in 304 BC, after an abortive attack on Northern India, made an amicable treaty with the ruler of the Maurya dynasty, and even sent an envoy to the Maurya capital, the modern Patna. This envoy, Megasthenes, wrote extensively and accurately about much of Northern India and much of Indian life, customs, peoples, and natural history, but he too succumbed to travellers' tales, and included in his *Indica* a number of fables that were to last well into mediaeval times, scarcely doubted. To Megasthenes, for example, we owe the existence of the description of the one-legged people whose single foot was so large, that they could lie on their backs and use their foot as a sun shade. Megasthenes' work was extensively used by later Greek authors, though much was forgotten before the Middle Ages.

The most easterly of the Greek states of the Seleucid kingdom, the Bactrian Greek states, were cut off from the main Seleucid lands by the invasions of the Parthians in the mid-third century BC. Taking advantage of the decline of the Maurya power, they moved into North India, and shortly after that were expelled from Bactria by the Yue-chi tribe, who were later, as the Kushan Empire, to rule North-west India, Bactria, and Sogdiana, and who had been driven from Mongolia by the Hsiung-nu. Hsiung-nu power was expanding, and the Han Emperor of China, Wu Ti, sent, in 128 BC, an embassy under Chang Ch'ien to the Yue-chi, hoping to form a military alliance. The mission was abortive, but Chang Ch'ien had taken, as gifts to the Yue-chi, silk, and returned with gifts to China. The Emperors of the Han dynasty realized the

Map to illustrate Chapter 1

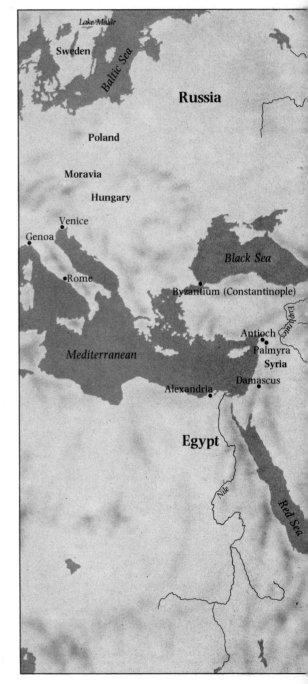

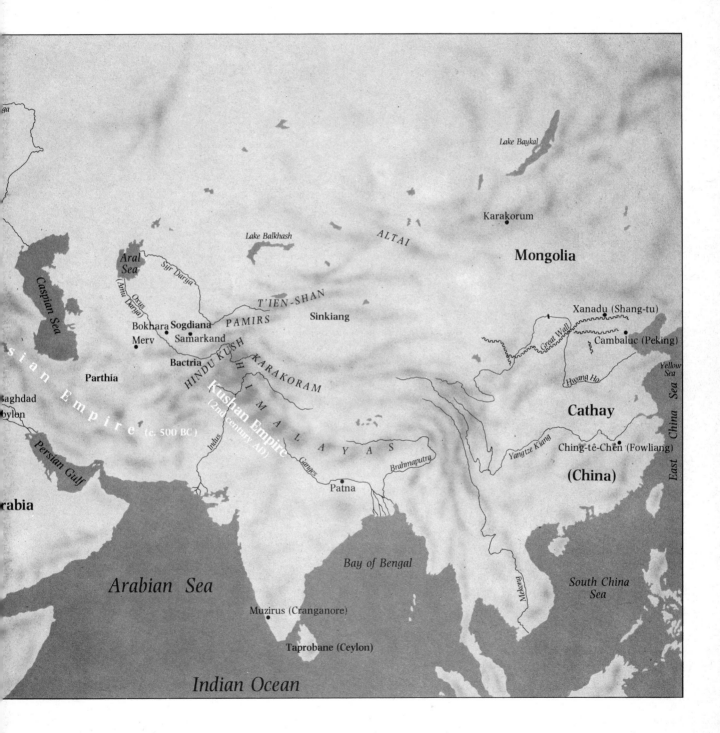

Lake Baykal

Karakorum

Mongolia

ALTAI

Lake Balkhash

T'IEN-SHAN

PAMIRS

Sinkiang

Aral
Sea

Syr Darya

Oxus
(Amu Darya)

Caspian Sea

Bokhara Sogdiana
Merv Samarkand

Bactria

HINDU KUSH

KARAKORAM

Parthia

H I M A L A Y A S

Kushan Empire
(2nd century AD)

Persian Empire (c. 500 BC)

aghdad
bylon

Persian Gulf

rabia

Indus

Ganges

Brahmaputra

Patna

Xanadu (Shang-tu)

Great Wall

Cambaluc (Peking)

Hwang Ho

Yellow
Sea

Cathay

Ching-tê-Chên (Fowliang)

(China)

East China Sea

Yangtze Kiang

Mekong

Arabian Sea

Bay of Bengal

Muzirus (Cranganore)

Taprobane (Ceylon)

South China
Sea

Indian Ocean

prestige value of such gifts, and started to send embassies throughout Central Asia, one under Kan-ying even reaching Babylonia in AD 97.

By the time of the Han dynasty, the manufacture of silk in China was an important and efficient industry. This is known not only from literary evidence but also because Han silks in a variety of techniques and qualities and of numerous different designs have been found in recent excavations of contemporary tombs in China. They are known also from a few surviving examples from central Asia. Silk immediately came into great demand: probably in the first century AD the Parthians introduced it in some quantity to European traders, and the Great Silk Road was opened. Silk was to remain an important trade item even after the beginning of sericulture in Europe under the Byzantine Emperors.

Meanwhile, Rome had become the dominant power in the Mediterranean basin and had taken Egypt from the Ptolemies. Egypt had never had a direct sea trade with India, because of the depredations of the middlemen of South Arabia, but this was soon altered by Roman power. The appetite of Rome for pepper, ginger and cinnamon was soon equalled by its desire for silk. The trade was made easier, and because of the description by a certain Hippalus of a direct route from Egypt to Southern India across the ocean by sailing with the south-west summer monsoon. The journey from Rome to Muzirus (modern Cranganore) now took only some four or five months, including the overland stage through Egypt.

In 26 BC Augustus received an embassy from Ceylon (then called Taprobane and now Sri Lanka), and this was followed by many other embassies to Augustus and his successors. Roman traders reached Indo-China and sailed up the Mekong river, and Chinese sources attest to Roman 'embassies' reaching China in AD 166, 226, and 284. The sea traffic between Rome and India continued as the cheapest and most fruitful until the decline of Roman power in the third century AD, when Arab and Abyssinian

intervention closed the way. It was to remain cut until the voyage of Vasco da Gama in 1498.

The overland routes were slower and more expensive. Roman traders such as those described by the merchant Maës Titianus, who travelled through Parthia, never reached China, so that many middlemen had to be paid their due. These routes were always changing, too, according to the ebb and flow of peoples and dynasties, but continued to operate until the rise of Islamic power in the seventh century.

Spices and silk made the staple of the trade; though Pliny tells us of furs and 'the best sort of iron'. The Romans imported some Indian animals for the arena, though they were much more familiar with African animals, even the elephant. In exchange, Rome exported linen, wine, coral, glass and pottery (Arretine table ware). Pliny complains of the drain of money to pay for all the imports, and archaeology shows us the gold, silver, and copper coins of Augustan and later Rome found all over India. 'India', says Pliny, 'is brought near by the lust for gain'. It was with the great Kushan Empire that the Romans traded in North-west India; one of the side effects of this trade was the rise of the so-called Gandharan style of Buddhist sculpture, a style greatly influenced by Roman art, in the first century AD. *The Periplus of the Erythraean Sea*, a sort of mariners' guide by an anonymous author of about 50 BC, described much of this trade and the lands of India. The *Periplus* mentions the land of Thin, an early reference to continental China, but does not necessarily associate it with the land of Seres, the source of silk. It is at about this time that Seres is first thought of as a large land in far distant Asia, where there is a somewhat despotic but just rule. The myth of the absolute justice of Chinese rule was to persist for another eighteen centuries.

At the end of the third century the waning and re-waxing of Roman power seriously reduced Alexandria's position as the commercial centre of the sea trade, and destroyed that of Antioch and of Palmyra as the centres of the land trade.

Silk panel from Lyons in the style of Pillement, *c*. 1750. A fine example of rococo-chinoiserie.

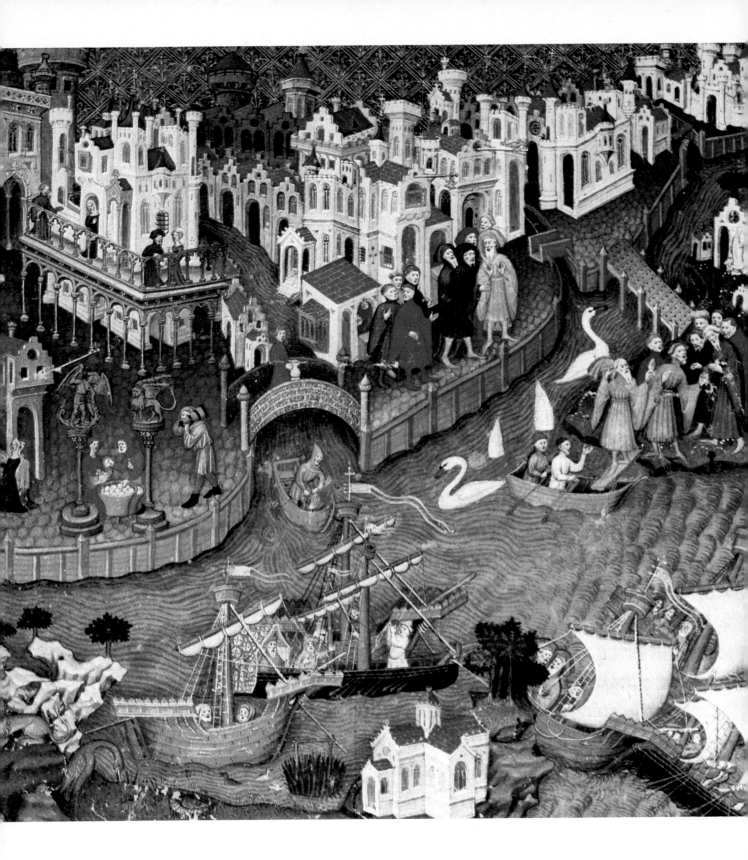

The land trade-routes shifted northward at their western end, and this was only accentuated by the ascendency of Constantinople of AD 330.

In China, the Han downfall in AD 220 did not affect the well-established export trade in silk, which journeyed for the most part via Samarkand, while sea-borne trade from China to the Indian Ocean increased. In the fourth century Diocletian and Constantine restored the Roman Empire to stability and prosperity and in Byzantium the demand for silk increased. In the late fourth century Ammianus comments on the spread of the use of silk even to the lowest classes. And certainly silk was known to the barbarians: in 408 Alaric the Visigoth laid siege to Rome and demanded the ransom of 5,000 pounds of gold, 30,000 pounds of silver, 3,000 scarlet-dyed skins, 4,000 silk tunics and 3,000 pounds of pepper.

The trade between Byzantium and Persia was conducted by merchants who purchased the unwoven silk, but had first to offer it to the state. In 540 there was a shortage, owing to war with Persia, and Justinian declared a state monopoly in 542. It was in about 553 that the celebrated smuggling of live silkworms into Byzantium, possibly by monks who concealed them in hollow canes, occurred, and the silk industry of Syria was started. By the late sixth century the production monopoly of China and the trade monopoly of Persia were broken.

In the sixth century, Sasanian Persia became the greatest power in the Near East. Already in the sixth century Sasanian merchants were trading in India and Ceylon, and by the eighth century, sea trade was established with China. Among imports to Persia are T'ang mirrors, paper, the peach and the apricot and the cross-bow, while the Sasanians exported glass, the vine and the date. There are some pieces of Sasanian glass in Japan which are inventoried since AD 731, which must have come via China, and in Europe, a piece of Sasanian glass is among the treasures recorded in the Abbey of St. Denis before 1144 by Abbot Suger. While Chinese metal technology was very advanced, it

is noticeable that most Chinese T'ang metal-work is greatly influenced by Sasanian design. By the year 800, huge quantities of T'ang pottery, mostly bowls with painted decoration in brown or green, and green or black glazed jars were being imported into the Persian Gulf for distribution throughout the Near East, attesting to the large volume of the sea-borne traffic, and in the tenth century some Sung dynasty white porcelain appeared.

The rise to power of Islam after the preaching of Mahomet in 622 was quick and spectacular. By the beginning of the eighth century Islam not only controlled most of the Levant but stretched across North Africa and as far as Spain, which was conquered by the Omayyads in 710–712. They had even penetrated France as far as Poitiers, when they were defeated by the Franks under Charles Martel and expelled beyond the Pyrenees.

It was Islam, in the seventh and eighth centuries, that almost cut off East from West again. Up until Renaissance times, western knowledge of eastern lands was virtually confined to the travellers' tales of pilgrims, and the observations of the Crusaders, though some interchange and trade carried on through Byzantium and through Spain. From northern Europe, the Swedes were able to trade in Bokhara and Samarkand, where they sold slaves. Kufic coins struck in Merv in the ninth century have been found in Scandinavia, and in excavations on the island of Helgö in Lake Malär, probably of the ninth century, a small Kashmiri bronze buddha (possibly of the sixth century) was found, which had been used by its viking owner as an amulet.

Translations and adaptations of all the more fantastic of the Greek books added to the lack of discrimination between fact and fable — particularly to blame was the tenth century version of the second century, anonymous (pseudo-Callisthenes) *History of Alexander*, which was much believed by the credulous. Megasthenes, Eratosthenes, and even Ptolemy of Alexandria were almost forgotten.

It was thought, however, that a great Christian

The Polos prepare to leave Venice. English miniature, probably by Johannes, *c.* 1400.

11 An illustration from a late 12th-century English manuscript. That people could believe in these absurdities is not so surprising when it is remembered how little was known of any far-off lands.

kingdom existed in Asia, beyond the Saracens, ruled by the fabulous Prester John. It was the hope of the Crusaders that an alliance could be formed with this kingdom, whose existence was testified to by a famous literary forgery, a letter to the Pope purporting to be from the Prester. Even Marco Polo in the thirteenth century looked in vain for this kingdom within Asia, though after the fourteenth century, Prester John was thought to rule in Africa. This is not so odd as it may seem, because there was considerable vagueness over the distinction between Africa and Asia.

In the early thirteenth century the Mongol hordes of Jinghiz Khan appeared on the scene.

12 The Kashmiri buddha found in Helgö in a 9th-century Viking grave.

13 A simple 10th-century Chinese porcelain whiteware dish of the type exported to the Near East.

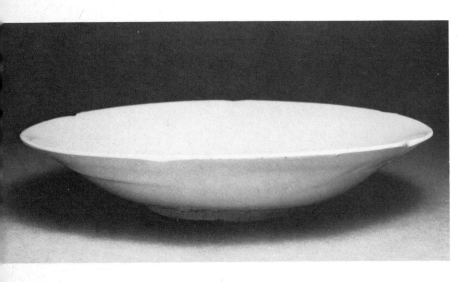

Victorious wherever they went the Mongols soon controlled virtually the whole of Asia: in the late 1230s they invaded Russia, and in 1241 ravaged Poland, Moravia, and Hungary. Fortunately for Europe the Great Khan Ogodai, the son and successor of Jinghiz, died on 11 December 1241, and by Mongol custom, all contenders to the succession had to return to the family, in Karakorum. Europe breathed again, and Pope Gregory IX called off his 'crusade' against the Mongols. Remembering that the Mongols had defeated the Muslim armies, and because the Great Khan had married a Christian princess, it was, optimistically, believed that an alliance might be formed between the Mongols and Europe, to crush Islam.

From the Council of Lyons in 1245, Pope

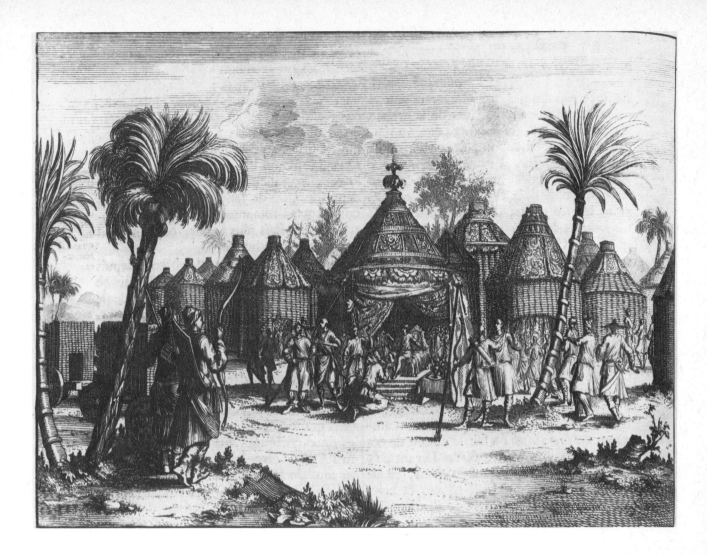

14 A fanciful engraving of William of Rubruck at Karakorum. From *Voyages faits principalement en Asie* by Pierre Bergeron, 1735.

Innocent IV sent John of Plano Carpini on a mission to Karakorum via Poland and Russia. He returned in 1247, unsuccessful, but giving a factual and sensible account of Asia in a *History of the Mongols*. Other embassies followed: from the Crusade, Louis IX of France (St. Louis) sent first Andrew of Longjumeau in 1249 and then William of Rubruck in 1254. William went as a missionary, and though he spent eight months at the Mongol Court in Karakorum he failed to convert any Mongols. He wrote of his travels, like John, accurately and carefully. He has much to say of Seres, the land of silk, which he correctly equates with China. He knew even of Chinese calligraphy: *'They do their writing with a brush such as painters paint with and a single character of theirs comprehends several letters so as to form a whole word'*. Europe's diplomatic missions were a failure, and though the Mongols sacked Baghdad in 1258, thereby greatly increasing Christian hopes, they were held back by the Mamelukes of Egypt.

In 1264 the Mongols turned their attentions south and east of Mongolia and crossed the Great Wall into China, where Kublai Khan established his capital at Cambaluc (Peking) and his summer retreat at Xanadu (Shang-tu), creating the Yüan dynasty. It was at Cambaluc that Kublai Khan was visited by two Venetian brothers, Nicolo and Maffeo Polo. The Polos had followed the northern trade route, leaving the Crimea in 1260 and staying some three years in Bokhara: Kublai Khan sent them back to Europe as his emissaries to the Pope, and they

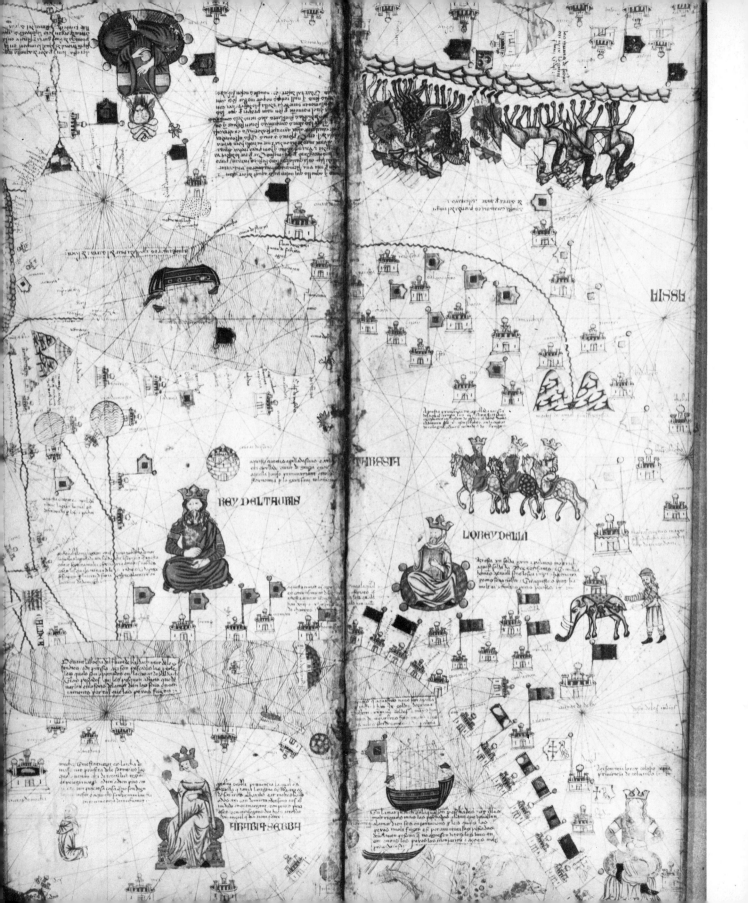

reached Acre in 1269. When they arrived, the Holy See was in the process of electing a new Pope and when Gregory X was elected, he eventually sent them back as Apostolic Delegates. Instead of the 100 *savants* asked for by the Khan, Gregory sent two Dominican friars. In 1271 the Polos left Acre taking with them Nicolo's young son Marco. Although the friars turned back, the Polos reach Xanadu in 1275.

The Mongols, having only recently conquered China, were reluctant to use too many Chinese in the senior ranks of their civil service, preferring to use foreigners. Marco was employed by the Khan for seventeen years. For the Khan, he travelled virtually all over China. Marco was not the only European working for the Khan: some of the captives from the raids of 1240–1241 were living and working in Mongolia and China.

While the Polos were on their final journey home, another embassy was on the way out to Mongolia; John of Monte Corvino was sent in 1289 by Pope Nicholas IV to evangelize. He reached Peking in 1292 or 1293 and by the time he had been there six years he had many converts and had built a church with a campanile and three bells. In 1307 the Pope heard of his success and created him Archbishop of Cambaluc. When, in 1328, Corvino died, he had a considerable Christian following in several towns in China.

Taking advantage of the Mongolian hold over the Levant, Italian traders, especially from Genoa and Venice, came to China in some numbers, chiefly engaging in the silk trade, and the Papacy and the Yüan court entered into a considerable diplomatic correspondence, and exchanged presents. Chinese goods appeared more frequently in the Near East, and in the fourteenth century, porcelain from Ching-tê Chên, decorated in underglaze cobalt, the celebrated blue-and-white, appears in the Near East, and later filters through to Europe.

Marco Polo's 'history' was one of the most important sources of information about the East, but other later travellers left useful accounts

15 A page from the Catalan Atlas of 1375 partly based on information brought back by travellers to the Orient.

of travels throughout Asia and South-east Asia: Odoric of Pordenone, Marignolli and Pergoletti and the Arab traveller Ibn Batuta being among the most informative. Unfortunately, such was the arrogance of Europe that the marvels related by Polo, nicknamed 'Il Milione' for his 'million lies', and the others were not always believed. How could it be true that so far away there were cities four times as rich as Venice, and governments both just and efficient? It was much easier to believe the work of one of the

16 Early 16th-century blue-and-white porcelain vase with an Arabic inscription, probably made for the use of Muslim eunuchs at the Chinese Court.

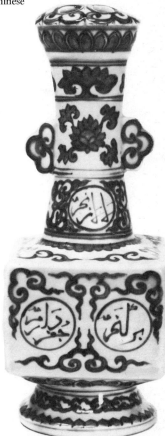

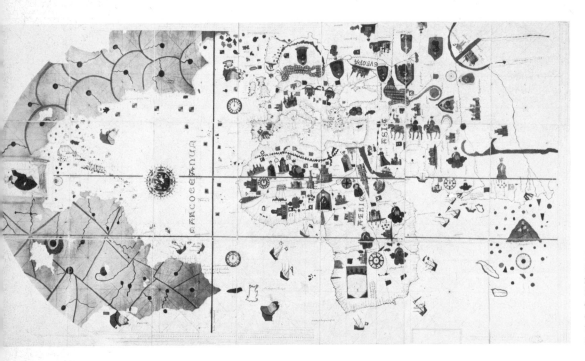

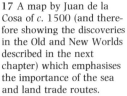

17 A map by Juan de la Cosa of *c.* 1500 (and therefore showing the discoveries in the Old and New Worlds described in the next chapter) which emphasises the importance of the sea and land trade routes.

greatest plagiarizers in history, the pseudonymous Sir John Mandeville. This romantic compound of all the most far-fetched stories from the Greek writers was an immediate success. Translated into almost every European language before 1500 it has coloured the European picture of the East, particularly of Cathay, ever since.

In 1368 the Mongols were expelled from China by the Ming: the Chinese expanded into Mongolia, and the northern trade routes were closed. This threw the entire weight of the spice trade in particular onto the sea route, which was controlled and exploited by Islam: Europe could produce its own silk, but it could not produce spices. The result of this was to stimulate the search for a new way to India and the Indies. In 1492 Columbus had sailed from Spain expecting to find China, and thence go on to the Spice Islands, but it was Vasco da Gama, in 1498, who found the way round Africa.

18 Vasco da Gama by an unknown artist

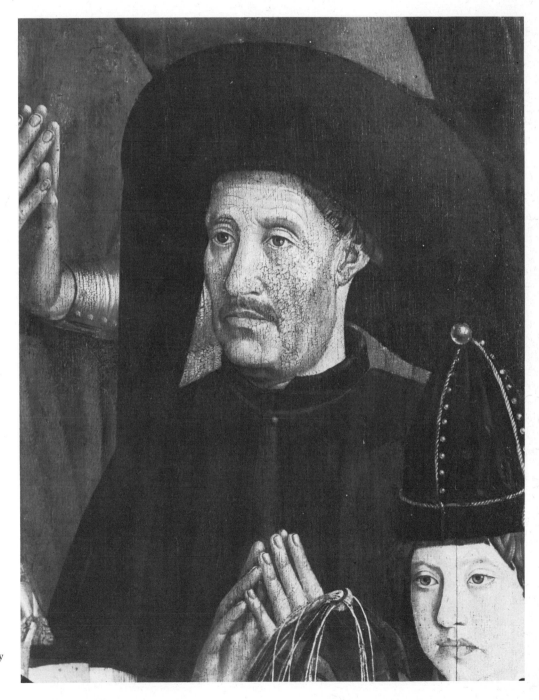

19 Prince Henry the Navigator — a detail from the triptych of the Veneration of St Vincent (15th century Portuguese school).
See p. 29

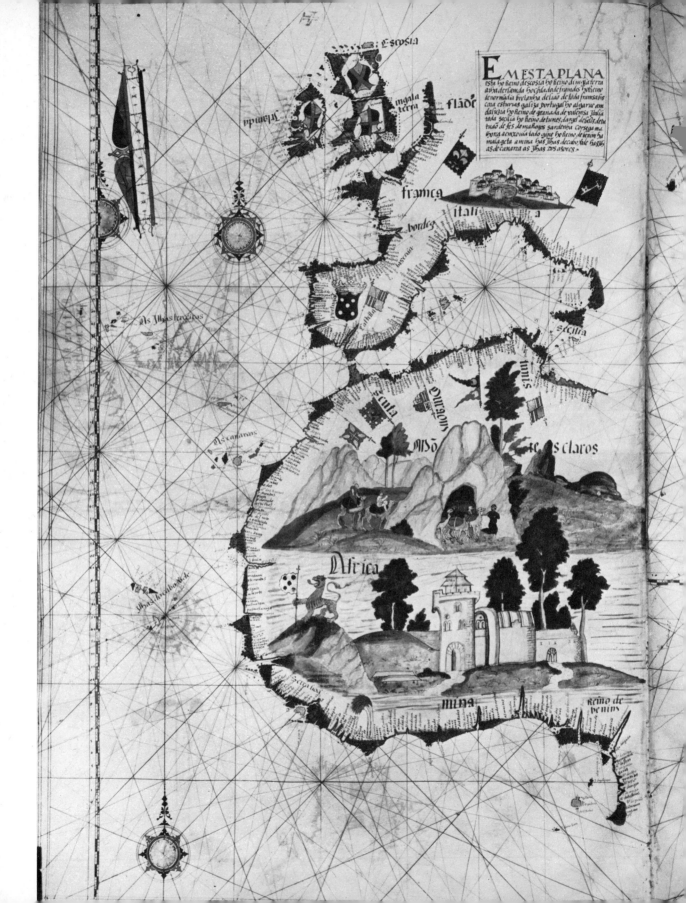

Chapter Two

The Way round Africa

In the thirteenth century the merchant rivals, Venice and Genoa had virtually divided the Mediterranean trade between them. Genoa controlled trade in the west, and beyond the Straits of Gibraltar, while Venice, which controlled the eastern Mediterranean, had grown rich on the profits of the Crusades and held the monopoly of the spice trade with Egypt. With the Greek restoration in Byzantium in 1261, the Genoese, who had helped Michael Palaeologus in his unscrupulous rise to power, took over the Black Sea trade, and hence had access to the Central Asian land trade. They took ships overland to the Caspian, and even proposed to take ships overland to the Persian Gulf, by treating with the Mongol Empire. This proposal was foiled, possibly by Venetian interference, but it shows the intentions of the Genoese to bypass Egypt and the Venetian monopoly of the seaborne spice trade by getting their own ships into the Persian Gulf and the Indian Ocean. Frustrated, they determined to take advantage of their expertise in ocean navigation and sail round Africa, hoping to reach the Indian Ocean. Early geographers and travellers' tales had suggested that perhaps the Indian Ocean was open from the south and not enclosed by an eastward extension of Africa. But Africa itself was largely unknown. If the Venetian monopoly in the spice trade was to be broken, then perhaps the best thing to do was to begin the exploration of the southward extent of Africa.

From Genoa, Ugolino de Vivaldo set off in two ships in 1291. He sailed through the Straits of Gibraltar, was sighted once off the west coast of Africa, but was never heard of again. For over a century, no one else dared try. Then it was the turn of the Portuguese. In the fourteenth century Portugal became a seapower, at first employing Genoese sailors and pilots. Lisbon became an important entrepôt in the trade from Genoa to Flanders, and, later from Venice and Florence to Flanders.

It was natural for the Portuguese to explore southwards down the west coast of Africa. The moving spirit behind this exploration was the

Crown Prince Henry, later known as Prince Henry the Navigator, whose mother was Phillipa of Lancaster, daughter of John of Gaunt. Henry had heard of inhabited lands south of the Muslim lands, from the Moors, who told him of the caravan trails from Tunis to Timbuctoo. By 1444 Henry's captains had reached the Senegal and Gambia rivers, starting a considerable and lucrative trade in gold, ivory and slaves. But the Portuguese had, as yet, little thought of participating directly in the spice trade.

Henry died in 1460 and it was only after much hesitation that King Alfonso V continued the exploration. Meanwhile Alfonso was approached by a Florentine astronomer called Toscanelli, who proposed a voyage in the opposite direction, due west, across the Atlantic to the 'Indies'. Toscanelli relied on Marco Polo's account of China and of Java and Sumatra (both of which Polo had visited) and his real interest was to reach China, to go to Zayton, a port Polo had described as the centre of the spice trade. For it was the spice trade that was the lure. But Alfonso did not like the idea, which, after all, was a very radical one, and Toscanelli sent his plans and maps to a Genoese adventurer called Christopher Columbus.

Alfonso's successor John II renewed the exploration of Africa, but this time it was not the ivory and slaves of the west coast that attracted his attention, but the possibility of reaching the Indian Ocean, and hence India and the Spice Islands. In 1488 Bartholomew Diaz was sent to discover the southern extension of Africa. He rounded the Cape of Good Hope, so named by John 'for the promise it gave of the finding of India', discovered that the coastline ran northwards, and then, as ordered, returned to Lisbon.

John had also sent out two travellers overland, and it was the reports sent back by one of these, Pedro de Covilham, of the probability of access to the Indian Ocean from the south, together with Diaz's discovery, that finally determined John to send an expedition around the Cape, to India. Then, in 1492, Columbus,

20 A map by Lazaro Luis of 1563 showing the discoveries on the west coast of Africa up to the time of Fernão Gomes (1470–75), who had alarmed the Portuguese by showing that the westward-running coast of Africa turned southwards.

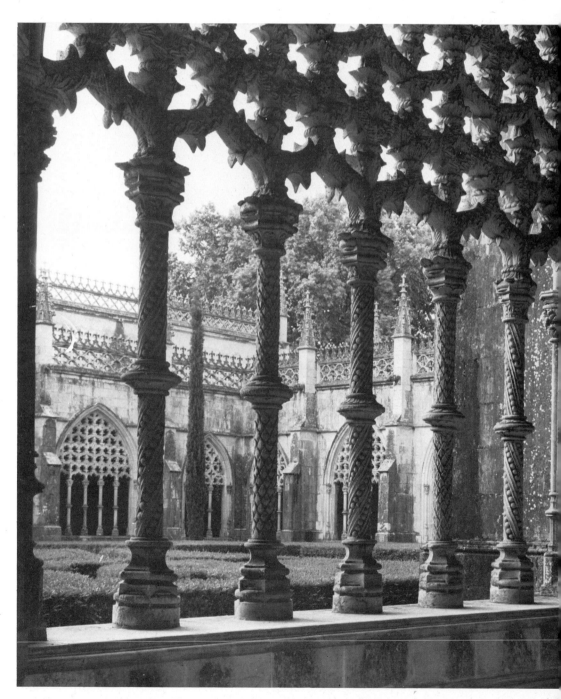

21 The Manueline cloister in the monastery at Batalha showing the 'oriental' extension of the International Gothic style, that is more fantastic than oriental, though it is partly based on Moorish detail.

having found a patron in the Queen of Spain, discovered the West Indies. There had been several expeditions across the Atlantic before Columbus, looking for 'islands' vaguely reported, but these failed because the commanders were looking for islands, not for mainland. Mediaeval sailors always underestimated sea distances, and when they did not reach the 'islands', where they thought they should be, they were obliged to return while they still had enough water to last the voyage home. Columbus succeeded because he believed that he was going to reach mainland China. After all, one could not miss a continent, and so he intended just to sail on until he did reach it. What he reached was Hispaniola in the West Indies.

That it was the Spaniards who reached land, whatever that land was, the other side of the Atlantic, of course upset the Portuguese, but they were greatly encouraged by the conspicuous lack of success of Columbus' second expedition. In 1494 Spain and Portugal made a treaty, with the blessings of several Papal Bulls, dividing the world into an eastern and a western half: the Portuguese were to have the monopoly of the eastward route, and the Spanish the monopoly of the westward. The details of the division show that both sides were equally ignorant of Atlantic geography, while holding different wrong opinions. Part of the point of the Papal Bulls was, of course, to warn off other nations. The maritime nations of northern Europe paid no attention whatsoever to this pretension to temporal power, the Cabots, for instance, sailing from England to America in 1497 and 1499.

Eventually, in 1496 King Manoel I, who had succeeded John II in 1495, sent Vasco da Gama, with four ships to sail around the Cape of Good Hope to India. Da Gama sailed up the east coast of Africa, and, with an Arab pilot crossed the Indian Ocean with the south-west monsoon, reaching Calicut on 20 May 1498. King Manoel was so excited by news of da Gama's successful voyage, that he started on an ambitious public works programme in and around Lisbon, beginning the Manueline style in architecture. He

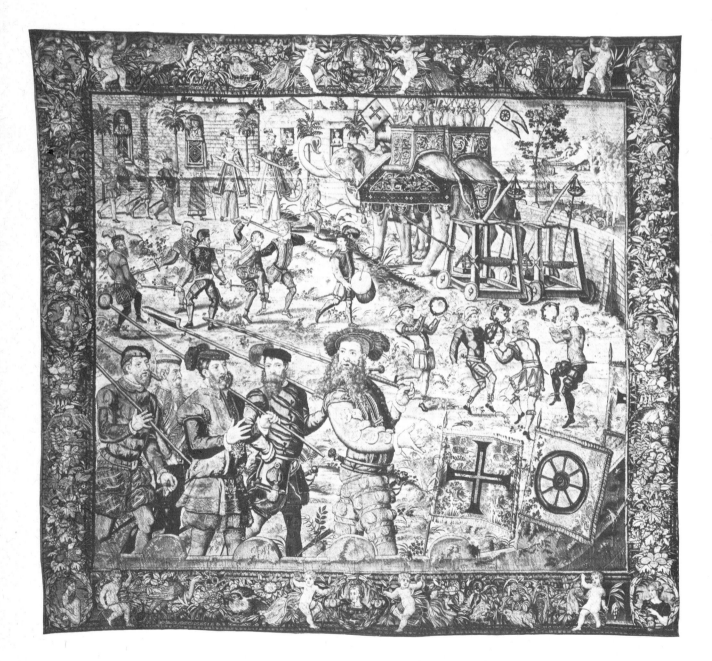

22 A 16th-century Brussels tapestry from a series showing the deeds of João de Castro, governor of Goa in 1547. *See also illus. 26 and 60*

also proclaimed himself 'Lord of the conquest, navigation, and commerce of India, Ethiopia, Arabia and Persia'. François I of France, more prosaically, called him 'the Grocer King'.

Trade in the Indian Ocean in the first half of the fifteenth century had been in the hands of the Muslims and the Chinese. The Yung Lo Emperor of the Ming dynasty sent several large expeditions, under the Grand Eunuch, Cheng Ho, throughout South-east Asia, and as far down the east coast of Africa as Malindi. Apart from extending the suzerainty of China over Asian seas, their main interest was the acquisition of gemstones and jewels, but there is also mention in the Chinese records of exotic items such as giraffes, zebras, and ostriches, none of which are found in India, and all of which must therefore have come directly or indirectly from Africa. The western base of the Chinese traders was Malacca, on the West coast of the Malay peninsula, but in the second half of the century, driven out by Muslim competition, and restricted by the orders of Yung Lo's successor, the Chinese kept to the east of Malacca only. Malacca became an important state, nominally subject to China, and a major port of the spice trade.

Da Gama found the Muslim traders in Calicut hostile, fearing to lose their monopoly, and the second Portuguese expedition to Calicut under the command of Pedro Cabral (who discovered Brazil *en route*) took pains to be heavily armed. Indeed, after some Portuguese sailors were killed by Muslims, Cabral bombarded the town. Battles in Indian seas followed, and in 1509 the Portuguese commander Alfonso de Albuquerque took the island of Ormuz, which controlled the entrance to the Persian Gulf. The Portuguese now had complete control of the western Indian Ocean and began to act as the intermediaries in the spice trade, as Egypt had done hitherto. In 1510 they consolidated their position by the capture of Goa on the west coast of India. Goa was strategically placed not only for the pepper trade, but also for the horse trade between South India and Arabia and Persia. The Portuguese encountered Chinese traders directly for

the first time when, in 1509, Lopes de Seguiera took a fleet east, to Malacca. Here the Portuguese were able to buy silk directly, without middlemen's profits. But this was not enough, they also wanted direct control of the spice trade.

In 1511 Albuquerque took Malacca, with great difficulty, but without the interference of China, thus gaining the opportunity to venture further east, and winning a large part of the

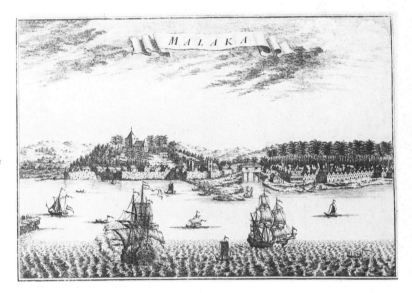

trade in pepper from Bantam, nutmeg from the Banda Islands, and cloves from the Moluccas. As Tomé Pires wrote in 1515: *'No trading port as large as Malacca is known, nor any where they deal in such fine and highly prized merchandise. Goods from all over the East are found here; goods from all over the West are sold here. It is at the end of the monsoons, where you will find what you want, and sometimes more than you are looking for.'*

Portugal thus had control of the Banda Straits, the west coast of India, and the entrance to the Persian Gulf. It had failed only

23 An 18th-century engraving of Malacca

34

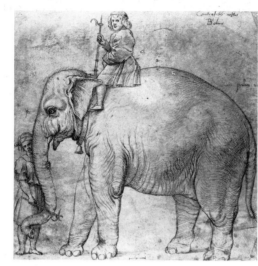

24 Hanno, the Indian elephant sent to Pope Leo X in 1513 by King Manoel. Drawing after a lost original by Raphael.

25 The Ganda, woodcut by Albrecht Dürer, 1515.

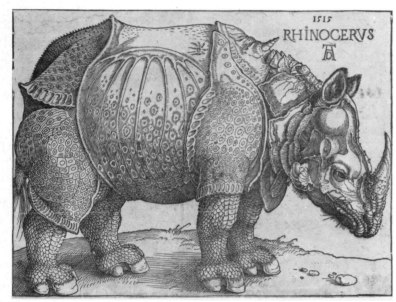

Germany and Italy were very considerable. The profits from the trade in spice were enormous, and while Asia derived relatively little immediate gain from the trade, Lisbon rapidly became one of the great cities of Europe.

Among the presents that the Portuguese sent back to King Manoel in Lisbon were, in 1513 an elephant[1], and in 1515 an Indian rhinoceros. This unfortunate beast after a stay of six months in Lisbon was shipped to Italy as a present to Pope Leo X. On the way, the boat called in at Marseilles, where François I of France came to see it, but later in the bay of Genoa the boat was sunk and the rhinoceros drowned. Its body was washed ashore, and Leo X was presented with a stuffed rhinoceros instead of a live one. But the rhinoceros had been immortalized in a drawing and a woodcut by Dürer, who had never seen the animal himself, but only draw-ings by others: hence, perhaps, its somewhat exaggeratedly armour-plated appearance, and the touches of fantasy. This woodcut has pro-vided the model for innumerable later represen-tations of the rhinoceros.

In 1517 the Portuguese sent an embassy to China, to Canton, under Fernão d'Andrade, taking an envoy who was to go to Peking to the Emperor. Owing to bad behaviour by the Portu-guese, the envoy, Tomé Pires, was sent straight back to Canton, to prison; he did eventually reach Peking in 1521. Nevertheless, trade was established, though it had no official sanction, nor did the Portuguese acquire trading rights in a particular port until 1557 when they were allowed the town and harbour of Macao.

Portugal's successes in the spice islands and in the spice trade aroused Spain's cupidity, and three different routes were tried in order to reach South-east Asia. In 1519 Magellan set off with five ships; after rounding South America through the straits named after him, he crossed the Pacific to the Philippines, where he was killed: of his five ships only one returned to Spain. This was the first circumnavigation of the globe, but it was a financial disaster for the investors, and was not attempted again until

to take Aden, which it had wanted in order to command the entrance to the Red Sea, but this failure proved less important as Portuguese control over all coastal shipping increased: no eastern ships (except the great Chinese sea-junks, which did not enter the Arabian Sea) could move without a Portuguese licence.

During the sixteenth century, the European market in pepper in particular became so im-portant that it was the subject of endless inter-national intrigue, and the complexities of the financial negotiations between the importers, the dealers, and the great banking houses of

1. p. 79

1525, when a similar financial loss was made. In 1524 attempts were made by Spain to find the North-west Passage, where the northern maritime nations had already failed. Thirdly, in 1527 Hernán Cortés sent a fleet from Mexico across the Pacific to the Philippines. There were problems here, too, for it was not until 1565 that it was learned that to cross the Pacific in an easterly direction, to get back to Mexico, it was necessary to sail to 43° north latitude, to catch the eastward North Pacific current.

Meanwhile, in 1542, a Chinese junk with three Portuguese passengers was blown off its course to Tanegashima, off the coast of Kyushu, the southern island of Japan; Europe had heard of Japan since Marco Polo's description of Xipangu but no westerner had ever been there. Two years later trade had begun, and in August 1549 the Jesuit Francis Xavier arrived to preach Christianity: *'The people whom we have met so far'*, he wrote on 5 November, *'are the best who have yet been discovered, and it seems to me that we shall never find among heathens another race to equal the Japanese. They are people of very good manners, good in general, and not malicious; they are men of honour to a marvel, and prize honour above all else in the world.'*

The Portuguese had brought with them trade-goods that made them welcome to the local lords of southern Japan; most important of these was the smooth-bore musket. Initially it was in the hope of attracting more Portuguese ships with more Portuguese guns to sell that the Jesuits were received so well.

Whereas in India the missionaries had made little headway, and their conversion of the rulers of the two kingdoms of Ceylon had been made almost at gun point, in Japan Christianity met with some success. The Jesuit Visitor, Alessandro Valignano realized that hope for missionary success lay in the intellectual and personal calibre of the missionaries. For Japan had a much more sophisticated culture than had been encountered before, and it was realized that something must be offered: western knowledge. Where Xavier had attempted to

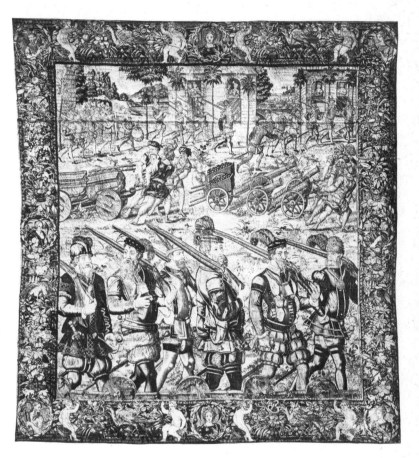

preach, the later missionaries were to teach. This was the same pattern that was to be followed later, in China, by Matteo Ricci.

In 1552 a Japanese convert had been sent to Europe to study. After two years in Portugal he had paid a brief visit to Rome where he was received by the Pope. 'Bernard' was probably the first Japanese visitor to Europe, but he died in 1557 without returning to Japan. Thirty years later Valignano sent a more ambitious delegation to Europe: four converts, all young men of the minor nobility, arrived in Lisbon in 1584. Travelling through Spain they were royally

26 'The deeds of João de Castro' (*see also illus 22 and 60*) showing muskets of the type taken to Japan.

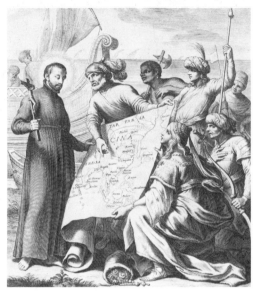

27 Symbolic representation of the Jesuits' mission. Title page of *Dell' Istoria della Compagnia di Gesù l'Asia* by Daniello Bartoli, Rome 1657.

treated by Philip II (and were able, on leaving, to see some of the Great Armada Philip was preparing against England). Sailing to Italy they had an almost triumphal tour through Leghorn, Pisa, and Florence, where they were received by Francesco dei Medici, through Siena to Rome. They made a very good impression on Pope Gregory XIII; among the presents they gave to His Holiness were a pair of folding screens decorated with pictures of Nobunaga's Azuchi castle. It is tempting to think that these may have been painted by the great Kanō painter Eitoku, but they are no longer to be found in the Vatican Palace. Gregory died while the embassy was there, so the four converts were able to witness the election of Sixtus V, and they left Rome in June 1585 visiting Assisi, Bologna and Ferrara on their way to Venice. At Venice they were received with great pomp, and altogether they made a remarkable impression in Europe. Valignano's instructions to Father Nunō Rodrigues were clear: the four converts were not to see anything of heretics or Protestants and should only see such 'things which will contribute to their edification'. A most selective tour. They left Lisbon for Japan in April 1586.

Up until this time the great centre of distribution of the spice trade in Northern Europe, had been Antwerp, one of the greatest cities in Europe. But in 1555, Charles V of Spain, the Holy Roman Emperor, abdicated. As the Netherlands were still under the power of Spain, its rising Protestantism greatly concerned Charles's successor in Spain, Philip II, who was an almost fanatical Catholic. Philip's attempts to suppress heresies in the Low Countries not only destroyed Antwerp as the centre of the spice trade, but eventually lost the Northern Netherlands to Spain. At the end of the sixteenth and the beginning of the seventeenth centuries the United Provinces of the independent Netherlands were to rise as a sea power equal to Spain, Portugal or Britain.

In spite of Philip's preoccupations in Europe Spanish ships continued to visit the east in considerable numbers, using Manila in the Philippines as their eastern headquarters, and more competing with the Portuguese. In 1580, Philip succeeded to the Crown of Portugal, thus joining the two kingdoms, and avoiding the conflict of interests. At first, Philip kept the two kingdoms and empires under separate administration, but after 1591 they were joined. That this was not always a success is shown by the effect this had in Japan where the petty squabbling of the Spanish Franciscans with the Portuguese Jesuits did much to hasten the eventual expulsion of the Christians.

The Spanish and Portuguese monopoly was not to remain complete: in 1580 Francis Drake returned to Plymouth from his successful circumnavigation of the world, having avoided the Portuguese in the West Indies; much to Philip's indignation, he was knighted by Queen Elizabeth. Nearer the end of the century Dutch ships were venturing into Far Eastern waters for the first time, for Philip had closed Lisbon to them. In 1600 the English founded the East India Company, while the Dutch *Vereenigde Oost-Indische Compagnie* was founded in 1602.

Valignano had seen the goal of the Jesuit missionaries as China. But in the 1580s, the Spanish were considering a wholesale invasion of China, and it was mainly on account of the failure of the Great Armada to invade England in 1588 that this plan was abandoned. That the West first penetrated China peacefully was mainly due to one man, the Portuguese Jesuit Matteo Ricci.

Ricci arrived in Macao in 1582, and then in 1583 went to Chao-Ching, in Hangchow, to join Michele Ruggiero who had been there for a year. For seventeen years Ricci stayed in Chao-Ching, learning the Chinese language, and the history and customs of the Chinese people. Deliberately, as had been suggested by Valignano, he set out to win the respect of the Chinese, and he evidently succeeded, for in 1601 he was at last allowed to go to Peking.

Almost until the end of the sixteenth century, then, the East Indies trade was in the hands of the Portuguese and the Spanish. But the Portuguese carracks sailing around the Cape of Good Hope, and the great Spanish galleons sailing from Mexico were natural prey for the privateers of England, licensed by Queen Elizabeth. In 1592, for instance, the great *Madre de Dios* was captured off the Azores, and taken to Plymouth. By good fortune, we have a list of the cargo, given by Richard Hakluyt:

'the principal wares after the jewels (which were no doubt of great value, though they never came to light) consisted of spices, drugges, silks, calicos, quilts, carpets and colours &c. The spices were pepper, cloves, maces, nutmegs, cinamom, greene ginger; the drugs were benjamim, frankincense, galingale, mirabolans, aloes, zocotrina, camphire; the silks, damasks, taffetas, sarcenets, altobassos, that is, counterfeit cloth of gold, unwrought China silke, sleaved silke, white twisted silke, curled cypresse . . . There were also canopies, and course diaper-towels, quilts of course sarcenet and of calico, carpets like those of Turkey; whereunto are to be added the pearle, muske, civet and amber-griece. The rest of the wares were many in number, but less in value: as elephants teeth. porcellan vessels of China, coco-nuts, hides, ebenwood as black as jet, bedsteds of the same, cloth of the rindes of trees very strange for the matter, and artificiall in workemanship. All which piles of commodities . . . amounted to no lesse than 150000 li. sterling, which being divided among the adventurers (whereof her Majesty was the chiefe) was sufficient to yeeld contentment to all parties.'

This gives us an idea of the astonishing rich-

ness of goods from the East. It also tells us that the goods were from various countries of the Far East: India, China, and the Spice Islands for sure, probably Japan, Ceylon, Malaya, Java, Sumatra and Siam as well. It is no wonder that by the time these goods reached Europe there was considerable confusion over their ultimate origin, with consequent muddles of nomenclature.

It is also no wonder that the Dutch and English were so anxious to engage in this hazardous trade, and not rely on the occasional capture of a laden cargo ship of Portugal or Spain. The way round Africa must be opened to all.

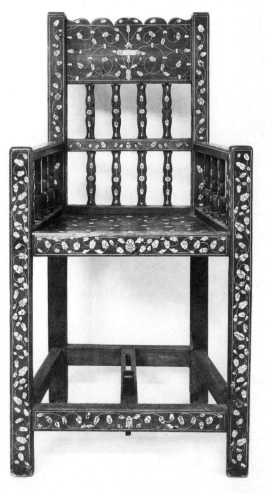

28 Chair inlaid with mother of pearl formerly in the possession of Catharina Stenbock, widow of King Gustavus I Vasa of Sweden (d. 1560). Probably Mogul, late 16th century.

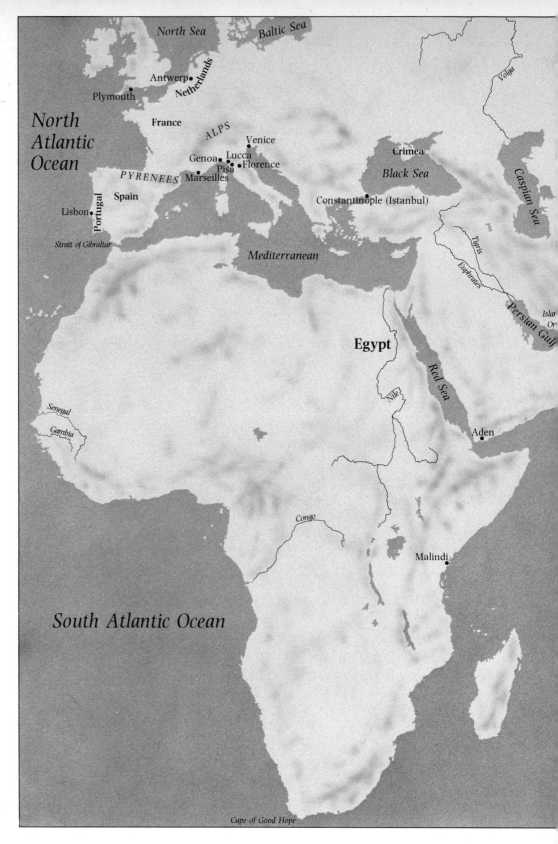

38

North Sea
Baltic Sea

Antwerp
Plymouth
Netherlands

North
Atlantic
Ocean

France

ALPS
Venice

Genoa Lucca
Pisa Florence
PYRENEES
Marseilles

Crimea
Black Sea

Volga

Caspian Sea

Spain
Portugal
Lisbon

Constantinople (Istanbul)

Strait of Gibraltar

Mediterranean

Tigris
Euphrates

Persian Gulf

Islar
Or

Egypt

Senegal

Gambia

Nile

Red Sea

Aden

Congo

Malindi

South Atlantic Ocean

Map to illustrate Chapters 2
and 3

Cape of Good Hope

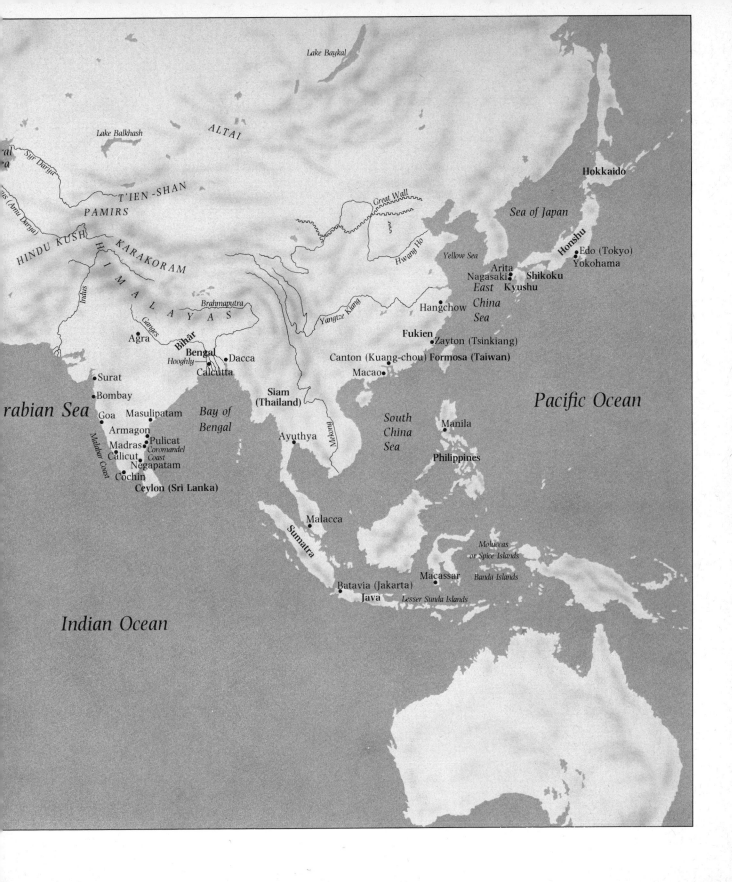

Lake Baykal

ALTAI

Lake Balkhash

T'IEN-SHAN

PAMIRS

HINDU KUSH

KARAKORAM

Indus

HIMALAYAS

Brahmaputra

Ganges

Agra

Bihār

Bengal

Hooghly

Dacca

Calcutta

Surat

Bombay

Arabian Sea

Goa

Masulipatam

Bay of
Bengal

Armagon

Madras

Pulicat

Calicut

Coromandel
Coast

Malabar Coast

Negapatam

Cochin

Ceylon (Sri Lanka)

Great Wall

Hwang Ho

Yellow Sea

Sea of Japan

Hokkaido

Honshu

Edo (Tokyo)

Yokohama

Arita

Nagasaki

Shikoku

East

Kyushu

China

Sea

Hangchow

Fukien

Zayton (Tsinkiang)

Canton (Kuang-chou)

Formosa (Taiwan)

Macao

Yangtze Kiang

Siam
(Thailand)

Ayuthya

Mekong

South
China
Sea

Manila

Philippines

Pacific Ocean

Malacca

Sumatra

Moluccas
or Spice Islands

Macassar

Banda Islands

Batavia (Jakarta)

Java

Lesser Sunda Islands

Indian Ocean

Syr Darya

(Amu Darya)

Chapter Three

The Merchant Adventurers

It was at the turn of the seventeenth century that the Portuguese and Spanish monopoly of the sea borne-trade in the Indian Ocean, in South-east Asia and the Far East began to break down. The first years of the century saw Dutch, English and Danish ships in eastern waters, to be joined later by French, Swedish and Prussian ships.

The Dutch were successful in breaking the Portuguese monopoly and, with the English a not very good second, dominated the eastern trade until the eighteenth century. The main difference between Dutch and English expansion into the eastern trade was that, whereas the English were perfectly happy to co-exist with other European trading nations, especially the well-established Portuguese, the Dutch actively and by force of arms sought to oust the Portuguese, and to set up a monopoly by excluding the English and Danish from trading activity. As Sir Josiah Childe, President of the Court of Directors of the East India Company wrote: 'Our business is only trade and security, not conquest, which the Dutch aimed at . . .'

On the whole the Dutch policy was incredibly successful in spite of the fact that the Dutch were fighting the Portuguese and Spanish not only in eastern waters, but also on both the west and east coasts of Africa, in Mexico and Brazil. Indeed, before 1600 they had ousted the Portuguese from some of their African settlements, and in 1605 they had control of a major part of the Spice Islands, though in competition with the Spanish.

On the west coast of India the Dutch opened a trading-station (a 'factory') in Surat, and in 1606 and 1610 two more, on the Coromandel coast, at Pulicat and Masulipatam. In 1608 William Hawkins in the *Hector* arrived at Surat, and travelled to Agra to attempt to negotiate with the Mogul Emperor, Jahāngīr, for a British factory. Owing to the machinations of the Portuguese Jesuits at the Mogul court, he failed, but later the Jesuits themselves fell out of favour, and an English factory was set up in 1612. It was not successful, and in 1615 the Company sent Sir Thomas Roe to negotiate for better terms. Roe was also to act as ambassador from James I to Jahāngīr. In 1616 the English also had a factory at Masulipatam, and in 1626 at Armagon near Pulicat, both of which they were allowed by the King of Vijayanagar to fortify: these fortifications, like those of the Dutch, were to safeguard the factory against the Portuguese, not against the local inhabitants. In 1609 the Dutch opened a factory on Java at Batavia (modern Jakarta), which became their head-quarters in the East.

One of the few Dutch ships in Eastern waters before 1600 was the *Liefde*. After a terrible crossing of the Pacific, in which most of the crew died, the ship reached Funai, in Kyushu in April 1600. The Shōgun, Tokugawa Ieyasu, sent for the Captain, who was too weak to travel and so had to send his pilot, an Englishman called Will Adams. Although the Jesuits tried to persuade Ieyasu that the Dutch and English were pirates, Ieyasu took a liking to Adams and put him to work in Japan, just as Kublai Khan had employed Marco Polo. Adams had been trained as a shipwright and he was employed to build sea-worthy ships and also to advise Ieyasu on western ideas, techniques, and, eventually, politics. He worked for Ieyasu until he died in 1620, without having revisited England.

The Portuguese Jesuits were still being successful in Japan, though they were by now quarrelling with the Spanish Franciscans. They failed to keep the Dutch out of Japan, for in 1609 the Dutch were allowed to set up a factory on Hirado Island, not far from Nagasaki harbour where the Portuguese factory was. In 1611 the English East India Company sent out Captain John Saris in the *Clove*, with express instruction to seek the help of Will Adams. Saris also carried a letter and presents from James I to Ieyasu. Unfortunately Saris and Adams, both of whom seem to have been difficult personalities, failed to get on together, and Saris ignored Adams' advice, setting up the English factory in Hirado Island where it was in close proximity to and in direct competition with the Dutch,

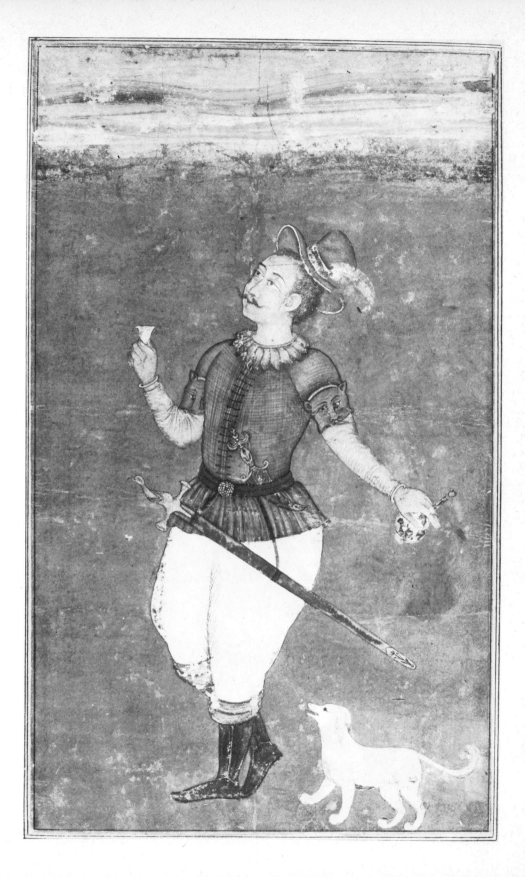

29 A European, as seen by
a Mogul miniature-painter,
17th century.

instead of being near Yokohama where it would have been closer to the seat of the Shogunal administration, Edo (modern Tokyo). This, and the incompetence of the chief factor, Richard Cocks, led to disastrous losses and in 1623 the English withdrew from the Japanese trade.

The *Clove*, returning to England in 1614, was the only ship ever to sail with a cargo from Japan to England until the nineteenth century. The vast quantities of Japanese goods that did reach England were either bought in other countries in Asia, such as Ceylon or Siam, or bought in Holland and Portugal, or captured by privateers.

The Dutch continually tried to obtain a monopoly in Japan by persuading the Japanese to expel the Portuguese and Spanish. Tokugawa Ieyasu's successor, Hidetada, interpreting the boasting of a Spanish sailor as threats of a Spanish invasion, finally determined not only to expel the Iberians, but to crush Catholicism as well. In 1639, after appalling massacres, Catholicism was virtually exterminated and all the priests and merchants from Spain and

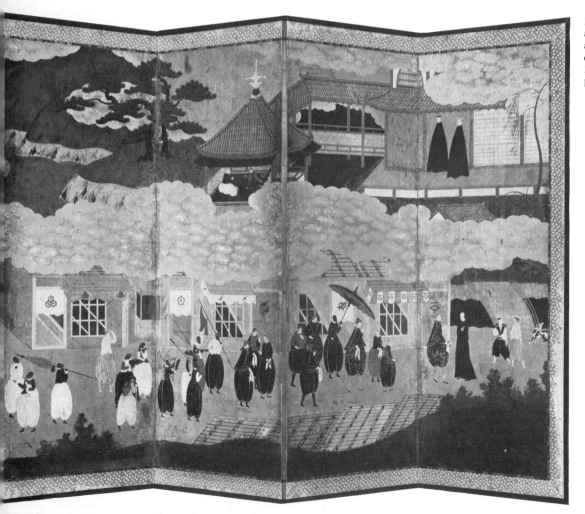

30 Europeans and Africans as seen by a Japanese artist. Part of a 17th-century screen showing Dutch merchants and priests at Nagasaki.

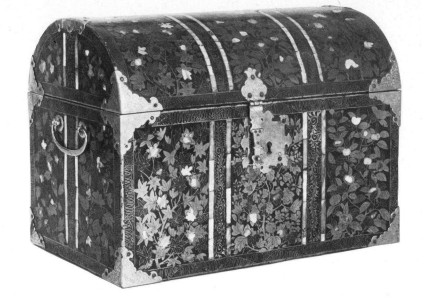

31 Japanese lacquer and mother of pearl inlaid coffer, late 16th or early 17th century. Partly based on European prototypes, such coffers and other lacquers became a staple of the trade to Europe. *See Chapter 9*

Portugal were either killed or expelled from the country. The Dutch remained, somewhat discreditably, but found to their horror that they were to be rigidly confined to a small reclaimed mudflat in Nagasaki harbour, Deshima Island, where they were not only allowed very limited trading facilities and restricted to a small number of ships per year, but were also subjected to very humiliating conditions.

In 1690 Engelbert Kämpfer was sent to Japan as doctor to the factory in Deshima. Part of his journal describes two annual visits to the Shōgun to offer presents: in one year two brass fire-engines were found unacceptable (one wonders why, when Edo was a town of wooden houses) as was a live cassowary: the latter ate too much! He describes how the Court made the Dutchmen perform all sorts of antics, to the intense amusement of the Court and the embarrassment of the Dutch.

'Soon after we came in, and had, after our usual observances, seated ourselves in the emperor's name, he then desired us to sit upright, to take off our cloaks, to tell him our names and age, to stand up, to walk, to turn about, to sing songs, to compliment one another, to be angry, to discourse in a familiar way like father and son, to show how two friends or man and wife compliment or take leave of one another, to play with children, to carry them about in our arms, and to do many more things of a like nature . . . Then they made us kiss one another like
man and wife, which the ladies particularly showed by their laughter to be well pleased with.'

In spite of the continual difficulties encountered by the Dutch in Japan, they maintained their factory on Deshima until well into the nineteenth century. But they never had the complete monopoly they desired, for despite the official closing of the country to foreigners, the Chinese were also allowed trading facilities in Nagasaki.

The Dutch drove the Portuguese from Ceylon between 1638 and 1658. Portuguese power had already been weakened by the loss of Ormuz in 1622 to the Persians (aided by the English), and Malacca was taken by the Dutch in 1641. By 1663 the Dutch had control of the Portuguese settlements on the Malabar coast, though Goa held out, and in 1667 the Dutch succeeded in driving the Portuguese, Danish and English from Macassar. In Ayuthya, the capital of Siam, the English East India Company tried to trade with the Japanese, who had an extensive settlement there, but were prevented by the Dutch, who forced concessions from the King of Siam. There was, however, competition for the Dutch in Siam from the Muslims and, later in the century from the French, brought in by the adventurer Constant Phaulkon, who had virtually complete political power in the 1680s. Phaulkon sent two embassies to Louis XIV and Siam received one from Louis in 1685. In 1688, however, Phaulkon

fell from power and was killed, thus averting the complete dependence of Siam upon France, but England withdrew from Siam and left trade there in the hands of the Dutch and the French.

The Dutch failed to take the Lesser Sunda Islands, nor could they take Macao, or Goa, but it would be fair to say that by the end of the 1660s the Dutch had supplanted the Portuguese as the major European power in eastern waters. Their position was complicated by the fact that the Spanish and Portuguese separated again as nations in 1640, the Spanish maintaining their hold on the Philippines, and by the Dutch wars with England in 1652–4 and 1665–7, fought in European waters but won by the English, so that Dutch interference with English trading settlements in India was minimized.

In 1632 the Mogul Emperor Shāh Jahān drove the Portuguese from Bengal, and allowed the Dutch and English to establish factories on the Hooghly River, where they were able to obtain silk from Bengal, saltpetre from Bihār and, later, fine muslins from Dacca. In 1640 the English moved from their factory at Armagon, near Pulicat, to Madras, and by the middle of the century Madras had taken over Surat's position as centre of the calico trade. The Dutch took Negapatam and Cochin by force from the Portuguese in 1658 and 1663, but English trade was greatly assisted by the transfer of Bombay from Portugal to England as part of the dowry of Catherine of Braganza on her marriage to Charles II in 1661.

At the end of the century, the English factory on the Hooghly, Calcutta, was fortified, and so were the French and Dutch stations: the French had only appeared in India after the foundation of the *Compagnie des Indes* by Colbert in 1664.

The Dutch were never very successful in the direct trade with China. They failed to take Macao from the Portuguese in 1604, 1607, and 1622, nor did they succeed in negotiating for a trading station with the Chinese. To counter this failure, they took the island of Formosa (Taiwan) in 1624: this they held until they lost it to the pirate and supporter of the deposed

Ming dynasty, Coxinga (Chen Ch'eng-Kung) in 1661. When the Ming dynasty fell in 1644, the incoming Manchu dynasty, the Ch'ing, kept to the former system of trading directly only with the Portuguese, and allowing other trading nations only limited facilities. The Dutch sent several fruitless embassies to Peking requesting formal trading agreements, which are mentioned here only because of the journal kept by the Steward to the ambassadors, John Nieuhoff, which gave to contemporary Holland a remarkably accurate account of China. It was not until the end of the seventeenth century that English, Dutch, and other European nations were allowed to trade at Canton and a few other ports. Even then, the monopoly held by a few rapacious Chinese official merchants in the ports made the trade less easy and less profitable than had been hoped.

Whereas Portuguese Macao had been a trading place for Portuguese, Chinese, and Japanese only, Canton was now opened to all. In 1736 Canton was visited by five English ships, three French, two Dutch, one Danish, and one Swedish. In 1753 at Canton there were ten English ships, five French, six Dutch, two Danish, three Swedish, and one Prussian. This demonstrates not only the increase and volume of the trade but also the way in which the British came to dominate the South China trade.

In India, as the Anglo-Dutch wars in Europe had weakened the position of the Dutch in favour of the English, during the eighteenth century the dominant position of the English was threatened only by the French. During the War of the Austrian Succession there was fighting in India in 1746–8 in the south: the French captured Madras, and both sides, for the first time, used native troops, sepoys. Madras was ceded back to the English on the signing of peace, but war broke out again, still basically only between the English Company and the French Company, in 1751. The war ended in 1754 when the French withdrew their brilliant Governor Dupleix, in order to make peace with Robert Clive.

The Warham Bowl, a Chinese celadon bowl of the 14th century (with European gilded mounts) presented to New College, Oxford, in 1516. *See p. 54*

Japanese lacquer cabinet, late 17th century, mounted on an elaborate carved English stand. This pictorial type of lacquer (*see pp. 112–3*) was much imitated in European japanning.

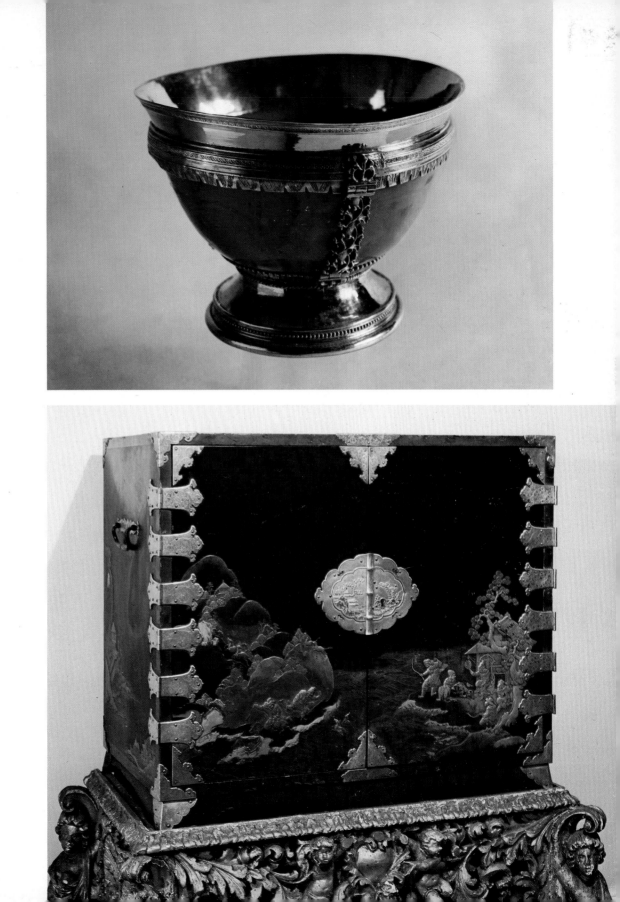

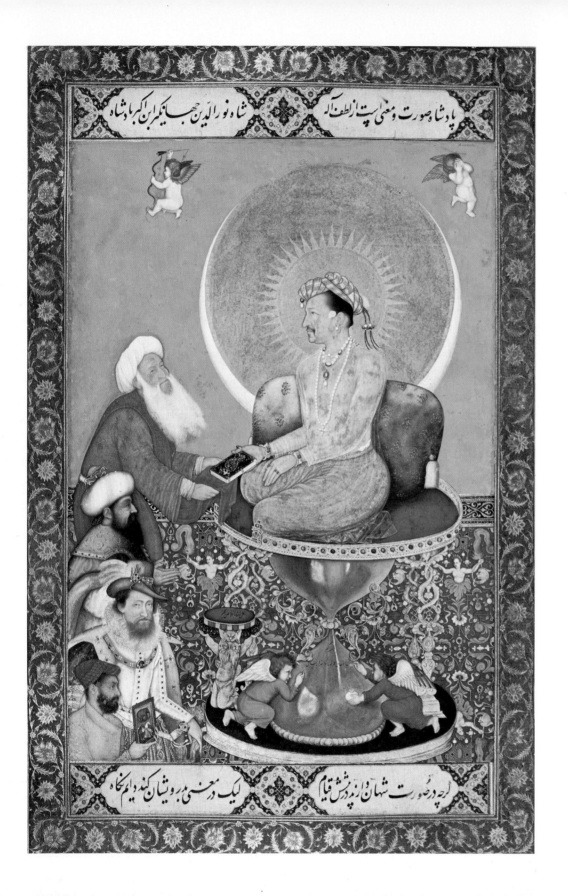

Calcutta was attacked without warning in June 1756 by the Nawāb of Bengal, Sirāj-ud-Daula (the 'Surajah Dowlah' of Macaulay) and captured, whereupon the English prisoners were shut in the infamous 'black hole' prison, where many died of suffocation in a single night. Clive recovered Calcutta in January 1757 and was forced to play Indian politics, setting up Mīr Jafar as Nawāb after the battle of Plassey. Indirectly this led to a virtual British rule in North-east India.

In the south, the Seven Years War again saw the English and French in conflict, with the English eventually successful, capturing Pondichery in 1761 and gaining control of the whole Coromandel coast. The seeds were already sown for the future British sovereignty of India.

In many ways, trade in the East was one of trans-shipment, of shuffling the goods from one port to another, to sell goods in a country where they fetched a high price, having obtained them from others, where they were cheap.

On the whole, western goods were not in great demand in the East, much to the disappointment of the western trading nations, though in 1615 Captain Saris suggested to the East India Company that among eastern goods acceptable in Japan were also some western things, 'Broad cloaths, Bayes, Leade, Gallyopotts, wrightinge tables . . . Holland cloath Cambricke and Lawnes, . . . with sundrye other particulars', and he presumably had had the advice of Will Adams. The 'sundrye other particulars' had been enumerated in a letter from Saris to the Company written on 17 October 1614, and included: thread of all colours, carpets for tables, muske ('worth the wayght in silver'), gilded leather, 'Pictures paynted, som lacivious, others of stories of warrs by sea and land, the larger the better', quicksilver, vermilion, 'payntinge for womens faces', tin, iron, steel, sugar, 'suger candie', velvets of all colours, and cut velvets. Also 'Drinkinge glasses of all Sortes. Bottles. Canns and Cupps. Trenchers. Platters. Beare glasses. Saltes. Wine glasses. Bekers. Looking

glasses guilt, of the larger sortes. Muscovia glasses. Writing table bookes. Paper bookes. Lead to neal potts. Spanish sope . . .', amber, alum, wax for candles, and 'Huny'. Other, later, writers mention watches, telescopes, alarm-clocks, microscopes, snuff, pencils, eye-glasses, and cough syrup.

The staple of trade with Japan was, however, Chinese silk, spices, fine woods, exotic materials such as shark-skin (shagreen, for sword-handles), and other materials collected in India, China, and South-east Asia. From Japan, Europe obtained gold (until 1740 when it was replaced by copper), silver, hemp, camphor, lacquer-ware, porcelain (after 1650 only) and craftwork (including canes and umbrellas), rice, sake, soy-sauce, and Japanese kimonos. Paper was brought to Europe, for by the 1640s Rembrandt, for instance, was printing etchings onto Japanese paper; and Saris also mentioned dyes, 'brym-stone', saltpetre, and cotton wool.

Porcelain was in great demand in Europe. The Portuguese had begun the systematic import of Chinese porcelain in the mid-sixteenth century, buying at ports on the southern coast of China in the Fukien region. Before that, of course, much had been shipped to the Near East, South-east Asia and even East Africa, particularly celadon wares[1], but the shipment to Europe, on a large scale, of blue-and-white porcelains was something new. These porcelains were the coarse export wares, mostly made in the reign of the Wan Li Emperor of the Ming (1573–1619). This ware can be seen in collections[2] throughout Europe, and is depicted in many Dutch still-life paintings[3] of the seventeenth century. Coarse from the Chinese point of view, it was very fine in European eyes and inspired the tin-glazed earthen wares of Delft, Frankfurt, Rouen and, later, Lambeth, Bristol, and Liverpool, to name but a few factories[4]. It also provided the prototype for some Japanese porcelain of the 1650s and later, and, indirectly, of the fine porcelains of Europe, first made in the second decade of the eighteenth century.

Perhaps the first time that appreciable quan-

Jahāngīr preferring a *shaikh* to King James I of England and the Ottoman Sultan. Miniature painting by Bichitr *c.* 1625 – the portrait of James I presumably after a painting brought to India by Sir Thomas Roe.

1. illus. **78** 2. plate facing p. **68**
3. illus. **80 and 81** 4. Chapter 8

tities of this porcelain reached northern Europe was in 1604 when the Dutch auctioned, in Amsterdam, the contents of the Portuguese carrack *Catharina*, which they had captured off Malaya; among the cargo were some 100,000 pieces of porcelain. The Dutch themselves started to ship Chinese porcelain in 1610.

In 1644 the Ming dynasty fell, and by 1658 little porcelain was available to the Dutch, presumably because of internal difficulties in China. The Dutch had, however, foreseen this, and had started to order Japanese porcelain, made in Arita and shipped through Imari, in 1650. By the 1660s they were obtaining the same quantities (some thousands of pieces per year) as they had previously had from China, and in addition they were buying coloured wares (Imari) and, later in the century, the famous 'Kakiemon' wares of much better quality. Also, later in the century the Chinese started again to export porcelain: for instance in 1699 the first English ship to Canton, the *Macclesfield*, was able to buy some Chinese porcelain. Throughout the seventeenth and eighteenth centuries, and, indeed, later, porcelain was a regular export from both China and Japan.

32 left Chinese *Kraak porselein* dish of the late 16th century, much imitated in Europe.

33 centre Japanese (Arita) bottle, *c.* 1670. Based on Chinese models, but with Dutch influence visible in the pattern on the neck.

34 right Japanese (Imari) barber's bowl, late 17th century.

In India, as in China, the main demand was for silver, though other goods were also required. Among the goods shipped to Surat on the *Septer*, an English East Indiaman of thirty-six guns, in August 1695 were 553 pigs of lead, 300 copper plates, 206 bales of broadcloth, 10 barrels of cochineal, 10 casks of red lead, 5 chests of looking glasses, 2 chests of clocks, 1 chest of knives and scissors, 1 box of coral beads, 1 box of books, 4 cheeses made up in lead, and 19 chests of 'foreign' bullion. Exports were mainly cotton and spices, though many other lesser items occur in the lists, notably ebony furniture from Ceylon and the Coromandel coast. In 1692 the Directors of the East India Company wrote to their factors in Bengal: '*You can send us nothing amiss at this time, when everything of India is so much wanted.*'

In order to obtain the spices that were not grown in India, cotton had to be exported to the Spice Islands (where silver meant nothing) while the greatest problem of all was in China. The Chinese really only wanted gold and silver, though they also bought ivory, pepper, cloves, and precious woods, and some European cloth. Although gold and silver were obtainable from

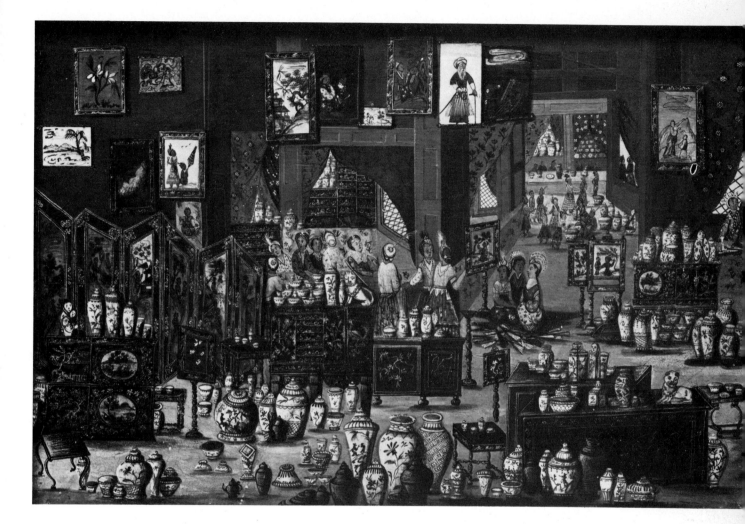

35 A Chinese merchant's shop. From a Chinese painting, 18th century.

Japan, much of it had to come from Europe. Spain also sent gold from Spanish America, though there were continual attempts to check the amounts diverted from the Spanish Treasury. At Manila the Spanish bought Eastern goods not only from Chinese merchants but also from other European nations, for the Spanish wanted Indian goods which they could not obtain direct, and the other European nations wanted gold, to spend in China.

In the eighteenth century a Chinese demand for opium ('foreign mud') was exploited, particularly by the British, and increasing amounts were brought from India. In the nineteenth century, America joined the trade, sending to China the herb ginseng (which is native to America), furs of the California sea otter and dried sea slugs. The main export from China was still silk in the seventeenth century and also lacquer, porcelain and tea. Tea gradually took over the prime position in the China trade: a novelty in the mid-seventeenth century –

36 Clipper ships racing with the first load of tea. The *Taeping* and the *Ariel*.

Samuel Pepys on 25 September 1660 'did send for a Cupp of Tee (a China drink) of which I never had drunk before' — by the end of the century some 20,000 pounds were imported into England annually, and by the 1770s some ten and a half million pounds were coming each year to England alone. In Holland also, tea was the major import from 1730. In the nineteenth century it was tea that was carried by the beautiful clipper ships of England and America.

America did not enter the oriental trade until 1784. Obliged by Britain to buy all her oriental goods through Britain, America had been unable to trade direct with eastern countries. Indeed it was the high taxation on eastern goods that finally sparked off the American War of Independence. It was the tax on tea that provoked the 'Boston Tea Party'. As soon as peace was signed, the first American ship to sail to Canton, the *Empress of China*, left New York with Samuel Shaw of Boston as supercargo, or merchant. America had no East India Company, nor did she ever found one, so each American ship had to look after itself. It was the Atlantic seaboard of America that was the centre of the China trade,

the major ports being Salem, Massachusetts, and New York, though Boston, Providence and Philadelphia also had their share. Both the southern routes were used: from Salem most ships went by the Cape of Good Hope, trading wherever they called, while most other ports sent ships by Cape Horn, so that they could visit Hawaii and also collect furs on the north-west coast.

So successful were the American traders that in 1794 Lord Macartney, then in Canton on his way back from Peking, was obliged to ask the Chinese Viceroy not to confuse the English with Americans! By 1800 more American ships visited Canton each year than those of any other nation.

In an age when the West was becoming familiar with India, through the activities of the English, and with South-east Asia through the activities of the Dutch, China and Japan were less well known. China, as we have seen, virtually closed her doors to European traders, and Japan in the 1630s followed suit. Japan was to remain closed to the outside world save only through the Chinese and Dutch trading posts in Nagasaki until the arrival of Commodore Perry in 1854. But China, even before the opening to trade in the reign of the K'ang Hsi Emperor was becoming known to the west through the writings of the Portuguese Jesuits in Peking.

In the last chapter we saw how the careful planning of the Jesuits, whereby some of their cleverest men were trained in the Chinese language and in Chinese culture, had succeeded in getting the first missionary, Matteo Ricci, to Peking. Ricci became such a good scholar in the Chinese classics that he was able to converse on equal terms with the scholar mandarins. In Peking Ricci met Islamic mathematicians and persuaded the Society of Jesus that astronomy was a good way to be useful to the Chinese: a series of Jesuit astronomers were sent to Peking over the next two hundred years, to serve on the Board of Astronomy, while other experts made instruments or guns or practised medicine.

The paintings and engravings brought by the

Jesuits also interested the Chinese enough for the K'ang Hsi Emperor to ask for European painters to come to Peking: Fathers Gherardini and Belleville arrived in 1699, and started a vogue for European styles. In the reign of Ch'ien Lung this received a curious twist when Father Guiseppe Castiglione learned to paint in a Chinese style, using the name Lang Shih-ning. In this reign there was another vogue for European styles, rather as in Europe there were vogues for chinoiserie (as we shall see), and Ch'ien Lung built a series of semi-Baroque style palaces in the Yüan-ming-yüan designed by Castiglione and with elaborate parterres and fountains by Father Benoist.

These short-lived vogues for European art in China are almost the total effect that western art had upon Chinese art. The European styles and influences, shapes and decorative motifs visible on so much Chinese lacquer, porcelain and wallpaper imported into Europe, in no way reflect Chinese taste, but are merely a measure of the Chinese estimate of the taste of the European buyers.

This should not surprise one, even when, in the next few chapters, we shall see the tremendous influence that the East in general and China in particular had upon European taste and design, for whereas the European connoisseur prized novelty and originality, his Chinese counterpart prized tradition, skill of execution, and scholarship.

The descriptive writings of the Jesuits in Peking had a far-reaching effect in Europe. In the Age of Enlightenment, Confucianism met a long-felt need; Father Louis Le Comte's descriptions of administrative methods for instance were more than startling: '*Nobility is never hereditary,*

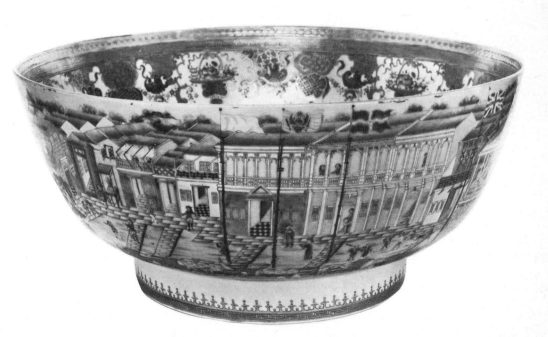

37 The European nations' trading posts (factories) at Whampoa, Canton, as shown on a late 18th-century Chinese punch bowl, itself copying a European engraving. The flags of Britain, Sweden and Austria can be seen.

neither is there any distinction between the qualities of people, saving what the offices which they execute make . . . When a viceroy or governor of a province is dead, his children . . . if they inherit not their father's virtue and ingenuity, his name which they bear, be it never so famous, gives them no quality at all.' (This, in the France of Louis XIV!)

Indeed it was in political and intellectual theory that the influence of China, however second hand it may have been, was most felt in Europe. By comparison, the artistic influences that we shall discuss in the second part of this book were superficial and ephemeral.

Part II

Chinoiserie

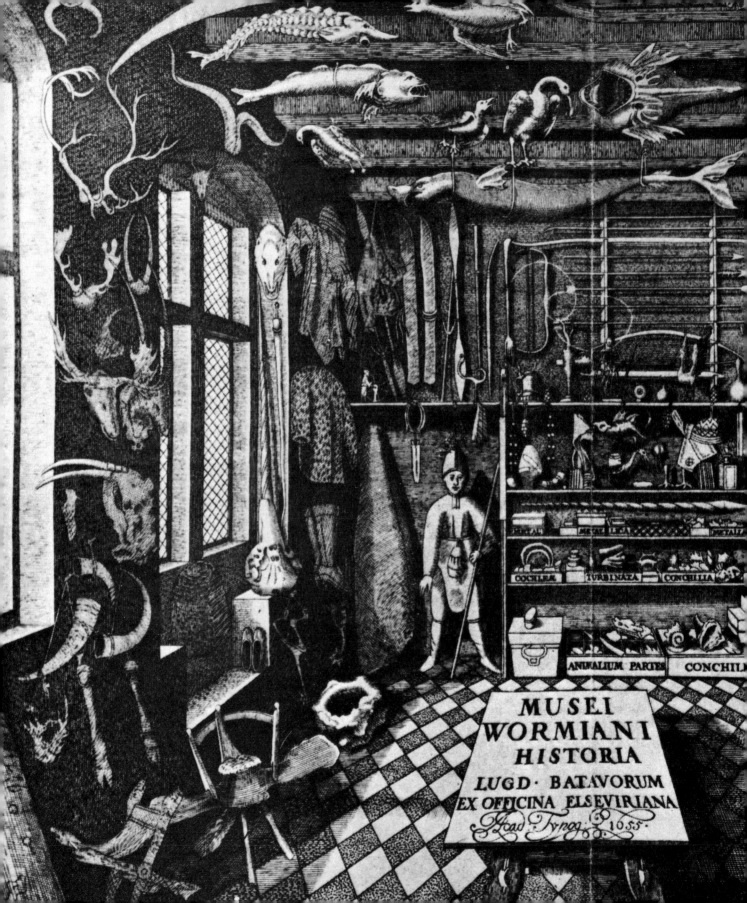

MUSEI
WORMIANI
HISTORIA

LUGD · BATAVORUM
EX OFFICINA ELSEVIRIANA
Acad Typog. 1655·

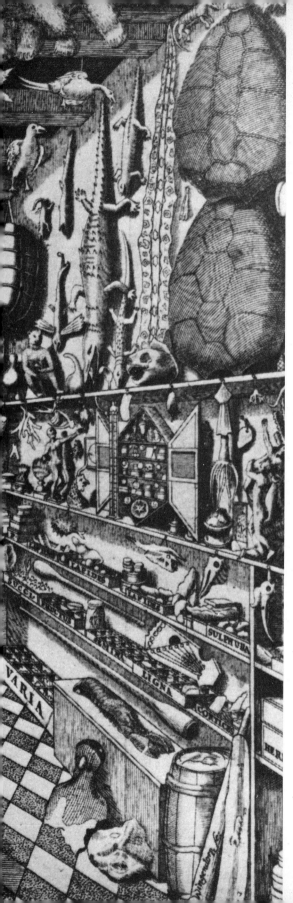

38 The Cabinet of Curiosities belonging to Ole Worm, at Leyden, 1588–1666. A typical mixture of curiosities. *See p. 57*

Chapter Four

Collecting, and the Cabinet of Curiosities

Collecting must be nearly as old as curiosity. The urge to collect things for their beauty is a late phenomenon. Alexander sent curiosities of natural history back to his tutor, Aristotle — other objects would have been so much booty.

The Romans, we shall see, had an insatiable appetite for silk and imported as much as they could lay their hands on, along with rhubarb, cinnamon, exotic woods, furs, and animals for the arena. By Augustan times, tigers were well known in the arena, and the list of exotic animals used is long and varied. But these things had a practical purpose and were not merely useless exotica. The Romans did collect antiquities, particularly Greek sculptures and vases, and had an especial fondness for cameo jewels. Collecting became somewhat of a competitive mania, and Greek statues for the garden of one's country villa became almost indispensable.

Outstanding among Roman collectors for his rapacity and ruthlessness was the Proconsul Verres, who became Governor of Sicily. He ransacked temples, stole from rivals and blackmailed other collectors: Cicero's prosecution of Verres in 70 BC sought an indemnity of 100 million sesterces for his Sicilian thefts alone. His collection would have been mainly statues, vases, paintings, jewels and treasure: there would have been little interest in eastern goods. We do know, however, that some eastern works of art, or at least of craft, were reaching even provincial Roman cities by the first century AD. In the excavations of Pompeii (buried by Vesuvius in AD 73) an Indian ivory mirror handle probably made in the first century BC was found in 1938.

The next step in collecting, and one which included oriental things, was the trade in so-called Holy Relics. No doubt many perfectly genuine relics exist, but the trade in false relics became one of the growth industries of the Middle Ages. The Story of the Finding of the True Cross by St. Helena depicted by Piero della Francesca at Arezzo, and by other artists elsewhere, would seem one of the earliest Christian myths.

53

39 Fourth-century Roman mosaic of a tigress killing a bull, clearly drawn by an artist familiar with imported tigers. (From the Basilica of Junius Bassus.)

40 Reliquary of St George; silver, partially gilt, and precious stones, by Bernt Notke c. 1490. A typically extravagant creation for a Holy Relic.

Relics were carefully and expensively mounted in gold and silver and jewelled reliquaries throughout Christendom: these made the basis of church treasuries and to that extent formed the basis of collections, parallel to the accumulations of treasure of the temporal princes. Many early reliquaries and church furnishings still exist: fewer possessions of temporal lords have lasted, though certain objects can be traced back to very early owners. These are nearly all classical works of art. Only a few unusual patrons had eastern works of art; among them was the Duc de Berry, but even he treated them just as oddities. The major exception to this was the Pope Nicholas V who, during his Papacy of 1447–55, sent a special envoy or agent, Cyriac of Ancona, to collect for him in Egypt and the Levant.

In fourteenth- and fifteenth-century Italy, though porcelains had been available for centuries, they were not systematically collected, as opposed to being owned for their rarity value. Porcelain was very precious, partly because it was made of an unknown material impossible to imitate in the West (see Chapters 7 and 8), and partly because it was widely believed that it was incorruptible by poison: in other words, if poison was placed in a porcelain bowl, the bowl would break. As death by poison was a not uncommon one in the Middle Ages, this (entirely fictional) attribute was highly desirable. Even after the sea-borne trade in porcelain had, in the sixteenth century, introduced far more porcelain in a few shiploads than had been available in Europe before, porcelain was still highly regarded. Its move from the cabinet of curiosities to the general scheme of decorative effects occurred at the end of the sixteenth or in the early seventeenth centuries.

The collecting of Roman antiquities (and of Greek antiquities found in Italy and therefore collected by the Ancient Romans) started again in the fourteenth century, and was widespread in Italy in the fifteenth century. Many painters owned considerable collections of antiquities – Lorenzo Ghiberti, Andrea Mantegna and others.

41 Yüan (Mongol) dynasty early 14th-century porcelain dish of a type that occasionally reached Europe in the late 14th and 15th centuries, but was much more common in the Near East. *Contrast with illus. 32*

A friend of Mantegna's at the court of the Este family at Mantua has left a delightful account of an expedition looking for antiquities, when he and his friends dressed in togas and, crossing Lake Garda by boat, playing at Romans, arrived at a Temple of Minerva where they offered thanks, and copied inscriptions.

Mantegna's collection was so well known that Lorenzo dei Medici made a special trip to see it. Mantegna had even had his house in Mantua designed with rooms in which to exhibit his collection: this was an exception in that most collectors used their pieces for their decorative effect throughout the house, courtyards and gardens.

In the early years of the sixteenth century the discovery of the sea route to India (and beyond) and the contemporaneous discovery of America brought the major change in collecting habits of all time. In the revelation of the East to Europe, it was hardly surprising that scholars should have noted, collected and classified those curiosities of nature or of man that were brought back by the returning Portuguese carracks. Not trade goods such as porcelain, though of course these also at first formed part of the cabinet of curiosities, but more the object of interest although of little value. In fact these objects of apparently little value did attract collectors and prices of anything eastern rose accordingly.

Shops in the Rua Nova dos Mercadores in Lisbon sold exotic goods, and agents of the scholars of northern Europe, of the Princes of

42 'Rarities' – in this case ostrich eggs protected and embellished with silver-gilt mounts.

western and eastern Europe, and of the bankers of Germany, scoured Lisbon for curiosities – gold jewellery from Siam, exotic woods, seashells, parrots, textiles, drugs, amber were almost as much in demand as spice or porcelain. Retired adventurers grew exotic trees on their lands and kept exotic animals on their estates.

Dürer in the Low Countries in 1520–21 made friends with Portuguese and Flemish exporters and importers, to whom he gave engravings: they gave him curiosities from the East, cocoanuts, Calicut cloths, several green parrots, and other oddities.

François I of France, no doubt stimulated by seeing in Marseilles in 1516 the rhinoceros (Dürer's Ganda) that was on its way to Leo X[1], started a menagerie at Amboise. Subsequently he began to collect for a cabinet of curiosities at Fontainebleau, using agents in Europe and the Near East.

Objects still extant in Europe that can be shown to be the actual ones listed in inventories or in documents of the early sixteenth century are extremely rare. Many eastern pieces of the time survive, but we are not certain of their history.

43 One of the ivory caskets from Ceylon presented by the King of Kotte to John III of Portugal in 1541. The precious mounts were added in Europe.

Particularly interesting, therefore, are the two ivory caskets brought to King John III of Portugal from Ceylon by the emissaries of the King of Kotte in 1541. One of these caskets contained a statue of the King of Kotte made of gold, which John symbolically crowned. These caskets were bought in 1555 by agents of the Fugger banking house for Albrecht V of Bavaria. They are mentioned in the inventories of the treasures of the Wittelsbach family drawn up by Fickler in 1598, and are now in the *Kunstkammer* of the Residenz-museum in Munich. They are remarkable (apart from their history and documentation) by the fact that Europeans are represented in the carvings.

Although collections were widespread throughout Europe, it was in the Netherlands in the second half of the sixteenth century and the first half of the seventeenth century that the collecting of curiosities reached its height. Many scholars and humanists collected, and often these collections passed intact to one or other of the royal, ducal or princely collections of Europe. Two particularly well known collections were those of Abraham Ortelius[1] and of his younger contemporary Bernhardt Broecke (known as Paludanus), who became friends, and who knew the traveller Linschoten. These men had correspondents all over Europe, and collected what objects and knowledge of the East that they could: they even discussed the possibility of a northern route to China.

Paludanus' collection was so well known that in 1592 Duke Frederick I of Württemburg paid

1. plate facing p. 68

a special visit to Enkhuizen to see the collection and to the Duke's secretary, Jakob Rathgeb, we owe some knowledge of the collection. It was housed in eighty-seven numbered cabinets and comprised a very wide range of geological, botanical and zoological material, all sorts of manufactured objects from India, China, South-east Asia, and the Americas, such as porcelains, wooden implements and articles of clothing. When Paludanus died in 1633 he left some pieces to the University of Leyden, while the rest was bought in 1651 by Duke Frederick III of Schleswig-Holstein-Gottorp. The University of Leyden was at that time forming a 'Publick Theater and Anatomie Hall' which was to become the model for several other museums.

Another famous private collection was that of a scholar, the charmingly named Ole Worm. An engraving of 1655 shows it to have been a splendid mixture of natural and made objects.

At this time every Germanic ruler felt obliged to have a *Wunderkammer*, partly for display: a picture of the room containing the great japanned cabinets (at least one of which survives) made by Gerard Dagly in the 1690s to hold the curiosities collected by Frederick I of Prussia at Berlin shows it to have been a public room (that is a room large enough to hold a considerable crowd, which implies that the collection was meant to be shown off to Frederick's court and visitors).

The largest collections seem to have been those of the Archduke Albrecht V of Bavaria and of Rudolph II of Prague. The collection of the Archduke Albrecht was the first to have a published catalogue, the *Musaeum Theatrum* of Dr. Samuel Quickeberg published in Munich in 1467. The 4,000-odd items were divided into five classes. The first class was further sub-divided into objects of religion; objects pertaining to the owner's family; views and descriptions of Bavaria, including maps; and local flora and fauna. The second class included sculpture, coins, medals and goldsmiths' work; the third included all divisions of natural history (which is where the bulk of the eastern material was probably to

be found). In the fourth class were scientific and musical instruments, and in the fifth class, works of art, paintings, landscapes and portraits, genealogies and coats of arms.

Among Albrecht's agents was the dealer Jacopo Strada, whose portrait was painted by Titian in 1567. Titian despised Strada — as can be clearly seen in the portrait of the cunning and obsequious dealer. Titian is quoted as saying: *'Strada is one of the most solemn ignoramuses that can be found; he knows nothing and it must be that*

44 Titian's portrait of Jacopo Strada, the dealer in antiquities and curiosities.

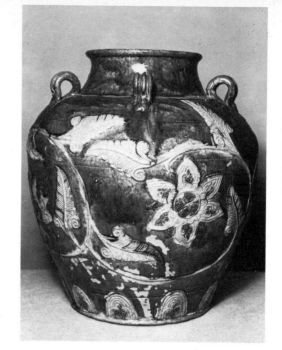

45 The Tradescant jar. A 'martabani' jar (from South China) mentioned in the Tradescant inventories of 1661. These were merely containers, of a type made for perhaps 500 years.

he has luck and knows how to adapt himself to people's characters, as he has done in Germany, where he makes fools of the Germans, who . . . do not see through the fine gentleman's duplicity.'

Much of the Wittelsbach's treasure still survives as the *Kunstkammer* of the Residenz-museum in Munich.

Rudolf II's collection, on the other hand, was dispersed when Prague was sacked in the Thirty Years War. We have, however, at least two inventories of Rudolf's collections, published in 1619 and 1621 (a previous inventory of 1607 has not been published) which show the extent of the eastern holdings of the collection. One complete section is given in the 1619 inventory to 'Indianische Sachen' (all 'eastern' objects

46 Engraving by David Loggan from *Oxonia Illustrata* 1676 of the Physick Garden in Oxford

47 **far right** Title page of the 1661 catalogue of the Tradescant collection, which was later to form the basis of the Ashmolean Museum.

are included under the heading Indian – even American). It comprises several hundred pieces, ranging from 'Indian' books to 'Indian' lizards.

In England the major cabinet of curiosities was that formed by the Tradescants, and first called Tradescant's Ark. John Tradescant had been gardener successively to Lord Salisbury, Lord Wotton, the Duke of Buckingham and King James I. He was sent on various plant-collecting voyages by his respective employers; to Archangel in Russia in 1618, and to Algiers and the Balearic Islands in 1620. In 1629 he set up his own garden and 'Ark' in Lambeth. He died in 1637.

The younger Tradescant, John's son John, collected mainly in Virginia, which he visited three times. (As a matter of interest the Virginian flora, as a relict flora, is in part remarkably similar to the Chinese.) John (junior) continued to collect until his death in 1662. Not only are there several inventories of various dates of the collection, which comprised a very wide variety of objects, but much of the collection still survives. This is because John Tradescant was befriended by Elias Ashmole, to whom the collection was willed on John junior's death. After some difficulties with Mrs Tradescant, Ashmole obtained the collection which he thereupon gave to Oxford University. A special building was constructed for the collection between 1679 and 1682, probably from designs by Wren (now the Museum of the History of Science), which was to be called the Ashmolean Museum. It was opened in 1683, the first public museum in England. The Tradescants' collections are now divided between the Ashmolean Museum (rehoused in the University Galleries), the University Museum (of Natural History) and the Bodleian Library.

The Tradescants' collections had been eclectic. They had a botanical garden in Lambeth where they grew many plants new to Britain, collected by both Tradescants on their various voyages. Their zoological collection was also extensive, including almost the last dodo (from Mauritius): alas, it got the moth and in 1755 it was ordered

Musæum Tradescantianum:
OR,
A COLLECTION
OF
RARITIES.
PRESERVED
At *South-Lambeth* neer *London*
By
JOHN TRADESCANT.

LONDON,
Printed by *John Grismond*, and are to be sold by *Nathanael Brooke* at the Angel in Cornhill,
M. DC, LVI.

48 The Dodo (painting by Savery), the flightless bird of Mauritius which was extinct by 1681.

to be burned, only parts of it being rescued from the flames. The 'artificial' collection was also extensive, and many eastern things are included, porcelain, clothes, weapons, musical instruments and so on, as well as European objects such as Palissy wares and Malines alabasters, and Roman and Egyptian antiquities. American items include the mantle of Powhatan, the father of Pocahontas.

The collecting of curiosities was less evident in the eighteenth century, though not unknown, for with the great increase in trade, curiosities were no longer curious.

In the nineteenth and twentieth centuries, with the rise of horticulture as almost a popular art form, it was the plant-hunters who provided material for collections. One of the most important of these was Robert Fortune, sent by the Royal Horticultural Society to collect plants in China. Fortune wrote several travel books and introduced many Chinese plants into Europe. Probably his most important act was the recommendation that tea should be grown in the Himalayas: it is due to Fortune that the India tea industry began in the 1840s.

Other plant collectors in the Far East included J. G. Veitch, E. H. Wilson and, in this century, Frank Kingdom Ward. The garden had become, again, a collection of 'curiosities', not useful, but interesting or beautiful.

49 One of the treasures of the Tradescants: the mantle of Powhatan, father of the heroic Pocahontas.

50 Plate-printed cotton
with chinoiserie figures and
scenes from the *commedia
dell' arte*. The background
is reminiscent of chintz.
Style of Pillement *c.* 1770.
See p. 66

Chapter Five

Textiles
Silk, Cotton and Needlework; Carpets; Tapestry

Silk, cotton and needlework

Silk was introduced into Europe from China by the Parthians in the first century AD, and immediately became immensely sought after. It was thereafter as important a trade commodity as spice. Silk was woven into complex patterns, often pictorial, and these patterns had an important effect in the transmission of pictorial styles from East to West and back again.

This is not the place to discuss Chinese silk technology, so let us content ourselves with saying that by the mid-Han period (206 BC–AD 220) looms were sufficiently sophisticated for repeat patterns of considerable complexity to be woven. Recent excavations have shown that many varieties of weaves were possible, and how fine such weaves and such materials could be.

Han patterns tend to be based on lozenge-shaped motifs and zigzag patterns: often these patterns enclose confronted-animal motifs (these become an important feature later), and sometimes there is a 'cloud scroll' that may be derived from a dragon motif. The dragon also occurs in a more 'naturalistic' form and so does the phoenix, and other animals both real and mythological.

The passage of silk to the Near East after the first century AD brought with it patterns and techniques not known before. Silk, with its very long thread, encourages a more complex technology than does wool or cotton, and clearly much was learned in Persia of Chinese techniques. The Sasanian dynasty which had taken over from the Parthians in AD 226 was less hellenistic than the Parthians, and more inclined to absorb eastern influences: their silk patterns, which were to become so influential in the West, were taken from India as well as from China.

The Roman world relied entirely upon the Great Silk Road for its silk. No true silk was produced in the West until the smuggled eggs incident in the sixth century AD. This was, of course, also true of Sasanian Persia. Silk was imported in the raw form, and as ready woven

material, which was laboriously unravelled and rewoven. Sometimes it was then even re-exported to China. There is a complication here over the Coan 'silk' (which derived from an insect totally different from the *Bombyx mori*), the substitute for silk woven on the island of Cos, and which was famous or rather infamous, for its sheerness. *'I see silken clothes'*, wrote Seneca *'if one can call them clothes at all, that in no degree afford protection either to the body or the modesty of the wearer, and clad in which no woman could honestly swear she is not naked'*. Whether these clothes were Coan or Syrian remains open to doubt, but in the Han period tomb of the Marchioness of Tai in Changsha excavated in 1972, a transparent silk coat or dress was found, that was certainly Chinese in origin.

The very fact that silk was unique made it the more desirable. From the fourth century Byzantium held a monopoly in the silk trade to western Europe, and after the acquisition of the secrets of silk manufacture this in no way diminished. Western Europe was forced to go to Byzantium for its silk, and was forced not only to pay its prices, but submit to rigorous customs control and a form of rationing. Meanwhile, of course, Sasanian/Byzantine patterns had become associated with silk, and were the accepted (and possibly the only acceptable) type of pattern, though by the tenth century Egyptian textiles were being imitated in Islamic Spain.

Early Sasanian textiles are of two major types of pattern, the one based on some hunting or battle scene, the other with a grid of circles each enclosing a single animal form. The latter type was much copied in Byzantine textiles and examples are still extant, scattered through the treasuries of churches in Europe. Most famous, perhaps, is the 'elephant' silk from the Tomb of Charlemagne at Aix-la-Chapelle (Aachen), a Byzantine 'copy' of a Sasanian design, woven shortly before AD 1000. (It was placed there after the Emperor Otto III had had the tomb opened in AD 1000.) Later Sasanian textiles have the single animal replaced by a pair of

confronted animals, in a style derived from Han silk, but still within the circle or a pattern similar to a circle. These confronted animals take on a heraldic pose that is maintained, with variation, well into mediaeval Europe. Often it is mixed with a central tree, perhaps derived from the Indian tree of life or the Babylonian palm motif. This tree gradually displaces the animal, and by the thirteenth century the plant forms are as important as the animal forms. These plant forms continue in Lucchese silk, and become even more important in Genoa velvet and French silks, giving rise to the 'bizarre' silk patterns of the first part of the eighteenth century. They also continue unchanged, or with but minor variations until today.

Silk patterns also have side effects. Islamic textiles of Moorish Spain retain, conservatively, the Sasanian confronted-animal patterns, and many of these are absorbed into romanesque art, not only as heraldic devices (the most famous, no doubt, is the double-headed eagle of the Habsburgs, a variation on the theme) but also as decorative elements of many sorts. Most obvious are the capitals of columns of some romanesque churches in the Cluniac style, where eagle forms follow Sasanian principles, notably at Moissac and La Charité-sur-Loire.

In the twelfth century, Roger II of Sicily brought weavers from Byzantium to Palermo; this was the first breach in the Byzantine monopoly as well as the origin of the Italian silk industry. In 1198 the Fourth Crusade and the subsequent Latin conquest of Constantinople in 1204 (engineered by the Venetians) brought the complete collapse of the silk monopoly, and the Italian silk industry on the mainland, and particularly that at Lucca, became the most important source of silk for the West.

Lucca specialized in rich materials for church vestments, with lavish use of gold and silver threads. Individual orders placed at Lucca were often made by the various Popes – in 1295 Boniface VIII ordered twenty-nine pieces of silk with the arms of his family, the Caetani. In the fourteenth century, the Mongol conquests en-

51 The 'elephant' silk from the tomb of Charlemagne. *See p. 63*

52 Detail from an altarpiece by Nardo di Cione (Florence, active *c.* 1343). Three saints standing on a textile, probably Byzantine, with the confronted-animal type of design.

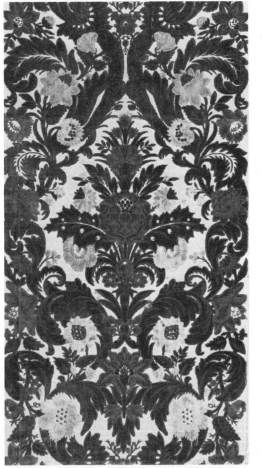

53 Detail of an Adoration by Veronese showing one of the Three Kings in a Venetian silk cloak

54 right Panel of Genoese velvet. The transformation of the Sasanian structure of design is clearly visible. The plants now dominate.

abled Chinese silks to be imported into Italy much more freely, and this caused a change in the style of Lucca silks; the designs became bigger and bolder, less heraldic and much more dependent on leaf and flower forms: there is a new openness to the pattern that is an important change.

Venice took over the major place in silk manufacture from Lucca in the early fourteenth century, importing Lucchese workmen. Designs became even more oriental, because of Venice's traditional eastern connections. It is clear, for instance, that the scrolling foliage patterns must be derived from Chinese silks. Venetian silks are particularly sumptuous, as can be seen in so many Venetian paintings, and many great artists such as Giovanni Bellini took an active part in designing for silk manufacturers.

At the time, of course, the precise origin of a style was not known, and one is unable to rely on the evidence of such inventories as that of Mazarin in 1653 ('Dix pièces de serge de soye à plusieurs couleurs façon de la Chine faites à Paris') that this was in Chinese as opposed to any other exotic style. Chinese silk itself was highly regarded. Le Comte (English edition 1697) wrote: *'The finest and fairest Silks are wrought in the Province of Nankin . . . Altho' all these silks have some resemblance to ours, yet the workmanship hath something in it that makes a difference. I have there seen Plush, Velvet, Tissa of Gold, Sattin, Taffaty, Crapes and several others'.*

This mix-up of styles was that taken over by the emerging silk industries of Lyons and Tours. By the mid-seventeenth century French designs were copied all over Europe. Fashion demanded quick changes of pattern, and only the French could cope with this effectively. Genoese velvets for furnishing alone remained immune from this competition. Of course the styles used in France grew further away from their origins, and though various plant forms predominate (the palm leaf or cone or pomegranate, and the floral meander are the most obvious) other forms are not uncommon. The great break with the orient occurs with the 'bizarre' silks of 1700–30,

when designs were so astonishingly similar to those of the 1940s. In the 1740s new chinoiserie patterns appear in European silks, during the great period of change in silk designs usually associated with Jean Revel at Lyons. These silks often follow the ideas of the painters Huet and Pillement (see Ch. 6). Both these painters also designed for the *Manufacture de Jouy*, which made printed toile for furnishing, somewhat similar to English plate-printed cotton[1], which had by then grown relatively far away from its Indian-style origins.

Calico, printed or painted with patterns, had been imported from India into Europe by the Portuguese in the sixteenth century, and was

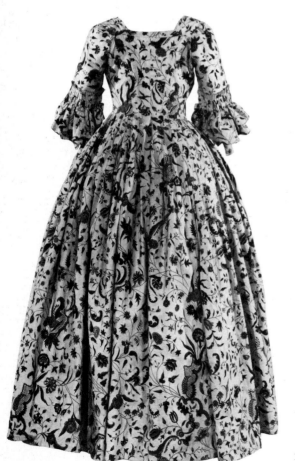

55 Overdress (18th century) made in England of imported Indian chintz of the smaller-patterned type.

sometimes to be found in England. The inventory of Hardwick Hall, taken in 1601, includes 'a quilt of yellowe india stuffe imbrodered with birdes and beastes and white silk frenge and tassells, lyned with yellowe sarcenet'. The Portuguese had called these cloths *pintados*: in England they were called chint, chintes, chintz, or pintathoes. In 1613 the spice-ship *Peppercorn* imported a few 'pintathoes', most of which were so greedily grabbed by directors of the East India Company as perks, that the Committee wrote to enquire if it would be worth shipping more. More were duly shipped, but in 1643 they fetched such a poor price that the Company wrote to their agent in Surat: *'Those which hereafter you shall send we desire may be with more white ground, and the flowers and branch to be in colours in the middle of the quilt as the painter pleases, whereas now the most part of your quilts come with sad red grounds which are not equally sorted to please all buyers . . .'* This is an important innovation, and it was to be followed by an even more important one. In 1662 patterns were sent to India to be copied. This parallels the sending of wooden models to China and Japan to be copied in porcelain (see Chapters 7 and 8).

In the 1670s so much chintz was being imported that it endangered the silk industries, and the Company ordered less to be sent. France banned the import of chintz in 1686, but this only increased the supply in England, for most of the chintz for France was re-exported from England, and in 1701 a ban was issued on imports into England. That this was consistently and successfully evaded is attested to in innumerable contemporary documents and chintz continued to be worn and to be used for interior decoration just as it had been before the legislation. In 1719 the Spitalfields weavers became so angry about the wearing of chintz that there were unpleasant scenes when ladies' dresses were purposely spoiled, or even pulled off.

Most of the Indian chintzes were based on the so-called 'Indian tree' design, which had also had an effect on silk, and hence on European design in general. By Tudor times English

1. illus. **50**

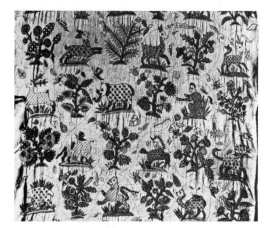

56 English needlework bedcover in coloured silks on satin, *c.* 1690. Not only individual motifs, but the overall pattern is influenced by chintz.

57 English stumpwork panel, late 17th century, based not on chintz patterns, but on lacquer.

needlework had often been based on a flowering and leafy tree on rockwork, which bears a marked resemblance to Indian chintz, some resemblance to some Chinese patterns, and also some parallel relationship to Verdure tapestries of northern France and the Low Countries. In the seventeenth century, as we have seen, this predilection for the tree patterns was confirmed by special orders followed by models to be copied.

Although none of the exported models exist, some chintzes exist that are certainly drawn from a pricked-out pattern, and not copied free-hand from a muster that lay at the painter's side. Other chintzes exist that are far from Indian taste; some derive from Bérain, some are actually copied from a *toile de Jouy*, and some are even copied from Japanese textiles.

As we know that Indian chintz provided the model for much of the printed cotton of Europe, and also for wallpaper, then the complications reach epic proportions. Which are chinoiserie? Certainly the European chintzes may be, but are not some of the Indian ones also? The fact that they happen to be made in India is almost irrelevant if they are based on European pastiches of an Indian style.

The printing of cotton in England had started in the seventeenth century: in 1676 Will

Sherwin was granted a patent to print on broad cloth in 'the only true way of East India printing and staynng such kinds of goods'. By the early eighteenth century the patterns used were still based on Indian calicos and could be printed in several colours, mostly browns, purples, reds and black. Polychromy in fast bright colours was possible by 1740, but monochromes remained popular also. New designs were actively sought (as in silks), and the chinoiserie scenes related to those of Huet and Pillement appear by 1768. Towards the end of the century there is the by now traditional confusion of styles, and chinoiserie and classical motifs can appear together with no undue stress to the imagination.

Needlework also, of course, paralleled contemporary woven and printed fabrics. In the seventeenth century dress materials and hangings were often embroidered with designs derived from 'Indian tree' patterns. Contemporary stumpwork, on the other hand, often has

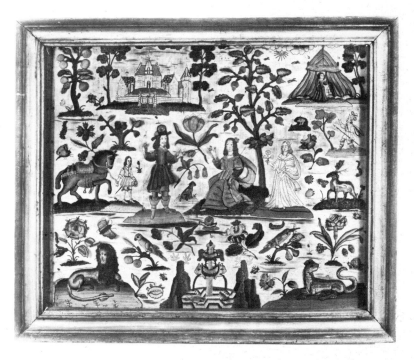

chinoiserie designs taken from lacquer, at least in the background. It is perhaps worth commenting on the frequent occurrence of stumpwork and japanning together, especially on mirror frames. They were thought of as suitable for each other.

Carpets

The pile carpet, that is one with knotted threads on the warp, is of oriental, possibly Persian origin. When it first appeared in Europe is uncertain, but enter it did, by two separate routes; firstly from Islamic Spain, and secondly, after the Crusades, via Venice. The earliest knotted works made in Europe, as early as any surviving oriental pieces in Europe, are the hangings at Quedlinburg Schlosskirche in Germany made about 1200 by Abbess Agnes II and her nuns. In the thirteenth century the Paris Book of Trades mentions *tapissiers nostrez* and *tapissiers sarrasinois* which may refer to tapestry makers and carpet makers respectively. Otherwise, almost nothing is known of carpets in Europe, or European carpets, until the fourteenth century. Carpets were still rare in the fifteenth century, and not in general use until the eighteenth century.

In the fourteenth and fifteenth centuries, carpets were imported into Europe by Venice, and can be seen depicted in Italian Renaissance paintings. Mostly these are Turkish carpets from Anatolia[1], and the word Turkey was later applied to all oriental rugs and even to European imitations. They were, of course, not used for floorcoverings, but were placed on tables or cupboards, or used for display. Only in religious paintings are they shown on the floor.

Venice failed to keep a monopoly on the import of carpets: not only did other Italian towns compete (Ancona specialized in importing rugs) but Filipo Sassetti tells us that at the end of the sixteenth century Persian rugs were being imported into Portugal from India at 40 per cent less than their cost in Venice.

England had been, until Henry VIII's reign, somewhat left behind in pre-Renaissance feudalism. Among the first carpets in England were the sixty sent from Venice to Cardinal Wolsey in October 1520, but by the end of the century they were commonly found in great houses (e.g. Hardwick). By the beginning of the seventeenth century, and possibly even before, armorial carpets could be ordered from Persia, and a few still exist. The two silk carpets in the Residenzmuseum in Munich, which bear the Vasa arms and later belonged to the Wittelsbachs were made in Kashan. These latter were ordered by King Sigismund Vasa of Poland in 1601 or 1602, through an Armenian, Sefer Muratowicz, whose account of 12th September 1602 survives: *'Price of the objects which I bought in Persia in the city of Kashan for his Majesty our gracious King . . . 2 carpets at 41 crowns, together . . . 82 crowns. For the execution of the royal arms extra 5 crowns.'* Of course by the time the transport and customs had been paid the cost was probably double.

Cheaper and more common were Anatolian carpets, from Ushak. The 1601 inventory of Hardwick Hall lists many examples; in the Low Great Chamber, for instance, were '. . . a long table Carved and inlayde, too long turkie Carpetes for it, . . . an other square table, a square turkie Carpet for it, a Cubberd, too turkie Carpetes for it, one of them with my Ladies Armes in it . . .', and in the Best bed Chamber 'three foote turkie Carpetes the grounde of them white, to laye about the bed'. The carpet with Lady Shrewsbury's arms was presumably made to order in Anatolia. European-made carpets are identifiable, for elsewhere in the inventory there are 'a Carpet . . . of nedlework', a 'say Carpet rowde yellows red and bleue, a little Carpett of Cruell Checkered red and yellow' and 'a white spanishe rugg'. The 'foote Carpet of turkie worke' in the High Great Chamber was probably an English copy of an Anatolian rug.

In the early seventeenth century, also, Indian carpets from Agra and Lahore appear in Europe.

A cabinet of curiosities, possibly that of Ortelius (*see p. 56*). Painting by Hans Francken. Note the blue-and-white Wan Li period Chinese bowl.

Soho tapestry, probably by Robinson. *See p. 73*

1. illus. **58** and **59**

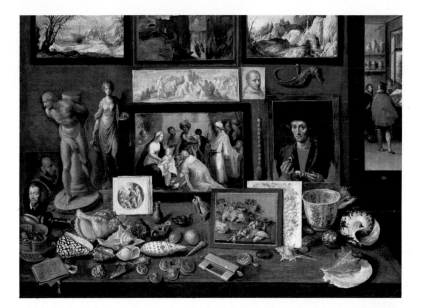

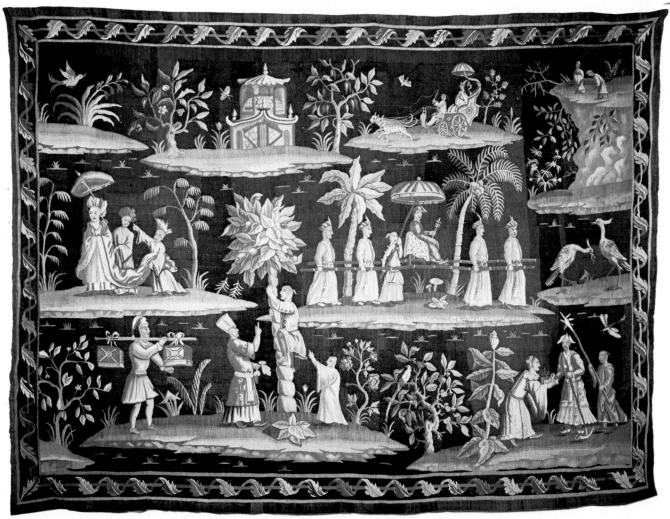

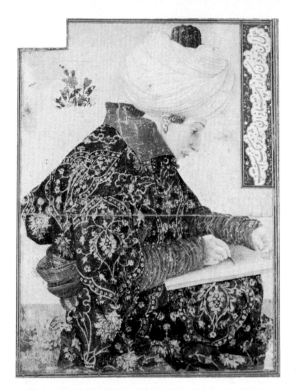

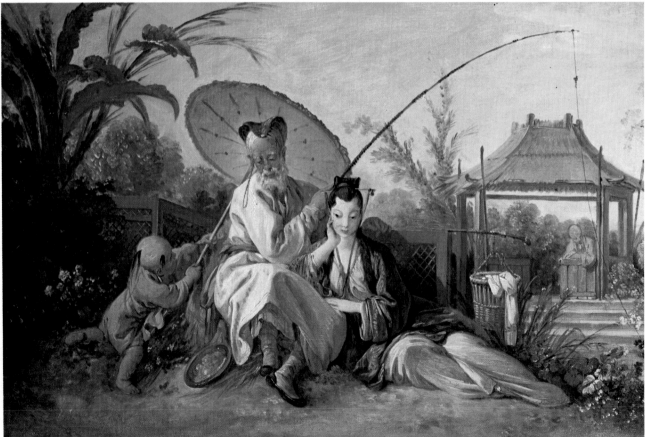

A young Turk sketching.
Drawing by Gentile Bellini
(the script added later).
See p. 77

The Chinese Fishing Party
by François Boucher. See
p. 82

Knotted carpets had only been made in India
since the Mogul Emperor Akbar (1566–1605)
brought weavers from Persia, but Sir Thomas
Roe, James I's ambassador at the Mogul Court
from 1615–19, ordered for himself 'a great
carpet with my arms thereon'. The East Indian
Company took an interest in this, but their
agents wrote on 25 December 1619: *'to my
knowledge there hath bin a carpett in Agra house
this twelve month amakings, and yett is little more
than half don; and they neither make them soe well
nor good collors as when they make them without
bespeakinge. And therefore yf those carpetts and
their sizes like you, that this yeare are sent,
question lesse you maye have greate quantityes of
them sent yearlye from one or both places; but
Lahore is the chiefe place for that commoditye.'*

Between 1630 and 1632 the famous carpet
of the Girdlers' Company was made to the order
of Robert Bell, in Lahore. The carpet has the
arms of the Company (unfortunately reversed)
and Bell's initials woven into the design, and
was probably made to the exact size of the
original Court Room table, which was destroyed
in the Great Fire of London in 1666 (the carpet
was saved by the Clerk Richard Davies). It
measures approximately eight and a half yards
by two and a half yards: John Irwin has calcu-
lated that it must have cost Robert Bell about
£20 – then a considerable sum of money.

Knotted carpets had been made in Spain by
Islamic workmen since the twelfth century at
least. Spain was a centre of carpet production
for some hundreds of years, even after the
Moors were finally driven from Granada in the
fifteenth century. But as Spanish carpets were
made by Islamic workmen, they hardly show
European degeneration of Islamic design until
the early sixteenth century. And by the six-
teenth century carpets were being made in
Poland, England and Flanders. Many of these
early carpets are armorial and can thus be
dated.

Perhaps the earliest English carpet is the
Verulam carpet with the arms of Queen Eliza-
beth and dated 1570. Two others, both in

close imitation of Anatolian designs, bear the
Montagu arms[1], and are dated 1584 and 1585.
Carpet making became a household activity,
and was called 'turkey-work'.

In France, in 1626, the Savonnerie factory
began in the old soap-works at Chaillot, but
made mostly baroque design carpets, not
oriental. Nor were the short-lived English
eighteenth-century factories of Fulham, Moor-
fields and Exeter involved in oriental styles, and
it would appear that by the beginning of the
eighteenth century oriental rugs were imported
in sufficient quantity for it to be uneconomic to
imitate their designs in Europe. A rare chinoiserie
exception is the large Axminster carpet made for
the Banqueting Hall of the Royal Pavilion at
Brighton in the early years of the nineteenth
century which has dragons in the design to
correspond with great dragons on the
chandeliers and ceiling.

With the coming of machinery for making
rugs in the nineteenth century, however, there
was a revival of interest in oriental designs, and
innumerable Axminster and other carpets are
made today in close imitation of Persian or
Turkish designs.

Tapestry

Tapestry as a technique may well have come to
Europe from the East; at any rate, the technique
was widespread throughout Europe by the
eighth century. The popularity of tapestry
greatly increased after the Crusades, when re-
turning knights brought luxurious textiles with
them as relatively easily transportable booty.
But not until the fourteenth century is there any
clearly recognizable influence of oriental pat-
terns. Then, in the Verdure tapestries of Arras
and Tournai in particular, the leaf and flower
motifs are not only in themselves, but also in
their relative disposition, highly reminiscent of
Islamic work. In the early sixteenth century
some sets of tapestries were made with oriental
subjects: in 1504 Johan Grenier of Tournai

58 *The Annunciation* by Carlo Crivelli (active 1457–1493). The Anatolian carpet (so-called Holbein type) on the balcony is a symbol of luxury.

made a set of tapestries 'à la manière de Portugal et de l'Indye' but these do not survive, so we do not know their real style.

The earliest extant tapestries with avowedly oriental subjects are probably the various slightly differing sets of the 'Gens et Bestes sauvages à la manière de Calcut' and the 'Voyage de Caluce' all of about 1520. Two of the latter set, by Gilles le Castre and from the workshop of Meaulx Poissonnier of Tournai, show caravans of camels and of giraffes and elephants. Camels were of course well known (though M. le Castre has taken liberties even there) but elephants and giraffes were less familiar and are here portrayed in a very charming and dignified way. There is a confusion in portraying African animals as being of eastern origin. The 'Gens et

Bestes sauvages' set is scarcely based upon any reality, but is more a travellers-tales illustration.

Reality is much more unusual, but there is at Powis Castle a Tournai tapestry, dated 1545, that depicts a real incident. This is the Venetian embassy to Cairo of 1512, which was led by Domenico Trevisano. It is a loose copy of a painting of the school of Gentile Bellini, now in the Louvre, which has been sometimes attributed to Giovanni Mansueti[1], and may have been itself taken from sketches made on the spot.

As histories and myths make up a great part of the subject matter of tapestries, it is to be expected that the eastern exploits of the Portuguese would be illustrated on tapestry. And in fact after the middle of the sixteenth century a

1. p. 77

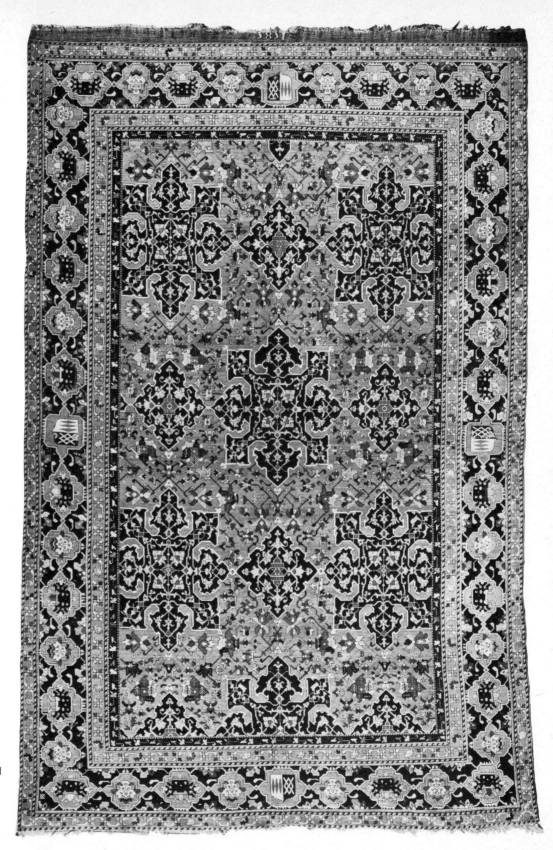

59 English imitation of an
Anatolian carpet (so called
Lotto type), bearing the
Montagu arms, 1585.

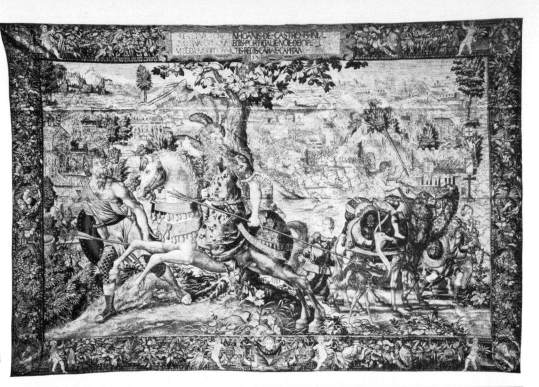

60 Another Brussels tapestry from the João de Castro set, showing a procession of exotic animals. *For others of this set see illus. 22 and 26.*

61 One of the great tapestries of the *Tenture chinoise* set designed by François Boucher – here the love of the fantastic has outstripped even the love of the exotic.

set was woven in Brussels showing the exploits of João de Castro, fully garnished with such eastern rarities as the ostrich!

Chinoiserie tapestry as such, that is in an attempt at an oriental style rather than a mere depiction of an oriental subject, seems to have begun in England in the Soho Factory in the late seventeenth century. The designs[1] are individually reminiscent of japanning, and were often taken somewhat loosely from engravings, but it is their placing on the tapestry that is so individual. Each 'picture' is small, bears little or no relation to the other 'pictures' and is placed in an arbitrary fashion of irregular rows, on a dark ground. It has no overall design or pattern other than a spaced-out irregularity. The designer may have been Robert Robinson.

On the European continent in the early eighteenth century sets of 'Chinese Hangings' with large chinoiserie figures in an exotic setting, partly out of doors, partly sheltered by architectural tent-like structures of somewhat gothick elaboration, were woven both at Beauvais and in Berlin. These may well have inspired the great set of nine tapestries, the *Tenture chinoise*, made at Beauvais from designs by François Boucher. The cartoons for these tapestries were exhibited in the *salon* of 1742. Several sets of these were woven, one of which was bought by Madame de Pompadour, probably for Bellevue, and another of which was the astonishing choice of Louis XV for a gift to be sent to the Ch'ien Lung Emperor of China. These have a much grander scale than the earlier set, but continue the mixture of origins so typical of chinoiserie.

Another set, the Gobelins 'New Indies' after François Desportes, has exotic elements and is somewhat similar in style to the Boucher tapestries. It would be stretching the point — already long extended — to call them chinoiserie, but they are descended from the set of 'The Indies' paintings by Albert Eckhout which had been given to Louis XIV by Prince Maurice of Nassau.

Almost the last tapestries made at the Aubus-son Factory before the Revolution were the 'Chinese landscapes' woven in the 1780s after designs by Pillement, showing exotic trees and so on, and chinoiserie buildings. By that time, tapestry was a dying art. In the nineteenth century it was little practised until it could be made on a machine, by which time chinoiserie had passed out of favour.

1. plate facing p. 68

Alessandro Mauro in Venet: Fec: e Adise: In occasione della Solenne e famosa Regatta Celebrata in Venetia adi 27 Maggio 1716 in onore dell'Altezza tiro a se singolarmente gli occhi e gli applausi la bizarra e ricca Peotta di cui qui si vede il disegno. Ella omaggio di suoi Pazzi, e sequaci i quali uanno ad offerire Vasi preziosi ripieni d'aromati, e d'erbe, e altre p

na il Prencipe Reale du Polonia, et Elettorale di Sassonia

China condotta in trionfo da. e Asia con

e, solite nascere in quela Prouincia,

Andrea Zucchi Scul

62 Processional barge for a Venetian regatta held in honour of Augustus the Strong in 1716. Engraving by Zucchi after Mauro. *See p. 79*

Painting, Drawing
and Engraving

Chinoiserie styles have rarely been used for large-scale, or self-sufficient works. For decoration they have occasionally been used as frescoes (as at the Villa Valmarana, see Chapter 12), as tapestries, as wall paintings and panel paintings. Very rarely is chinoiserie used for easel pictures, save by François Boucher.

Chinoiserie usually requires an intimate if not miniature scale, and was usually considered most suitable for the embellishment of small objects. Many chinoiserie drawings and engravings were done as patterns for some other medium: these are not discussed in this chapter, but in the relevant sections dealing with that medium. The exceptions to this are in the designs for ephemeral events, masques, festivals, costume-balls and banquets: only the designs survive, so they are discussed here.

In this chapter I will consider the main effects that oriental styles had upon painting, drawing and engraving, and how these effects in turn created further styles.

The influence of the East upon western painting was very considerable. In the early Renaissance this influence was, of course, mainly Byzantine, but it was also Islamic (particularly after the fall of Constantinople to the Turks in 1453) and, more tenuously, Chinese. Byzantine art provided the iconographical basis of early Italian painting (and virtually all early Italian painting was religious). The mosaics at Ravenna (fifth century) have the sharp outline against a gold background that was so important before the Renaissance. To this extent, then, thirteenth- and fourteenth-century Italian painting was dependent on the East. The essential difference between Byzantine art and Renaissance paintings lay in the Renaissance concentration on the depiction of reality, in roundness of form and indication of movement.

While the influence of Byzantium and Islam on Venice and hence on the rest of Europe was very considerable, Chinese influence was also felt. The proximity of the Mongols in the thirteenth century no doubt contributed greatly to this, and in the late fourteenth-century porcelain

63 St Martin by Simone Martini

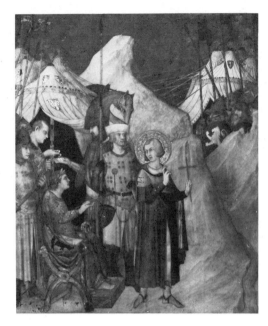

64 below Fourteenth-century Chinese blue-and-white vase showing the device for suggesting distance used also by Simone Martini.

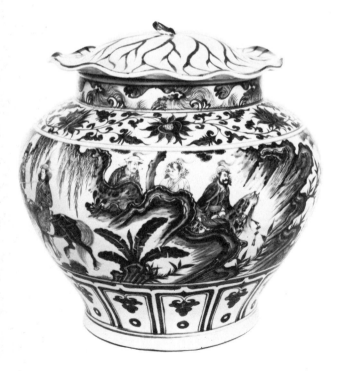

from China appeared in Egypt and later in Europe in increasing quantities. Chinese paintings and printed books almost certainly appeared in Europe as early as the fourteenth century. Pictorial devices typical of Chinese art can be seen in the work of the great Siennese painter Simone Martini (c.1284–1344). In the fresco cycle of St Martin in the lower Basilica of S. Francesco in Assisi, in the scene where St Martin takes his cross into battle instead of his sword, the enemy can be seen just appearing over some rocks in the right-hand upper corner. This closely parallels Chinese practice, for instance on a Yüan blue-and-white jar of a hunting scene (though here the jar is later than the fresco). Later still it turns up in Islamic miniature painting. Whether or not there is a real connection is not known, but it seems possible that Martini had seen Chinese block-printed books (the porcelain painter had probably taken his design from a book, too). Also the feeling of space in his painting of Guidoriccio Fogliano in the Palazzo Pubblico in Siena has been compared to that of a Chinese handscroll painting.

Not all things Chinese were welcome, and du Halde was to write of their painting in 1735: *We must not judge of the Air and physiognomy of the Chinese by the Pictures on their japan'd Works and China-ware. Tho' they are skilful in painting Flowers, Animals and Landskips, they are very ignorant in drawing Human Figures, maiming and disfiguring themselves in such a manner that they look more like Scaramouches than Chinese.*

Depiction of figures with oriental features, well observed, occur in paintings by Cimabue, Giotto, the Lorenzetti, Lorenzo Monaco and others. Curiously, it was typical of Siena more than of Florence. In the later fourteenth century it became fashionable – indeed almost necessary after the depopulation caused by the Black Death – to import slaves. Many of these were from eastern countries, and probably provided the models for the increasing number of oriental characters to appear in Italian painting, particularly in paintings of the Magi. (Only from the twelfth century does one of the Magi nearly

65 A scene in Cairo by a pupil of Bellini, possibly Giovanni Mansueti. *See also p. 70*

always appear as an African or a Moor.) The painters of the International Gothic, such as Gentile da Fabriano painted oriental dress, mostly Turkish, in some detail, and Pisanello in about 1440 drew a portrait of a Mongol archer, clearly from life, in his native dress.

Later, oriental dress was of interest more for the fabrics (imported into, and now much imitated in Italy: see Chapter 5) than for the cut, and rich 'oriental' fabrics become a feature of painting in Florence and even more so in Venice. This is the style I shall refer to later as costume-drama — the dressing up of someone in an oriental costume (this was even done for portraits) or in a pastiche of an oriental costume.

Some Italian artists of the fifteenth century had first hand experience of the East. Muhammed II, Sultan of Turkey, who had taken Constantinople in 1453, employed certain Venetian artists for short periods, most notably Gentile Bellini who was in Istanbul 1479–80 and who painted Muhammed's portrait.

Bellini made some superb drawings of Turkish figures. One drawing[1] usually attributed to Bellini can certainly be included as chinoiserie in its broadest sense. It is a coloured drawing of a young Turk sketching. As Benesch writes: '*In this drawing the artist purposely came close to the style and appearance of a Turkish or Persian miniature*'. It is tempting to suggest that this is the first chinoiserie painting. Curiously enough, this drawing was copied several times by Turkish artists of almost contemporary date.

Several other artists visited Constantinople, Egypt and the Holy Land. An unknown pupil of Bellini's (possibly Giovanni Mansueti) went to Cairo with Domenico Trevisano's Venetian embassy[2] in 1512.

Jan van Scorel from the Netherlands, who had worked as the Pope's Curator of Antiquities in the Vatican, visited the Holy Land in 1520–21. In 1533 Pieter Coecke van Aelst, the tapestry designer from Brussels, went to Constantinople to try to get commissions from the Sultan: while there he made many drawings and even learned the Turkish language. Another

1. plate facing p. 69 2. p. 70

tapestry designer, Jan Cornelisz. Vermeyen, accompanied Charles V's expedition against Tunisia, making drawings which provided the sources for engravings and a set of tapestries.

All these artists were essentially recording what they saw: they were not adapting eastern styles (the exception is Bellini). But nor were they concerned with the East save as a record of travels or as a job of work to be done. Apparently the first European artist to visit the East simply because he wanted to draw eastern places and peoples was Melchior Lorck: he stayed for four and a half years in Constantinople, and on his return to the Netherlands published his work as woodblock prints over the years 1570–83.

Woodblock prints had been an important factor in the spread of knowledge throughout Europe. Although printing on paper from a woodblock had been known in China, Korea and Japan since the eighth century, it was not known in Europe until the late fourteenth century. Whether or not it was learned from the East is often debated. Movable type was invented in Europe in about 1450 – again, it may have come from Korea where it had been in use since the twelfth century. Woodblock printed books of travel were very popular, and an influential example was Breydenbach's *Travels* published in Mainz in 1486, which had good topographical prints by Erhard Reuwich, and prints of oriental costumes, animals and even alphabets.

Hans Burgkmair engraved a series of six 'exotic races' and other depictions of oriental peoples in 1508, and Dürer included a date palm in his 'Flight into Egypt' of 1511. Pieter Coecke van Aelst's cartoons for tapestries of 1533 were called '*Les Moeurs et façons de faire de Turcs . . .*'

One of the most influential of later books was Nieuhoff's account of the Dutch embassy to Peking with engravings by Wenceslaus Hollar and other artists (first English edition, 1673).

The opening of the sea routes to the Far East by the Portuguese brought great changes in interest in the East, for western attention was drawn to China much more directly than before.

The import of strange goods brought strange pictures to be studied, and it was the somewhat inferior pictures on the minor crafts of lacquer and porcelain that were accepted as the standards of Chinese painting. In reality, of course, they bore little relation to the paintings a Chinese would regard as serious. But these, and the descriptions of the Jesuits, produced a new genre of painting that was to grow into the rococo-chinoiserie style.

Not many paintings can have reached Europe before the seventeenth century, from either China or Japan. But d'Andrade showed some Chinese paintings to King Manoel of Portugal in about 1520, a few others are mentioned in contemporary letters, and in 1585 the Japanese envoys to Europe presented Pope Gregory XIII with a pair of screens, probably of the Kanō school.

But by the seventeenth century the Jesuits were sending back some paintings, though they were more interested in getting oriental artists to paint in 'Christian' style than in commissioning or buying oriental painting. In 1697 a Father Bouvet presented forty-nine volumes of Chinese paintings to Louis XIV: these probably had less effect on the West than the engravings in the books produced by writers who had visited the East, such as Nieuhoff. Designs derived from Nieuhoff are found in paintings, japanning and even goldsmiths' work[1] (e.g. the 'Birthday of the Grand Mogul', see Chapter 13). Consequently, paintings and engravings of oriental scenes, objects, people, animals and plants became almost commonplace in the seventeenth century.

At the end of the sixteenth century Jacopo Tintoretto had painted the portrait of Mancio Itō, one of the Japanese envoys to Europe (1585), and in the seventeenth- and eighteenth-centuries portraits of visiting (and later resident) orientals became quite common.

Strange animals have always fascinated artists, and the sea route from India allowed the import of the larger animals, to be drawn from life, rather than from verbal descriptions. Leonardo's instruction that when drawing an

1. plate between pp. 176–7

66 'Habit d'Indien', costume for a ballet by Jean Bérain

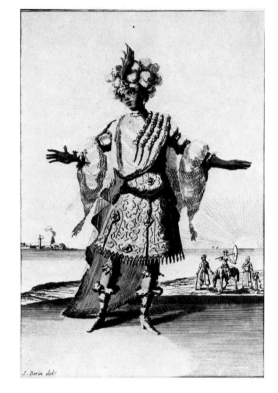

J. Bérin del.

imaginary animal, each individual part of that animal should be taken from a real animal, could be superseded by reality. In the sixteenth century, at least thirteen Indian elephants, for instance, reached Lisbon. Of these two got to Rome (one, Hanno[1], was drawn by Raphael in 1514–5), two to Vienna by different routes, one to Madrid, one each to France and England. The fate of the first rhinoceros (Dürer's Ganda[2]) was described in Chapter 2. Throughout the sixteenth century the elephant was regarded as a sort of symbol of the East, though African elephants had been known for several centuries – one had even reached England in 1255, sent by Louis IX of France to Henry III. A drawing of it[3] by Matthew Paris is in Cambridge.

With all these sources of information on the East, visual and verbal, the fashion for orientalia became more widespread. At the beginning of the seventeenth century exotic oriental figures appear in literature, especially in masques.

A major entertainment at Royal or Ducal courts throughout Europe was the masque. Plays of a more or less ephemeral nature, often grossly flattering by allusion the appropriate ruler or his favourite, were written *à la chinois*. Costumes then had to be devised for some of the characters in 'Chinese' style. Innumerable artists were thus occupied – even Inigo Jones, who introduced the Palladian classical style into England, designed Chinese costumes for masques. Sadly, there appears to be no example of a Chinese stage-set by him, for of course it was considered perfectly natural that a Chinese figure could appear in a classical setting.

In France, masque costumes appeared in the mid-seventeenth century and by the 1680s 'Chinese' costumes were regular features of every Court ball. In 1692 a theatrical performance of a play entitled *Les Chinois* was really an Italian comedy with a few *pagods* thrown in.

Jean Bérain, the first user of the grotesque style for semi-chinoiserie purposes, was the designer of Monsieur's *collation à la chinois* at Versailles where all the rooms were filled with *pagods* and so forth – even some of Monsieur's officers were dressed as *pagods*. Alas, the drawings have not survived.

In the eighteenth century it might almost be said that the home of the masque was in Venice. When Augustus the Strong visited Venice in 1716, a chinoiserie reception was arranged for him where a boat was got up as a junk crowded with costumed figures with parasols, musicians and dancers. An engraving[4] of this by Zucchi survives, and it shows a marked resemblance to an engraving of a decorated junk from Nieuhoff's book.

In the introduction I defined chinoiserie in the widest possible sense: here I want to divide chinoiserie by describing one special type of chinoiserie. This is the light-hearted and frivolous type of chinoiserie that one associates automatically and perfectly logically with the

rococo. And yet it is not really rococo[1], for it begins about a hundred years earlier. It provides many motifs for the rococo, and its air of unreality is a counter to the baroque that in its day must have seemed very extraordinary and extreme.

This style seems to have begun at the beginning of the seventeenth century. Imitations of oriental objects were beginning to give way to pastiches of oriental objects. This is true in many fields we shall be discussing, but most of all in textiles, engraving, japanning and ceramics. And above all, this style derived not from the Near East, nor from India, but from China, or rather from the imaginary China known as Cathay which was so well known from depictions on imported Chinese goods.

Chinese porcelain painters and lacquerers have little in common with western artists – even the method of perspective is different. In a Europe that had only discovered geometric perspective in the fifteenth century, was it likely that vertical perspective would be understood?

Chinese landscapes, houses and people, could therefore be dismissed from any serious consideration of reality: they could be utilized for their novelty and sense of the exotic while their actual content was so outré as to be almost abstract. As long as the 'copies' stuck to certain rules, lightness of touch, absurdity of stance, costume and physiognomy and so on, then they were recognizably 'Chinese' and suitable for decorative effects on small objects.

While textile designers looked to Indian calicos and French silks (themselves related to oriental styles though several times removed), engravers of designs looked to this flowery Cathay. The earliest designs in this style seem to have been by a Dutch engraver, Mathias Beitler in 1616, followed by Valentin Sezenius ten years later. Both these artists mixed other motifs, classical or imaginary, somewhat indiscriminately among a chinoiserie that is in its compound of rickety bridges, dilapidated buildings perched impossibly in the air, exotic birds and whiskered Chinamen anticipatory of the rococo. This,

67 A Chinese scene from Stalker and Parker's *Treatise* of 1688

which might perhaps be called the main branch of chinoiserie, reaches its peak in the late eighteenth century in the designs of Jean Pillement.

With the vogue for japanning increasing, engravings to be copied by amateurs were necessary, and were soon to be provided in such books as Stalker and Parker's *Treatise* of 1688 (see Chapter 9). The drawings here are so naïve as to beggar description: they are not purposefully primitive, they are plainly incompetent – and yet they were much followed. A curious insight is given to the current state of opinion of oriental civilization!

At least one painter was specializing in chinoiserie at this date in England, Robert Robinson[2], who may also have been responsible for the designs on the Soho chinoiserie tapestries. One such set was woven for a Nabob, Elihu Yale, who had collected Mogul miniatures which may have been part of the inspiration of the tapestries. Certainly they are more oriental and less frivolous than the engravings of Beitler and Sezenius.

The first great exponent of this type of chinoiserie was Antoine Watteau. Chinoiserie decorations, for which only engravings survive, were done by Watteau, under the direction of Claude Audran, at Château de la Muette, possibly in 1707. These consist for the most part of very Europeanized figures in oriental garb, and, at least the male figures, of oriental physiognomy. The titles to each engraving are clearly taken from some oriental source, perhaps the books belonging to Louis XIV, for the transliteration of the Chinese is good; possibly they are imaginative drawings from the descriptions by a Jesuit. Two particularly attractive larger panels depict a female seated on rockwork, and holding curious attributes one of which, as Hugh Honour points out, looks just like a feather duster, to whom two tough-looking male figures make elaborate obeisance. Watteau also drew some grotesque chinoiseries, including one purporting to depict the Emperor of China.

1. pp. 171–81

2. plate facing p. 68 and p. 73

68 'Femme Chinoise de
Kouei Tchéou'. An engrav-
ing by Watteau for Château
de la Muette.

It was Watteau who consolidated this frivolous attitude to chinoiserie – rococo-chinoiserie. It was not just frivolous, it was fantastic, exaggerated but also charming. Huet, whose *singerie* decorations are discussed on page 169, was a follower of Watteau, extending his graceful oriental figures into delightful realms of Chinese and simian absurdity. It should perhaps be pointed out that not all *singeries* are chinoiserie, for Watteau produced at least one that is classical.

But the way had been opened for chinoiserie painting on a larger scale. It was François Boucher who first painted chinoiserie scenes comparable to the idyllic landscapes, and the romantic-rococo *al fresco* scenes of mid-eighteenth-century French painting. Boucher's style was imitated all over France, mostly for

such decorative situations as over-door panels. It was a Chinese *fête champêtre*.

Boucher's tapestry cartoons for the Beauvais series, the *Tenture chinoise*, were also in this pastoral mood (see Chapter 5). Although the figures in the cartoons for these tapestries have a real Chinese look, the setting is more often exotic France: the backgrounds have elaborate tent-like canopies that are as much gothick as Chinese, and not really either.

Boucher also painted pictures[1] in a more serious vein, in chinoiserie style – not just decorative scenes, but proper pictures. These have the soft and sensual approach that was perfected (but not in chinoiserie style) by Fragonard.

If the chinoiserie style went one way towards Boucher, the romantic-rococo way, it went

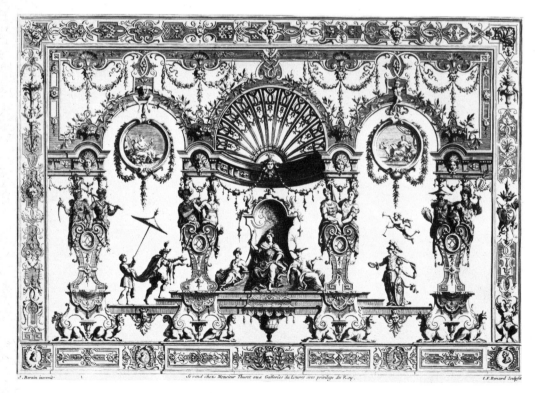

69 Grotesque panel designed by Bérain with chinoiserie elements appearing in a somewhat subdued form: see the figure under the parasol and the caryatids on the extreme right and left.

70 right Grotesque panel by Huet at Chantilly with *singerie* and chinoiserie as major themes

1. plate facing p. 69

another in the hands of Jean-Baptiste Pillement, whose frivolous rococo chinoiseries are perhaps the peak of the style. These are not of voluptuous Chinese maidens, but of absurd Chinese sages, pagods, astronomers in ridiculously unreal chinoiserie surroundings[1]. They were the eighteenth-century manifestation of that aspect of chinoiserie first seized upon by Beitler and Sezenius almost 150 years earlier.

One of the styles that often overlaps with rococo-chinoiserie is the grotesque. The grotesque style evolved first in Rome, after the discovery of the Golden House of Nero in the 1480s, that had some of the walls painted in an openwork style based on pillars, swags and small figures, that came to be called the grotto-esque. It was immediately used by Raphael and other painters as room decoration, fitting in well as it did with the Renaissance love of the odd, the unusual, the deliberately absurd.

The grotesque style quickly spread throughout Europe and is, for instance, an obvious contributor to the Tudor style of woodcarving as found at, say, Hatfield House. In France it was particularly popular and was much used by Jean Bérain, who first included monkeys instead of people (*singerie*, see Chapter 12), Antoine Watteau and others. Claude Audran designed tapestries in the style, and it continued in and out of favour throughout the eighteenth century, receiving its final neo-classical twist when it was included in the Etruscan (*sic*) style.

Grotesquerie was not only used for wall-coverings, tapestries or engravings, but also for other applied arts. Boulle used it on furniture, Dinglinger used it on silver and enamel teacups before the discovery of porcelain at Meissen. In Meissen porcelain it was used by Höroldt, and in Augsburg[2], grotesque chinoiseries were done in gold and silver on porcelain in imitation (in this unique technique) of Höroldt's enamel style: in faience it appears on Moustiers and on the wares of some other French factories.

Pictures of people in quasi-oriental dress do not necessarily count as chinoiserie, though they may. Rembrandt copied figures from Indian

1. plate facing p. 20 2. illus. **119** and **120**

71 above 'Costume drama'; detail of Turkish musicians by Carpaccio.

72 above 'Costume drama'; *The Death of Sardanapalus* by Delacroix.

73 right Chinese scene, not chinoiserie, by William Alexander who accompanied Macartney to Peking in 1793. *See p. 86*

74 below Copy of an Indian miniature by Rembrandt

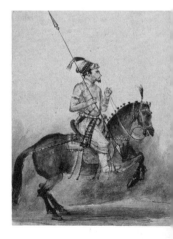

miniatures and adopted the poses for other purposes; thus they have to come under the heading of chinoiserie. But Rembrandt's figures of old men in turbans are 'costume drama' rather than chinoiserie. So are Carpaccio's Turkish musicians from the fresco cycle of St George in the Scuola di San Giorgio in Venice. So, too, is Delacroix's *'Death of Sardanapalus'*. These are romantic paintings in that they are choosing a romantic eastern exoticism. Ingres, on the other hand, goes over this tenuous boundary into romantic chinoiserie in *'Le bain turc'*, an evocation of eastern exoticism. Where Delacroix used eastern props and eastern figures for a romantic 'costume drama', Ingres is portraying a genuine

idea of the East – wishful thinking perhaps, on the somewhat primitive level of thought that the East is a centre of extravagant voluptuousness, but nevertheless an idea of the East.

It was not until the end of the eighteenth century that the reality of India and China was sought as Bellini and Lorck had sought the reality of Islam. William and Thomas Daniell travelled through India in order to make sketches – picturesque sketches – that they hoped to sell in India. This was not a success, but from the paintings they brought back they published a book of Indian views. They were regarded as experts in Indian architecture and were consulted over the building of Sezincote

75 *Le bain turc* by Ingres.
Dreams of eastern eroticism.

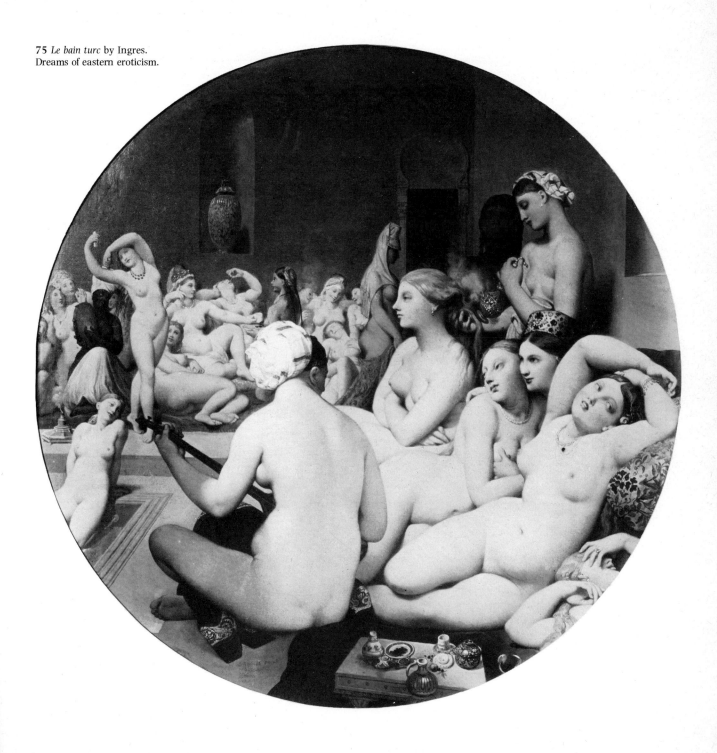

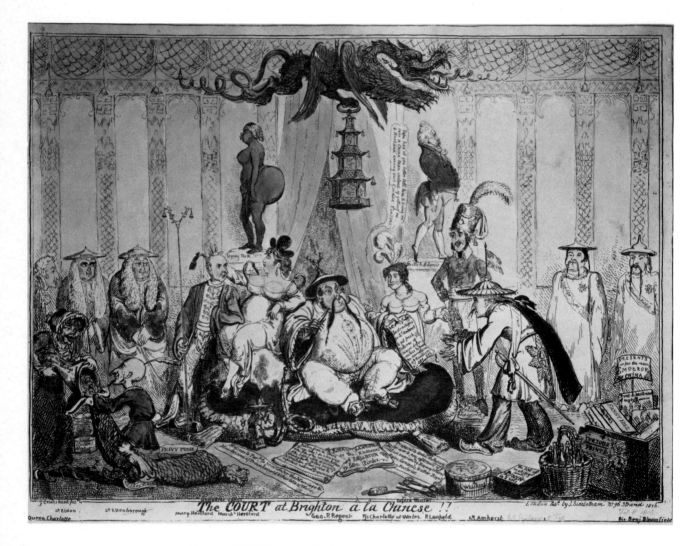

The COURT at Brighton à la Chinese!!

(see Chapter 11). William Alexander[1], who accompanied Lord Macartney's abortive mission to Peking in 1793, made similar sketches of China, in his role as official draughtsman. George Chinnery, living in Macao for seventeen years and several times visiting Canton, painted and sketched southern China. None of the artists can be claimed to have used a chinoiserie style: all drew what they saw. Chinnery has been claimed as a chinoiserie artist, but that is to misunderstand the term: his picturesque drawings of the Hakka boat people were taken from life.

In India, a slightly different pattern emerges. Professional artists from Europe were joined by hosts of amateurs who, with the aid of the *camera obscura* and other devices, produced quantities of sketches from life varying in quality from the absurd to the excellent. Rarely are these chinoiserie in style, being drawn from life

1. illus. 73

(and worked up later), but the attitude of the artist was often somewhat chinoiserie. *'The officer,'* wrote Emily Eden in her journal, *'a Russaldar — a sort of sergeant, I believe — wears a most picturesque dress, and has an air of Timour the Tartar, with a touch of Alexander the Great and he comes and sits for his picture with great patience.'*

It was not until the late eighteenth century that the British in India had taken Indian culture at all seriously: then such men as Sir William Jones, Warren Hastings and Sir Elijah Impey not only learned to read the local languages, studied local history and collected miniature paintings, but also commissioned local artists to paint for them. Many of these paintings are in a semi-European style that should perhaps be included under chinoiserie. The same problem arises in textiles and porcelain, when things are made to order.

In the nineteenth century there was a renewed fashion for near eastern topographical and other drawings, partly related to a renewed interest in classical antiquity. Artists such as Edward Lear, David Roberts and John Frederick Lewis catered to this taste with no hint of chinoiserie, which, by then, was beginning to smell of condescension.

In the second half of the nineteenth century a new culture was made available to the west. Japan, allowing very limited contact with the outside world since 1636, and that only through the Dutch and the Chinese, was opened in the 1850s to unlimited western commerce by forcible intervention of the United States in the person of Commodore Matthew Perry. Just as a vogue for European things and culture spread through Japan, so a vogue for *japonisme*, centred on Paris, then the cultural centre of the world, spread through Europe and America.

Its effects, which were widespread in all the arts, and had a profound effect on many modern styles, will be discussed in the last chapter.

76 Political satire: the Prince Regent's passion for chinoiserie was cruelly lampooned by such cartoonists as Cruikshank.

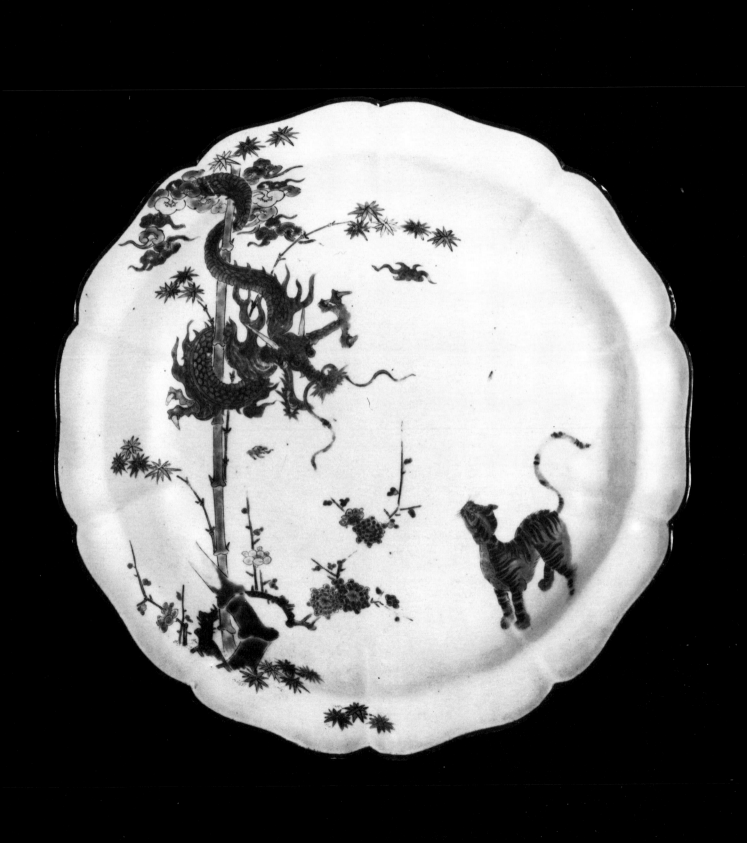

Ceramics-Inspiration

Many of the 'Chinese' figures that prance and strut across European vases, wall paintings, silks, or tapestries derive from blue-and-white Chinese porcelain decoration.

Of the minor arts imported to Europe, porcelain holds pride of place, save only, perhaps, for textiles. Being mostly specifically made for export, this porcelain is barely representative of Chinese taste in general and hardly at all of Chinese aristocratic or scholarly taste; much, indeed, is in part derived from European objects. But it was of tremendous influence, not only in the formation of styles of decoration, but also in altering the domestic habits of Europe. It is worth examining in some detail, then, the import of porcelain from the East, so as to follow its effect in Europe.

There can be no doubt that it was Chinese blue-and-white that played a major part in the foundation of that mixture of styles that we call chinoiserie, for it had been the major import among 'art objects' since the time when China-mania began in Europe, that is from the sixteenth century onwards; the polychrome wares only appeared in comparable quantity in the mid-seventeenth century. Thus blue-and-white became the material with which porcelain, and China itself, was automatically identified – from being Seres, the land of silk, China gave its name to porcelain, in a way that Japan was later to give its name to lacquer. Even more so is the blue-and-white colour scheme as such intimately connected with chinoiserie: the thought of each almost automatically evokes thought of the other. Sir Osbert Sitwell tells us how his father, the eccentric Sir George, among his many garden works and follies 'had determined to have all the white cows in the park stencilled with a blue Chinese pattern, but the animals were so obdurate and perverse as in the end to oblige him to abandon the scheme'.

77 Kakiemon dish of about 1700; sparse decoration in brilliant enamels on a fine white background. *See p. 93–5*

We have already seen that Chinese pottery was imported into the Near East by the eighth century. Some of the near-eastern wares are so similar to T'ang three-colour ware that they are at first glance difficult to distinguish. The mixture of styles is complicated by the imitation by the T'ang potters of some Sasanian metal shapes. Once again, it is worth noting the reliance on Sasanian influence that is followed into Europe through Hispano-Moresque pottery into majolica and through Byzantine textiles into romanesque architectural detail.

The Chinese first made true porcelain, as opposed to pottery or stoneware, in the seventh century and by the tenth century it was being exported to the Persian Gulf, and to Japan. These were the Sung white-wares (*ying-ch'ing*) and Ting, and also the green-glazed, grey-bodied stonewares of Chekiang that are called, in Europe, celadon. They were not intended for the European market, though some filtered through to Europe at an early date. The earliest surviving import may be the famous 'Fonthill vase', a Yüan dynasty *ying-ch'ing* bottle fitted with a gothic silver-gilt and enamel mount as a ewer, almost certainly in 1381, as a gift from Louis the Great of Hungary to Charles III of Durazzo on his coronation as King of Naples. In the eighteenth century this belonged to the collector William Beckford, builder of Fonthill Abbey. It is now in the National Museum, Dublin, lacking the unique mounts, apparently lost in the mid-nineteenth century. An early celadon is the Yüan bowl[1] in a silver-gilt mount presented to New College, Oxford, by Archbishop Warham, probably on 6 April 1516. The Medici inventories for 1553 include some 373 pieces of porcelain; white-wares, blue-and-white, celadon and even enamelled wares. Some pieces are readily recognizable from the descriptions as imports from the Near East, at least two 'Kendis' and some pieces with copper mounts (a near eastern practice), while another can be identified as Annamese (i.e. from Indochina) '2 ducklings attached together of white, red and green porcelain'.

Porcelain was not understood in Europe. Much controversy was raised over its composition: was it of eggshells or bones? *'It is certain,'* wrote Cardan in 1550, *'that porcelain is likewise*

1. plate facing p. 44

78 Ming celadon dish of a type much imported into the Near East and Europe.

made of a certain juice which coalesces underground, and is brought from the East.' Scaliger in 1557 claimed: *'They are made in this fashion. Eggshells and the shell of umbilical shellfish (named porcelains, whence the name) are pounded into dust, which is then mingled with water and shaped into vases. These are then hidden underground. A hundred years later they are dug up, being considered finished, and are put up for sale . . .'* In fact, Marco Polo's description was more correct than is usually supposed: his main exaggeration was in the length of time necessary to prepare the clay. Carletti, too, in 1606 had described it accurately in a letter to Ferdinando dei Medici, showing it to involve much the same processes as majolica, but with different materials, though his account was not published until 1701. Always the difficulty lay in the exact nature of the necessary clay. Ideally this is a secondary clay containing a high proportion of feldspar – a mineral that is present in decayed granite; (the clay 'pit' near Ching-tê Chên was called Kao-Lin).

'Blue-and-white' porcelain is in fact white porcelain painted under a transparent glaze with cobalt oxide which gives a rich blue colour after firing at a temperature of about 1280°C. This blue-and-white porcelain was first made at Ching-tê Chên in the latter part of the Yüan (the Mongol) dynasty[1], that is in the early fourteenth century. Remembering the pan-Asian hegemony of the Mongols it is hardly surprising that much of this ware was exported to the Near East. In fact it may well have been made especially for export, and certainly this lovely ware was highly considered in the Near East. In 1611 Shāh Abbas gave to his new shrine at Ardebil a collection of 1,162 pieces of blue-and-white Chinese porcelain. Many of the pieces are still there, some marked with his cipher, and they vary in date from early fourteenth century to late sixteenth century.

In Europe it was even more highly prized. Up until the sixteenth century when it was first imported systematically by the Portuguese, porcelain had a great rarity value, and belonged more to the 'cabinet of curiosities' than to the table. It was popularly held to have magical properties. Chinese porcelain can be seen depicted in some early Italian paintings, where it is usually associated with the Holy Family. The earliest example found so far is the bowl in a painting of the Virgin and Child of 1460–70 by Francesco Benaglio, now in the National Gallery of Art, Washington.

The fifteenth-century wares are much more refined than the earlier pieces, but lack their robust confidence: they have a more self-conscious beauty, reflecting the taste of the Ming Emperors. Again, relatively few came to the West; when they did, they were often given elaborate gold, silver, silver-gilt or, later, ormolu (gilded bronze) mounts and fittings, partly as protection, partly to emphasize their importance, rarity and value. Three fifteenth-century Chinese blue-and-white pieces are visible in the painting 'The Feast of the Gods' begun by Giovanni Bellini and finished by his pupil Titian in 1514. That porcelain should be depicted in such a context shows the esteem in which it was held. Several pieces of Chinese porcelain had been given to various Doges of Venice by the Egyptians in the fifteenth century, and presumably it was some of these that provided the models used in this painting.

The Portuguese were, of course, anxious to obtain Chinese blue-and-white porcelain. It is not known when they first could buy it in quantity, but it may be surmised that after 1554, when they acquired Macao, they were in a better position for regular trade and therefore more easily able to obtain pieces of porcelain to order.

This porcelain made to order was quite different from the refined fifteenth-century wares. Coarse in body, crude in manufacture and shape, and painted in skills varying from considerable to abominable, it was mass-produced. This is the *Kraak porselein*, the carrack ware (so named after the ships on which it travelled to Europe) that is familiar most particularly from seventeenth-century Dutch still-life painting. Huge quantities

1. illus **41** and **64**

80 right Ming blue-and-white bowl and cover, late 16th-century export type. *Cf. illus. 81*

81 below Still life by Jan Soreau (active *c.* 1615–38) showing two pieces of late 16th-century Chinese blue-and-white.

79 above Virgin and Child by Francesco Benaglio *c.* 1460–70 – the blue-and-white fruit bowl is early 15th-century Chinese.

82 below left 15th-century Chinese blue-and-white dish.

83 right 'The Feast of the Gods' by Giovanni Bellini and Titian (finished 1514).

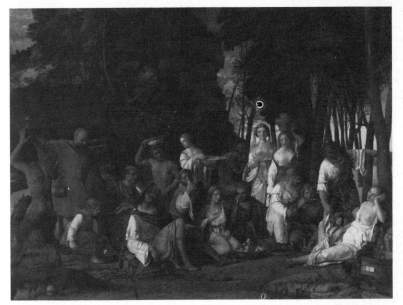

survive in Europe to this day that come from the last quarter of the sixteenth century from the reign of the Wan Li Emperor (1573–1619). Porcelain from earlier in the century is less common in Europe, but considerable numbers of Chia Ching (1521–1566) pieces do survive. This is a robust ware, better potted (though usually thicker-potted) than the Wan Li pieces, and the decoration is less formal. (It should be mentioned, perhaps, that this designation of a style to an exact reign is only approximately accurate. The Wan Li style is of course derived from the Chia Ching and clearly begins well before 1570.)

The earliest pieces dated with a Christian date come from before the acquisition of Macao: these are two bowls, each dated 1541 and bearing an inscription referring to Pero de Faria, who was Governor of Malacca in 1541. But the quantities imported into Portugal before that date had been very considerable. In 1522 the King had declared that ships returning from 'India' might carry porcelain as one third of their total cargo, and by 1580 there were six shops specializing in porcelain in the luxury shopping street of Lisbon, the Rua Nova dos Mercadores. We have already seen that the Portuguese carrack *Catharina*, captured by the Dutch in 1604, carried some 100,000 pieces of porcelain.

The success of the sales in Holland of the cargo of the *San Jago* (captured in 1602) and the *Catharina*, which attracted buyers from all Europe, including James I of England and Henri IV of France (who bought 'a dinner set of porcelain of the very best quality'), was so great that it must have provided the stimulus to the Dutch to engage in the trade in porcelain for themselves and also to produce the first tin-glazed faïence imitations of blue-and-white, at Delft.

From the beginning of the seventeenth century the Dutch took over the eastern monopoly from the Portuguese, as we saw in Chapter 3, and with it the import of porcelain to Europe. By 1614 the Directors of the Dutch East India Company (v.o.c.) were stipulating what sort of pieces, and what quantity should

be bought, many of these being of shapes that were of European origin — beer mugs, butter dishes, plates with flat edges, and so forth. The designs on these pieces were of course not European. Although new shapes appear in the orders every year, not until 1635 do the Directors write to Batavia sending drawings as well as models to be copied. Then, just as in the Indian textile trade (see Chapter 5), the European buyer instructs the oriental in oriental styles!

In 1615 the Dutch imported about 24,000 pieces of blue-and-white and in 1616 perhaps 42,000. On 10 October 1616 Jan Pietersz. Coen, the Dutch agent in Bantam, wrote *'The elephant tusks we have all traded with the Chinese, and mostly for porcelain . . . the porcelains for half the price they were formerly bought at . . . You are hereby informed that the porcelains are made far inland in China and that the assortments which are sold to us . . . are put out to contract and made afterwards with money paid in advance, for in China assortments like these are not in use.'* This shows that the pieces were of European shapes and specifically for European markets or at least for Europeans to sell (for some would be sold by the Dutch in the Middle East and India) and not for Chinese or south-east Asian consumption.

Soon the trade had reached hundreds of thousands of pieces of Chinese blue-and-white shipped to Europe each year. Some pieces were ordered by size and shape and quantity: in 1620 Coen was told to buy *'of the largest dishes 500, one size smaller 2,000, one size smaller still 4,000, double butter dishes 12,000, single butter dishes 12,000, fruit dishes 3,000, half-sized fruit dishes 3,000, caudle-cups 4,000, half-sized 4,000, clapmutsen 1,000, half-sized clapmutsen 2,000, saucer-dishes 8,000, table-plates 8,000, other small things as they come, but small brandy cups we do not want at all.'*

By 1638, it has been estimated, over three million pieces of Chinese porcelain had been shipped to Europe by the Dutch. With each year, new shapes had been ordered: candlesticks, mustard pots, goblet-shaped flower pots, small

Delft polychrome tin-glazed jug by Rochus Hoppesteyn

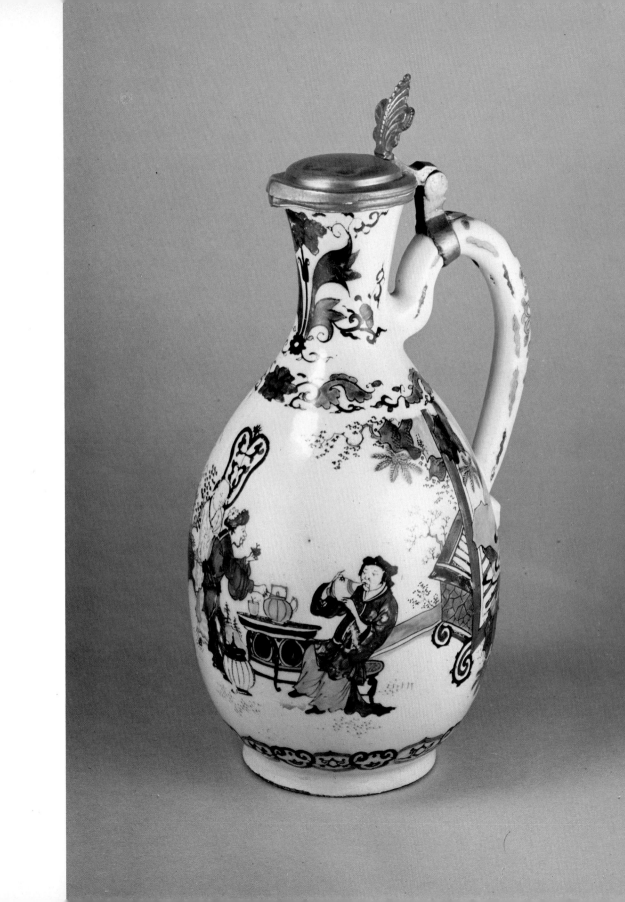

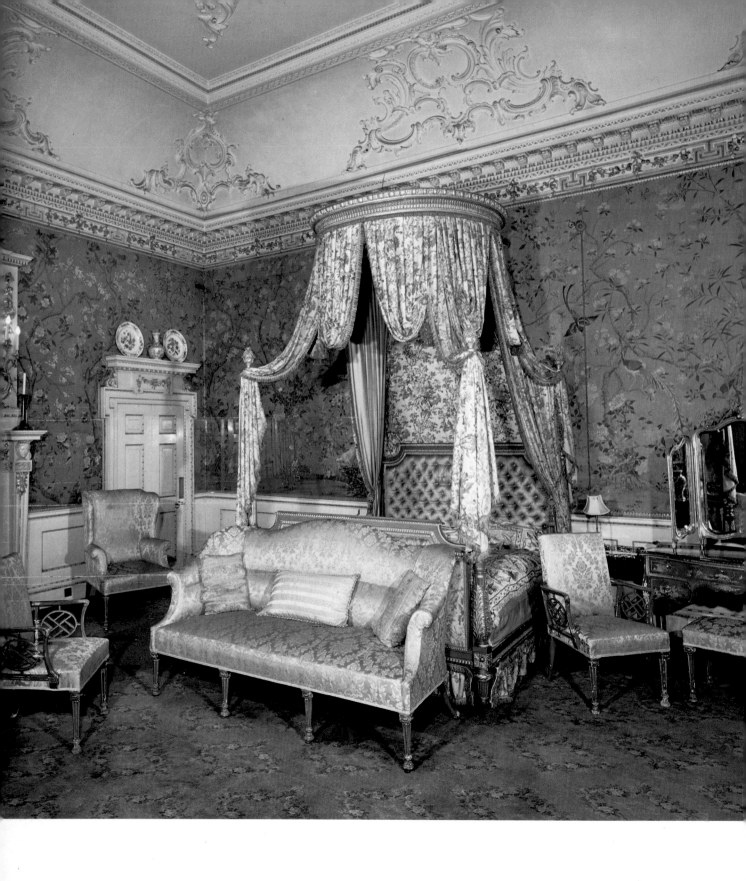

tea kettles, and so on, often derived from models sent out to China expressly to be copied. This explains the similarity of so many of the porcelain shapes to contemporary European stoneware, silver, pewter, and glass. It should be stated again, perhaps, that the motifs painted on these objects usually remain Chinese: it is the shapes that are European. But it is these motifs, these sauntering figures with large parasols, these grinning figures of *Pu-Tai* – the *pagod*[1], or *joss* of Western Europe – these children at play, and sages riding donkeys, these fantastic tree-paeonies and pine trees – it is these that are absorbed wholesale into the great grammar of European ornament and scattered, later, indiscriminately over the most unlikely surfaces and with the most extraordinary effects.

After the fall of the Ming dynasty in the 1640s, it took some years for the built-up supply of porcelain in China and Formosa to run out. The Dutch had been prepared for this. In Chapter 3 it was shown how the Dutch started ordering porcelain from Japan in 1650. In 1659, the first large order, of 56,700 pieces, was placed, for Mocha, and there was some difficulty in obtaining delivery at all quickly. Some of these pieces were copied from models specially sent from Batavia to Deshima, but many were in the Wan Li style, for doubtless the models were themselves copied or adapted from Wan Li prototypes, and perhaps painted in Delft, though the models themselves were of wood.

The Wan Li style persisted, in both Japan and Europe, with interruptions, well into the nineteenth century, and even recurs occasionally today. But in the mid-seventeenth century in China the Wan Li style was disappearing in favour of the T'ien-Chi style. Because the Ming fell, the T'ien-Chi style was never much used for wares exported to Europe but it was used for wares exported to Japan. It was the succeeding so-called Transitional style that appears on the export porcelain of China in the last part of the seventeenth century to be followed by the K'ang Hsi style. And here it was competing with Japanese porcelains from Arita, themselves often

in imitation of Transitional style. By the 1660s the Dutch orders from Arita were very considerable, amounting to hundreds of thousands of pieces per year. At first, these orders had been only for blue-and-white, but by the late 1650s coloured wares had been included – the Imari wares, to be followed, later, by the so-called Kakiemon wares which are of much better quality and in much quieter taste. It is the Kakiemon wares that are referred to in eighteenth century French inventories as *première qualitée coloriée du Japon*.

It is usual in England, at least, to call the Japanese blue-and-white export wares 'Arita', and the coloured pieces 'Imari' (after the port near Arita through which they were shipped to Deshima) except for those pieces which on account of their design and quality are called 'Kakiemon'. This in no way represents the entire truth of their history, but will be used in this account for convenience.

While the early blue-and-white Arita export wares differed but in degree from Chinese originals, the Imari wares went a great deal further. Essentially a florid, overblown style, often reaching considerable achievements in vulgarity and over-decoration, it was, at its best, of great beauty and quality. Again, it relied first on Wan Li style, but rapidly formed styles of its own that were much imitated in Europe, and, indeed, eventually even by the Chinese – the so-called Chinese Imari. Of European essays in Imari style perhaps Meissen and Worcester made the best, though almost every other factory tried, while the best known in England may well be the nineteenth-century Mason's Ironstone and its competitors. Many standard patterns of English china wares in production today are based on Imari.

It was, however, Kakiemon that in the eighteenth century made the greatest impact. Although in 1659 Wagenaer, the Dutch agent in Deshima, had complained that the porcelain was 'too sparsely decorated' and asked for 'more flower-work', yet it seems that it was just this quality that was admired in the early eighteenth

The State bedroom at Nostell Priory, with japanned furniture by Thomas Chippendale (*see p. 125*) and Chinese wallpaper hung by Chippendale's men (*see p. 162*).

1. illus. **112** and **115**

84 left Kakiemon jar of the late 17th century: this shape, so-called 'Hampton Court vase', was copied well at Meissen and Worcester.

85 right Japanese Arita blue-and-white jar and cover, 17th century. The decoration is Chinese Transitional style via Dutch imitations.

century. Kakiemon is essentially a lightly decorated ware, where an asymmetrical pictorial pattern allows considerable areas of undecorated transparent glaze to show the beautiful consistency of the milky-white body underneath. The areas of translucent enamels are enclosed, though not totally, by a defining outline of black. Underglaze blue is not used on the best pieces. The paste is hard and very white, and the transparent glaze has very little blue in it (unlike

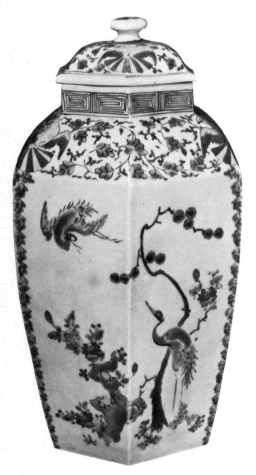

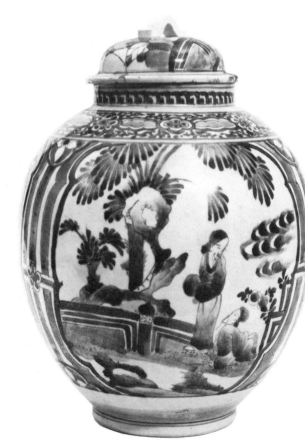

almost all other eastern transparent glazes). This is a refined and sophisticated style, but somewhat abbreviated and stylized[1], and therefore relatively easy for a westerner to copy. And it was this that was so brilliantly copied at Meissen.

Japanese modelled figures can be found itemized in both Dutch shipping lists and early inventories of European collections, and must have been collected keenly. In the Burghley House inventory of 1688 several are clearly recognizable; the figure of 'two China boys wrestling' is still in the house, and 'one Indian queen' is now in the British Museum, while the 'two staggs' were sold at Christies in 1959. These latter, or their twins, may have inspired the Meissen examples in the Residenzmuseum in Munich which were long thought to be Kakiemon. Imari figures of women are quite common in European collections, and these may

86 A 'Kendi' or gorgelet, a shape made for the Near-Eastern (Islamic) market. Chinese, 17th century.

87 centre Chinese Transitional style blue-and-white plate of the 17th century.

88 right Eighteenth-century Chinese salt-cellar, the shape taken from European silver.

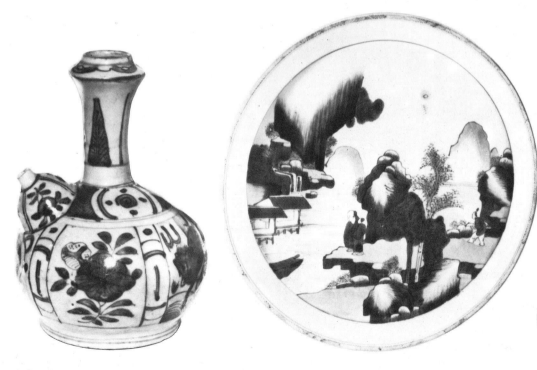

1. illus. 77

derive (or is it the other way round?) from the decorative knops of the enormous Imari vases that used to grace every great European country house. As figures very rapidly became set-pieces of almost every ceramic factory in Europe, it is tempting to suggest that the very idea of such figures is in some way derived from these oriental models.

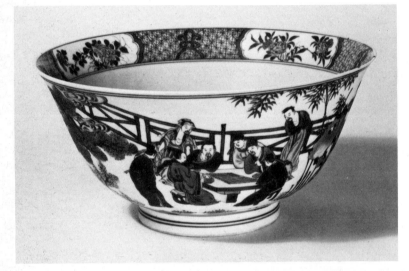

89 above Chinese (K'ang Hsi) blue-and-white bowl.

90 right *Famille rose* patchbox with European mounts – the shape made to order.

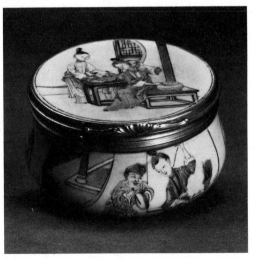

91 far right Porcelain mounted in German 18th-century ormolu to hold a clock. The elephant is 17th-century Japanese, the boys are 18th-century Chinese and the flowers are Meissen or Vincennes.

But the fashion for blue-and-white continued throughout the seventeenth and eighteenth centuries: the vases and dishes of Chinese or Japanese origin were mostly used for decorative purposes, and not for the table, where cheaper European wares would serve. Porcelain rooms housed the collections of magnates of all European countries (see Chapter 12) in a marvellous baroque display of brackets, shelves, niches, and racks. Pieces of furniture were provided with special brackets for display, such as a circular pad on the stretcher below a cabinet-on-stand, or the gap in a broken pediment on a tallboy or break-front bookcase, while the earlier gilt-wood or silvered-wood superstructures on lacquer cabinets were replaced with tasteful symmetrical arrays of blue-and-white vases.

The later seventeenth- and the eighteenth-century Chinese enamelled wares became very popular, too, in Europe. Coloured Transitional wares and then *famille verte* and the later *famille rose*, so named after the predominant or key colour in the palette of enamels, appeared in quantity. Often the *famille verte* pieces were enamelled on biscuit porcelain, that is on unglazed porcelain. These are usually figures, boats, horses and riders, lion-dogs, *pagods*, laughing boys etc., and they became a favourite subject for mounting in ormolu, particularly in France.

The habit of protecting and augmenting pieces of porcelain with ormolu mounts, already described for the fifteenth century, was much practised in eighteenth-century France. Pieces of porcelain were mounted, sometimes together and sometimes with lacquer, to form all sorts of more-or-less grotesque objects, and often with the addition of Vincennes porcelain flowers. A favourite object for mounting was the *famille verte* figure of *Pu-Tai*, the pagod. An early appearance in *blanc de Chine* had secured popularity for this really rather revolting figure of a semi-recumbent laughing old man. Imitations and adaptations, at Meissen, St Cloud and other factories were frequent and the *pagod*[1], in France at least, seemed somehow to become one of the symbols of chinoiserie, a typical denizen of the

1. illus. **112** and **115**

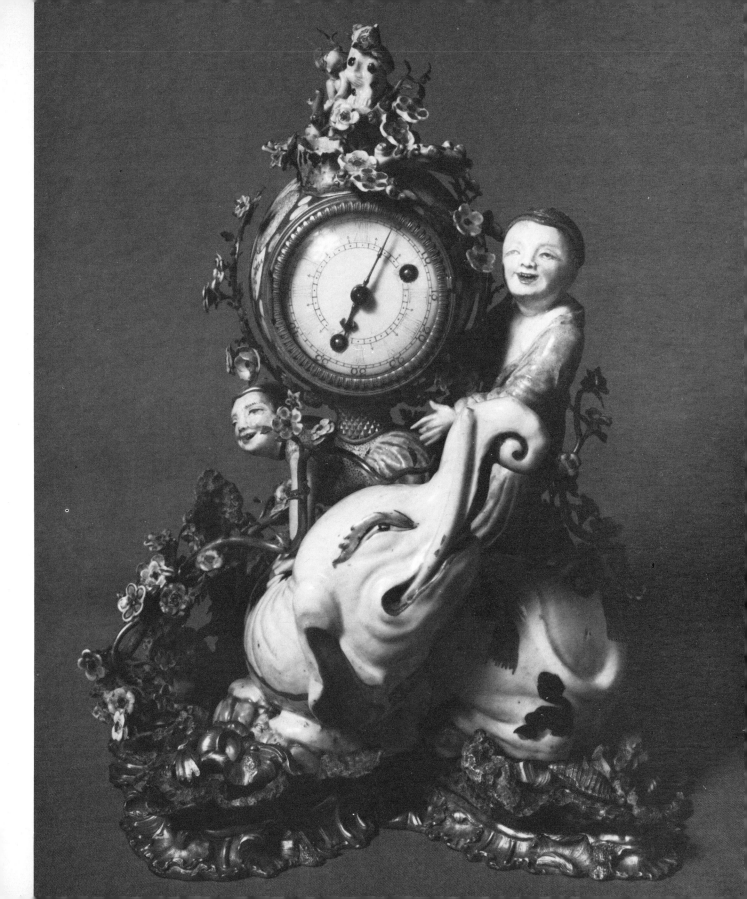

jungle of sages, monkeys (a curious, purely European element; see Chapter 6), young girls, fantastic birds, whimsical and obviously collapsing buildings and bridges, and upswept roof lines.

Chinese decoration of wares for export, besides conforming to European demands for useful shapes, was also often European in subject matter. Sometimes specific painting was done to order: the best examples of these are the armorial wares ordered by innumerable European families, at considerable expense. You sent your engraved book plate via the Company to Canton, and hoped the Chinese painters understood your directions for colours. Also, innumerable European engravings were copied: the 'Judgement of Paris', a riot in a Dutch town, the

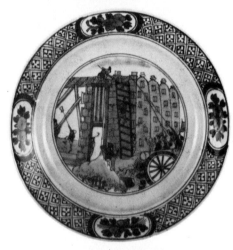

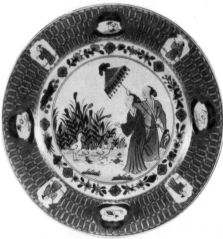

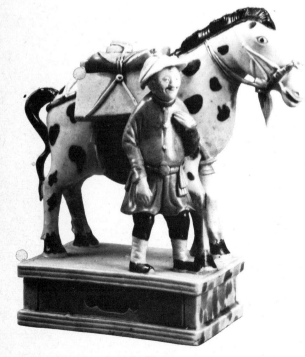

92 *Famille verte* biscuit figure, 18th century.

93 **above** Late 17th- century *famille verte* dish with the Arms of England (spelled here in the Dutch way).

94 **right** The Rotterdam riots copied from an engraving on a Chinese 18th-century blue-and-white dish.

95 **right** Chinese dish decorated with the design by Cornelis Pronck sent to China after 1734.

gate of the Botanic Garden of Oxford University, and so on. A particularly well documented example is the 'girl with the parasol' which was commissioned by the Dutch East India Company (v.o.c.) from Cornelis Pronck in 1734. The drawings for this still exist. One wonders whether the Chinese or Japanese porcelain painter, for this pattern occurs on both Chinese and Japanese porcelain, was aware that he was being instructed in 'Chinese' painting.

The European shapes demanded of the Chinese potters became more and more exotic, too. Some of the most peculiar are, perhaps, the imitations of the animal-shaped tureens made in faïence at Strasbourg: geese, tortoises, and even boars' heads, all accurately modelled and enamelled after their originals.

96 Tureen in the shape of a goose; Chinese, 18th century. Probably copied from a Strasbourg original.

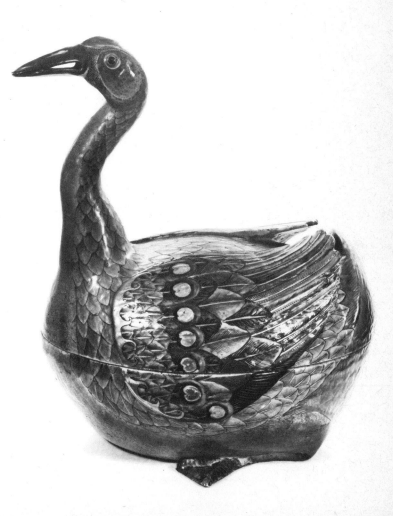

97 Chelsea 'red anchor' dish copying the Kakiemon design on illus. 77 (now called the Jabberwocky pattern) on a shape derived from silver.

Ceramics-Imitation

It is always necessary to distinguish a copy of another object from a pastiche of another object – a copy as opposed to an essay in another person's style. European 'copies' of eastern objects, particularly ceramics, are very rarely good enough for real confusion to arise over their eastern or western provenance. Nearly always the European 'copy' is readily recognizable. (I am not concerned here with the copying with intent to deceive – faking.) But it is of course from copying that comes the desire to use the style elsewhere. Nowhere is this more true than in ceramics.

As true porcelain could still not be made in Europe in the seventeenth century, it was useless to imitate it in faïence with intent if not actually to deceive, then at least to confuse. Only in Frankfurt were really close imitations made of Wan Li, Transitional, and Arita blue-and-white, though in Delft there were superbly Chinese-looking essays, especially by the Eenhorn family. When Meissen started making porcelain, true imitations were made (though usually marked with the Meissen mark), and some of these are the best examples of real copies that we have, but quite soon the factory was making porcelain decorated in Kakiemon style, rather than copying Kakiemon. And here we have the essence of chinoiserie: an oriental style, be it Chinese, Japanese, Indian, or anything else, being adapted to European needs and skills, and getting further and further away from its original style. However wild a Höchst modeller's ideas might be of the 'Emperor of China', at least his figures had to depend ultimately on a Chinese style of painting.

Apart from the short-lived production of Medici 'porcelain' made in small quantities (some fifty-nine known pieces survive to this day) for the Grand Dukes' own use or presentation, blue-and-white was not imitated in quantity before the Dutch Delft wares of the early 1600s. The Dutch already had, of course, factories making majolica-style wares, in techniques learned from Italy. Italian majolica is directly derived from Spanish and therefore Islamic

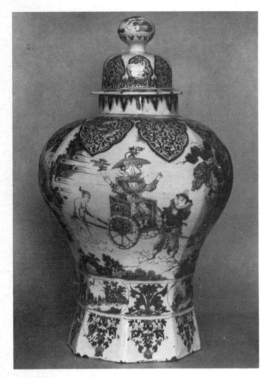

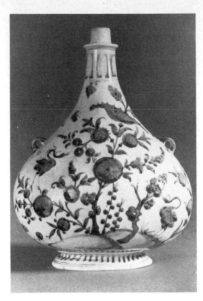

98 left Blue-and-white Delft jar by Samuel van Eenhoorn, 17th century.

99 above centre Medici porcelain pilgrim bottle *c.* 1565; Chinese style decoration, central asian shape. *See p. 104*

100 above right Fragment of an early 17th-century Delft dish imitating Wan Li export porcelain.

pieces are generally known. At first, motifs were copied fairly strictly (as far as a Northern Netherlands workman was able to copy the work of his counterpart in Ching-tê Chên), especially when it came to the border, which was usually in the standard Wan Li arrangement of alternating panels of rectangular and oval cartouches fitted with flowers, leaves, or 'precious objects'. In the well, or centre of a plate, the painter was in greater difficulty, and his depictions of Chinese figures, often almost

painted and lustred faïence – Hispano-Moresque. To look for Chinese motifs here would be off the point, but they do appear, though not usually until the 1530s. Instead one looks for the Byzantine and Sasanian influence, and it is very obvious, though less so in the developed *istoriata* wares. This itself is a sort of chinoiserie: an adaptation of a near-eastern style. Interestingly, Persian and Turkish (Isnik) pieces copying or partly copying Chinese blue-and-white porcelain are not uncommon from the beginning of the sixteenth century.

It was not until shortly after 1600 that any large scale attempt was made to imitate Chinese blue-and-white in Europe. Then several factories began to copy and adapt the designs on the *Kraak porselein* wares of the Wan Li period: the most famous of these factories were in Delft, and it is as Delft wares that these tin-glazed faïence

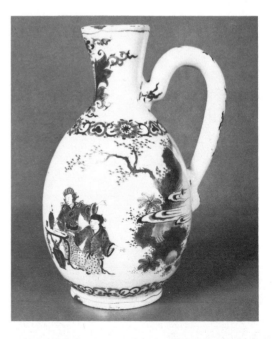

101 Delft polychrome jug by Hoppesteyn, 17th century. *See colour plate facing p. 92*

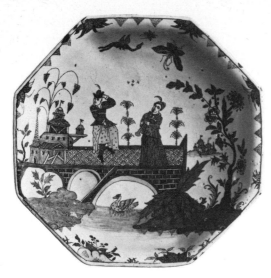

102 Rouen polychrome dish of the 17th century in chinoiserie style (not mannerist).

were made, as well as other types, and Hanau, where chinoiserie flourished. In France, Rouen and Nevers produced their better pieces of the seventeenth century mostly in a mannerist style that only sometimes permits chinoiseries to creep in. And in both Germany and France, innumerable small factories sprang up in the eighteenth century, producing some of the most charming of all European ceramics. Tin glaze has a particular soft, warm texture – like well-polished Georgian silver – and decorated with sophisticated or rustic chinoiseries or other

bent over double, are somewhat ludicrous, and can instantly be recognized as chinoiserie rather than Chinese: as adaptation rather than copy. Sometimes the painter used a European subject in the centre, surrounded by a Wan Li border, and of course there was no need to stick to Chinese shapes: any European shape that was in demand could legitimately be decorated in 'Chinese' style. As we have seen, Chinese porcelain was ordered in European shapes, and it seems more than probable that the wooden models sent to Ching-tê Chên in 1635 and to Japan in 1659 had been painted in Delft. So here we might have a vase, say, made in Japan, of porcelain, in a European shape and painted in blue-and-white with a pattern taken from a Dutch imitation of a Chinese original that itself may well have been influenced by a Dutch pastiche of an earlier Chinese motif. Small wonder that there is some confusion over styles!

Blue-and-white tin-glazed faïence, which is itself made in an extension of majolica techniques, was the standard ware of the seventeenth and much of the eighteenth centuries in most of Europe. Always cheaper than porcelain, it was never entirely supplanted by porcelain until the nineteenth century. In Holland, Delft was the centre of production, though Amsterdam and many other towns had factories. In Germany, the best seventeenth-century factories were those of Frankfurt, where remarkably faithful faïence 'copies' of Japanese porcelain

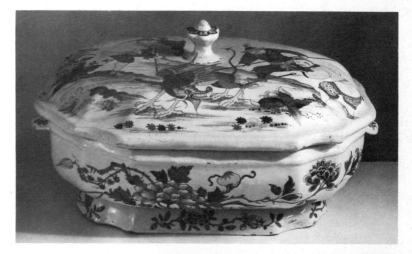

103 above French (Sincery) tureen, 18th century.

104 right Bristol (? or Lambeth) polychrome plate with *bianco-sopra-bianco* border, 17th century.

subjects, it has a direct and very strong appeal. There is a plate from a small Loire factory, dated 1805, decorated with a scene of *la vendange*, still owned by a Loire valley *viticulteur*, where the girl picking the grapes is clearly in 'Chinese' costume.

In Britain, too, there were many factories making blue-and-white and coloured faïence: Bristol, Lambeth, Liverpool, Southwark, and Dublin, to name only the largest. Here also a common demand for chinoiseries is apparent. Usually the painting is crude and simple, but sometimes, particularly at Liverpool and Bristol, the painters show considerable skill.

Attempts to imitate the body of porcelain with its properties of translucence, brilliance, and strength were numerous in Europe. Misleading accounts of Chinese production methods did not help, though several commentators had correctly given at least the main points before the end of the sixteenth century. Venice's attempts were based on glass, while the famous Medici 'porcelain'[1] produced after 1565 over a period of a few years only was a form of soft-paste quite unlike Chinese hard-paste. Curiously, little Medici porcelain attempts to imitate Chinese porcelain either in shape or in decoration — the best example that does is perhaps the bottle in the Louvre — but was attempting to imitate only the body and the blue-and-white palette.

Hard-paste porcelain was not made in Europe until 1709 when Johann Böttger, working for that colourful character Augustus the Strong, King of Poland and Elector of Saxony, at Dresden and later at Meissen, made a hard-paste translucent porcelain of very high quality. This production, first on sale in 1711, crowned years of effort by Walter von Tschirnhausen, to whom Böttger went (taken by force by Augustus) as assistant in 1707, after his, Böttger's, failure to find the philosopher's stone. Von Tschirnhausen died in 1708, leaving Böttger to perfect the paste, and to find the glaze.

Von Tschirnhausen and Böttger had already made a hard red unglazed stoneware, that could be polished on a jeweler's wheel. It was very like the red stoneware of Yi Hsing in central Eastern China, and although the shapes were based on faïence, glass, or silver, they were sometimes painted and gilded with chinoiseries. This Yi Hsing type stoneware was later imitated elsewhere, at Bayreuth, at Delft, in Staffordshire in England, and at Tokoname in Japan.

But it was true porcelain that Augustus wanted, and got: from almost its earliest days Meissen paste was of very fine quality and the enamels were of a clear translucent colour very similar to the Japanese model. At first the Meissen underglaze blue was not particularly successful. It may be because of that as much as for reasons of taste that the first productions of porcelain were made in imitation of Kakiemon (which never has underglaze blue on the best quality pieces: that is on those pieces with the milky-white body called by the Japanese *negoshide*).

Augustus formed perhaps the greatest of all collections of Japanese porcelain, mainly buying between 1715 and 1717, and the collection, which is carefully inventoried, contains large numbers of Kakiemon pieces, many of which were copied as accurately as was possible, so that the collection, now in the Zwinger in Dresden, sadly depleted though it is, still contains many Meissen pieces and their Japanese prototypes.

He also formed a large collection of Chinese ceramics, which were also imitated at Meissen. Stories of his collecting mania are almost incredible. On one occasion he acquired a set of twelve large Chinese blue-and-white vases in exchange for a regiment of dragoons.

There are several patterns on Kakiemon wares that are so well known as to be 'standard' patterns. Most of these were copied at Meissen and Chelsea, and some at the other English factories. Commonest is perhaps the 'quail and millet'; curiously, the Meissen copier decided one quail should be blue (unlike the Japanese original, where it is usually in shades of red and brown) and almost all European 'copies' have the nearer quail in blue enamel; often the millet

1. illus. **99**

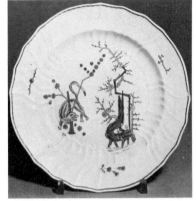

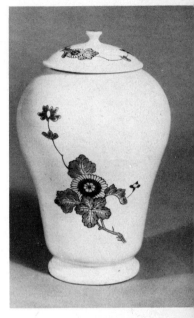

105 above Meissen bottle, early 18th century. An almost perfect copy of a Japanese (Kakiemon) original.

106 top Bow plate in Kakiemon style

107 centre Meissen plate in Kakiemon style

108 far right Chantilly jar with scattered Kakiemon-type designs

109 right Worcester vase in a Japanese shape (*see illus. 85*), the blue-scale ground imitating Meissen with the paintings in partly Chinese style.

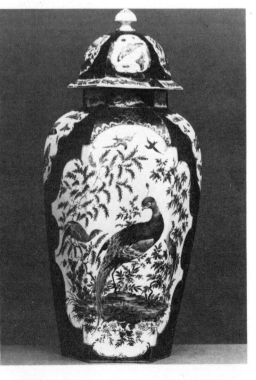

is omitted and instead we have the 'banded hedge' from the next commonest pattern, the 'tiger and banded hedge'. Usually the tiger is bounding through the air in a most improbable and rustic way and it should be remembered that the Japanese painter was as unfamiliar with tigers as was his Bow counterpart. These patterns and others were copied more-or-less faithfully at Meissen and Chelsea and less precisely at other factories, always with the laurel going to Bow, whose naïve and crude pictures have a particular appeal: Bow quails have been likened by Soame Jenyns to hedgehogs! And, of course, all these patterns could be changed or mixed to form the basis of many a chinoiserie design. In France, the Chantilly factory very rarely imitated a complete Kakiemon design. Usually the Kakiemon patterns are jumbled most charmingly together, often on shapes that are purely European.

Imari patterns were perhaps better imitated and used at Worcester than any other factory. Many Worcester pieces are of Japanese shape – such

110 right Worcester plate
– the 'Old Japan' pattern:
copied from the Japanese
in China, and at Chelsea,
Bow and Worcester.

111 far right Vienna
porcelain clock-case,
the red and gold deco-
ration in Chinese Imari
style (i.e. copying Chinese
copying Japanese).

112 An early Meissen
pagod. *See p. 93*

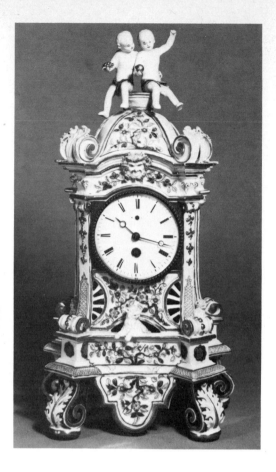

as the 'Hampton Court vase' shape – but
painted with wild chinoiseries or adaptations of
Imari patterns. Perhaps the idea was to show off
the splendid range of colours that Worcester
could make. The 'Old Japan' pattern was clearly
popular, for it was copied faithfully, but Imari
patterns are particularly prone to use and
extension elsewhere and are a major source for
nineteenth-century ceramic decoration in
Europe.

Soft-paste had been made in France before the
end of the seventeenth century at Rouen and at
St Cloud, and in England it was a form of soft-
paste that was made first at Chelsea, and then
at Derby, Longton Hall, Bow, Lowestoft, Wor-
cester, Caughley, and Liverpool. It was not until
1768 that hard-paste was independently re-
discovered by William Cookworthy (who had
studied the letters sent from China by Père
d'Entrecolles from 1712 to 1722 in which he
described the manufacture of porcelain) and
made at Plymouth, Bristol, and New Hall.

Soft-paste was first made in England in
Chelsea in the 1740s, and from the first,
Kakiemon patterns were used, though these
would as likely have been derived from Meissen
as from Japanese originals. The Chelsea imita-
tions are never as good as those of Meissen,
though always better than those of other English
factories.

Exact copies of oriental modelled figures are
not common; instead porcelain, and indeed
faïence models provide some of the best examples
of chinoiserie. No attempt at reality of dress or
physiognomy mars the frivolous charm of these
splendid Meissen, Höchst, Capodimonte, or
Vienna 'Emperors of China', these over-dressed
faïence figures from Lille, Nevers, and Rouen,
these under-dressed *pagods* from St Cloud, Chan-
tilly, and Meissen.

In Europe, porcelain modelling was perhaps
at its best at Meissen in the second quarter of
the eighteenth century, when J. J. Kändler and
Johann Kirchner produced models unrivalled for

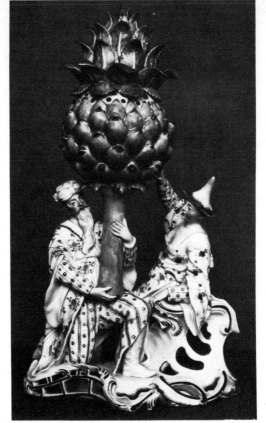

113 Frankenthal model of 'Turkish' and 'Chinese' figures supporting a West Indian pineapple.

skill and perfection, save only perhaps by the Nymphenburg models of Bustelli. Kändler's large animals for the *Japanisches Palais* were a very considerable technical achievement, and many of his smaller figures were copied elsewhere – even in China.

In Capodimonte[1] and in Buen Retiro figures were modelled, along with elaborate rococo scrollwork, to be mounted on a wall as wall decoration over an entire room. A logical extension, perhaps, of the *Porzellanzimmer*. To a lesser extent the Du Paquier figures inlaid into the walls and modelled on the chandeliers and wall brackets of the Dubskychen Palais in Vienna also make a *Porzellanzimmer*.

Japanese porcelain imported 'in the white', that is, undecorated, was often embellished by European enamellers, and even some Chinese blue-and-white can be found with European 'improvements', often in a quite incongruous style. The Dutch-decorated wares are the most common, and can easily be recognized not only by the drawing, but by the colours: particularly the rather violent red. One type is often distinguished as by 'the parrot painter' by the subject matter of many of the pieces, but the practice was common, and crude pieces are more usual than fine ones. In England, also, oriental white porcelain was enamelled, much of it in the workshop of James Giles, the celebrated decorator, where it was sometimes given the red anchor mark of Chelsea.

The unpainted white-wares of South China, from Fukien, called in China Te Hua and in Europe *blanc de Chine*, were also imported from the seventeenth century and sometimes decorated in Europe, where it was usually given Kakiemon-style enamels! Characteristically *blanc de Chine* of this period has a slightly grey-white body, with some of the appearance of white glass, and lacks the blue tinge of most oriental porcelain. It is usually thickly potted or moulded. Quite common are the figures, which have an attractive naïve quality, of 'Long Eliza' (*Kuan-yin*), Pu-Tai and other figures, sometimes ultimately of European origin ('Admiral Duff').

114 below St Cloud teapot in fairly close imitation of a *blanc de Chine* original, mid-18th century.

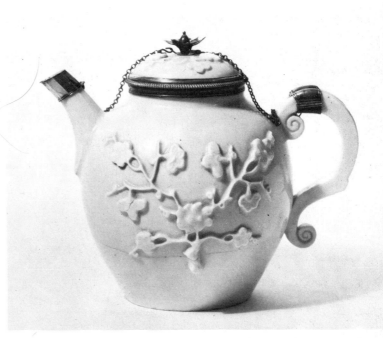

1. illus. 193

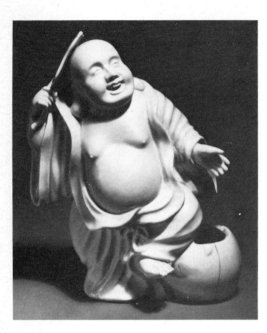

115 A Chantilly pagod of the mid-18th century

116 below Venetian (Cozzi) cup and saucer after the Imari manner (this style was much favoured in Ironstone in the 19th century).

by a Chinese or Japanese. Into this category fall most blue-and-white Delft wares (of all countries), much nineteenth-century English blue-and-white such as 'willow-pattern', most imitations of the non-geometric types of Imari, and the inspired nonsense of many porcelain painters and *haus-malers*.

2. The use of occasional motifs taken directly or indirectly from an oriental style and used appropriately or inappropriately on another object, perhaps in conjunction with non-oriental styles. The most frequently robbed designs are perhaps those on Kakiemon porcelain. The great coloured-ground *garnitures de cheminées* with reserved panels, of Meissen, or the smaller Chantilly pieces are perhaps the best examples.

3. The use of chinoiserie figures in a grotesque-style framework (see Chapter 6). In Augsburg these would be in gold or silver only, while in Meissen they would be in coloured enamels.

Many of the larger figures were originally lacquered (not enamelled), and some especially large ones had detached heads arranged so that the head could nod, suspended on an axle through the neck, and with a counterbalance within the hollow body. Better known, perhaps, are the tablewares with applied moulding of prunus branches and so forth. These were much imitated in French soft-paste, in early Böttger Meissen and at Doccia and Bow. On some of the European *blanc de Chine* the flowers have become entirely European, and one may perhaps blame this charming ware for inspiring some of the flower-covered ceramic horrors of later Meissen, though this is perhaps too far-fetched.

Apart from modelled figures, then, chinoiseries on ceramics fall into three main groups:

1. The chinoiserie landscape, with or without figures, or flowerscape, which, while obviously based ultimately on Chinese or Japanese porcelain decoration, is unquestionably of European workmanship and would not be recognized as oriental

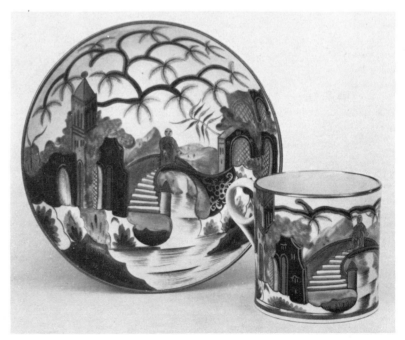

117 below Meissen tankard in the style of Löwenfinck.

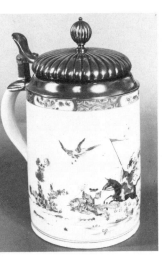

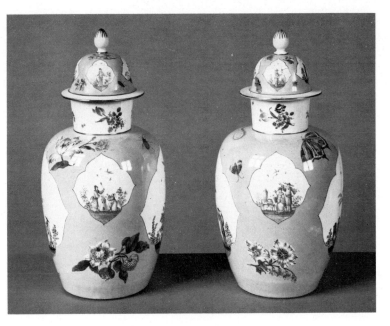

118 Meissen vases with chinoiserie scenes reserved on a coloured ground.

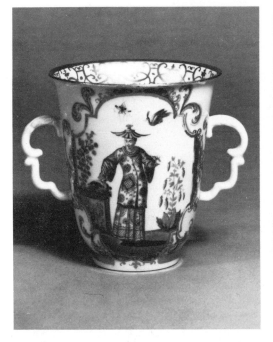

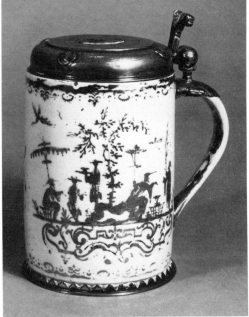

The grotesque style:
119 far left Meissen cup in polychrome enamel.
120 left Meissen tankard decorated in Augsburg in silhouette gold.

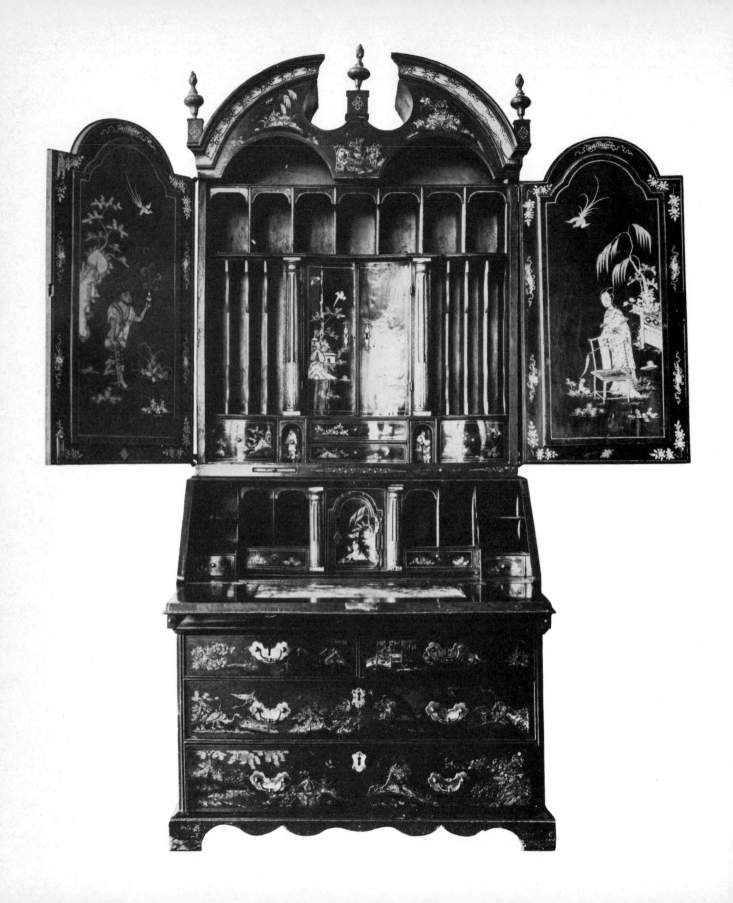

Chapter Nine

Furniture, Lacquer and Japan

Exotic wood had been imported to Europe from the East since classical antiquity, partly for use as good timber, but also for burning as incense and even for the flavouring of cooked dishes. In the sixteenth century, with direct shipping trade, not only wood, but also furniture was imported. Among the earliest of mentions of such furniture is the 'bedstead of Cambay wrought with gold and mother-o-pearl' given by the King of Milinde (east coast of Africa) to Vasco da Gama in 1502. Much of this was ebony, and it was often carved in low relief, or inlaid with mother of pearl or ivory. *'In India'*, wrote Linschoten (English edition 1598) *'they make divers things of them* [mother of pearl], *as deskes, tables, cubbards, . . . boxes, staves for women to bear in their hands . . . very fair to behold and very workmanlike made.'* Ebony furniture was also made in Batavia, in Ceylon and in Goa and some was exported to Europe, where it was even copied, especially in Portugal. The import of ebony furniture inlaid with mother of pearl and ivory did much to stimulate the increased use of furniture in the northern European nations. In France furniture makers are still called *ébénistes*.

Although furniture was imported into Europe, off and on, throughout the eighteenth and nineteenth centuries, in ebony, padouk, teak and even ivory, it never had the profound effect on European taste that was made by lacquer.

Lacquer furniture was imported to Europe from Japan from the late sixteenth century. Indeed, in the Momoyama period (1573–1614) in Japan, lacquer became one of the standard export trade goods for Europe. Many pieces of Japanese lacquer of this period survive all over Europe. Mostly they are pieces of furniture: small cabinets or chests of drawers and cupboards and coffers with domed lids.

These cabinets, containing short drawers and sometimes cupboards, usually enclosed by a down-folding door (such as was used on scriptors) bear no relation to any native Japanese shape: clearly they are based on imported Portuguese or Spanish furniture of the type now called a *vargueño*. This shape may have origi-

nated, itself, in Italy or Nuremburg in the early sixteenth century. As well as in Japan, they were copied on Portuguese and Spanish orders, in China, India and Mexico.

The domed coffer also was a European shape, and it came in several sizes: in Copenhagen there is even a set that fit one inside the other like Russian boxes. Often these coffers, like the cabinets, would be raised on European stands: a particularly splendid pair, on George I giltwood stands, is at Corsham Court, Wiltshire.

An early European reference to Japanese cabinets is a letter from Father Luis Frois of 1569 commenting on the European goods owned by Oda Nobunaga, at that time on his way towards becoming military dictator of Japan (Shōgun). Nobunaga had '. . . *Cordova leather skins, hourglasses and sundials, candlesticks and tapers . . . the finest glassware . . . and many other different kinds of things which I do not remember. All this in such abundance that he has twelve or fifteen chests, like those of Portugal, fitted with these things . . .'* These, then, may well have been early Japanese copies of Portuguese furniture – at least in shape. As for the decoration, mother of pearl had been used in the Far East for centuries, but the style often found on these early European-type pieces looks as though it is at least partly derived from near eastern or Indian (Gujarat) inlaid furniture. The mother of pearl inlays are generally in a pattern, or sometimes as pictures, in a dark brown or black base lacquer, and with gold overpainting. Sometimes the overpainting is raised in low relief: there may also be borders of small broken pieces of shell.

Of course the quality of these pieces vary: in the Dagh Registers of the Dutch East India Company (v.o.c.) the qualities are listed as extraordinarily beautiful, beautiful, of a quality in accordance with the expenditure, or poor. The contents of the *Clove* (see Chapter 3) when auctioned by the East India Company in London in 1614 included two 'small trunckes or chests[1] of Japan stuff guilded and set with mother of pearle' which fetched £4 5s and £5 and 'a small cabanet with drawers guilded and inlaid and

121 Early 18th-century English japanned bureau-cabinet.

sett with mother of pearle' at £6 15s. In 1618 cabinets were fetching £17 each, but perhaps these were of the better quality.

But 'cabanets' and chests were not the only lacquers imported into Europe. John Saris, Captain of the *Clove*, had written on June 1614 that his cargo included 'Some Japan wares, as ritch Scritoires: Trunckes, Beoubes (*byōbu*, Japanese word for screen), Cupps and Dishes of all sortes, and of a most excellent varnish, I have in the ship'. The Society of Jesus commissioned various wares including boxes and bible-rests bearing the Jesuit insignia which, in view of the persecution of the Christians, would probably have been made before 1614. The Dagh Registers include numerous other shapes including dishes, plates, inkpots, palanquins, shaving-basins, chairs, tables, backgammon boards, and lanterns with shades, and in 1617 Will Adams wrote to the British Factor in Hirado, Richard Wickham:
'I have sent by this bearer seventeen sundry parcels of contores [chests on stands] *and scrittores* [scriptors, writing desks] *marked R.W. . . . I have been at Meaco* [i.e. Kyoto, where the best lacquer is made even today] *and talked with the makeman* [the *maki-e* man, or lacquer-maker] *who hath*

promised that in short time he will have done. He hath fifty men that worketh day and night; that, so far as I see, he doth his endeavour. Your candlesticks when I was in Meaco were not done, but promised me in two or three days after to send them.'

Wickham's lacquer may possibly have not been the inlaid mother of pearl type, but the new pictorial lacquer that was to become so popular in Europe and was to be so much imitated. This type is painted with scenes, flowers, or birds etc. on a dark background, in coloured lacquers and often with powdered gold or cut gold leaf, and often raised in very low relief. The commonest piece of furniture to bear this style was that derived from the scriptor, the cabinet with two doors enclosing numerous small drawers and sometimes a small central cupboard. Typically the outside of the doors was covered with an all-over scene, the sides and the top being plainer, while the inside of the doors each had a scene, or pattern of flowers, usually much simpler than the outside, and the fronts of the drawers were also simply decorated.

These are the cabinets that were, throughout Europe, placed on stands of varying complica-

122 Japanese lacquer box, *c*. 1640, made for Maria van Diemen, wife of the Governor of the Dutch East Indies.

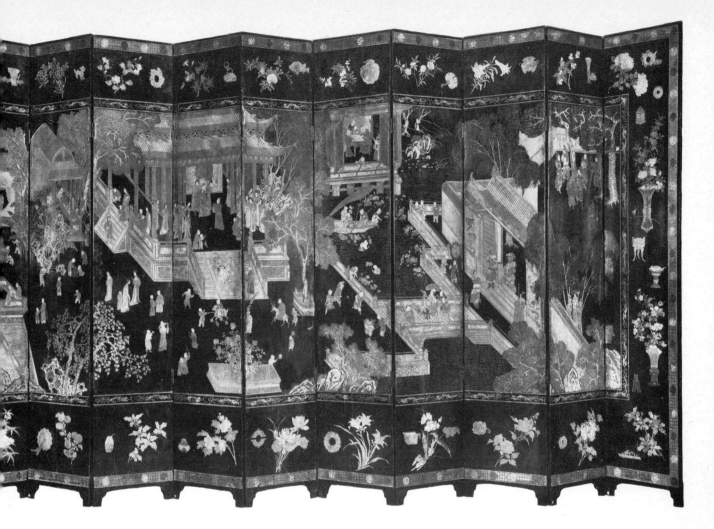

123 Chinese Coromandel lacquer screen of the early 18th century.

tion of decoration, and can be seen still in considerable numbers, scattered through the great houses of Europe. Sometimes, as in Holland and in England, particularly after the 1670s, the stands were elaborately carved in giltwood and may have had equally elaborate crestings attached. Later, Daniel Defoe complained: *'Queen Mary introduced the custom . . . of furnishing houses with Chinaware , piling the China upon the Tops of Cabinets, scritoires, and every Chymney Piece . . .'*

Certainly this style[1], which commences in perhaps the second decade of the seventeenth century, after a lull in fashion in mid-century (perhaps 1630–70), became highly fashionable again at the end of the century and into the eighteenth century. In 1672 the East India Company sent some joiners to the East so that

the frames of the cabinets could be made to order and in 1684 even sent some actual pieces in ballast to Amoy and Canton, to be lacquered. (By this time both the Chinese and the Japanese were making cabinets, etc. for export, and they are often so similar in style as to be difficult to distinguish.)

A third type of lacquer had meanwhile appeared. This is Coromandel lacquer[2], presumably so called because it was shipped from China via the Coromandel coast. Here the designs are cut out shallowly into a dark-lacquered background. The designs themselves are very brightly coloured. This type of lacquer was almost always imported as screens, usually of twelve folds, with a continuous scene on one side, surrounded by a framework of designs, and many different scenes or designs on the reverse. As the screens are

1. plate facing p. 44

2. p. 117

made of fairly thick planks, each plank could be split and both sides used for decoration.

But all these lacquers were expensive and so must be copied. If lacquer could not be copied exactly, an imitation would have to do – 'japan' bears the same relation to lacquer that tin-glazed earthenware does to porcelain.

Just as China lent its name to ceramics, so Japan gave its name to the European attempts at imitating lacquer. Lacquer is made from the resin obtained from a sumach tree, *Rhus vernicifera*, which grows in east Asia only. It is difficult to work, requiring many thin coats, each of which must be rubbed down before the application of the next. It is also somewhat toxic and has serious effects on the health of those who work in it. Various attempts were made to use true lacquer imported from the East, but never followed up, chiefly because of ignorance of its composition. Indian lacquer is not true lacquer, but is japan in that both Indian and European 'lacquers' were made of the same substance, imported into Europe from India as gum-lac or shell-lac. European (and Indian) lacquers are therefore really a form of opaque varnish, also applied in layers. No European 'japan' has either the strength or beauty of Japanese *maki-e* (which is, on export wares, usually better than the Chinese).

Lacquer and japan are both usually applied to a carcass of wood, which has to be very carefully and smoothly prepared. It is sometimes claimed that japanning was occasionally done on veneered furniture, because oak carcasses were too rough to take japan. I do not believe this to be the case: Stalker and Parker in 1688 gave precise instructions for preparing oak grounds. Most if not all veneered japanned pieces prove, on close examination, to be japanned at a much later date (frequently in the 1920s and 1930s). In the eighteenth century japanning was also done on leather, *papier mâché*, stoneware (e.g. Böttger's Meissen) and metal.

In this account of lacquer and japan, I shall use the former word only for Chinese and Japanese lacquer-work, and the word japan for

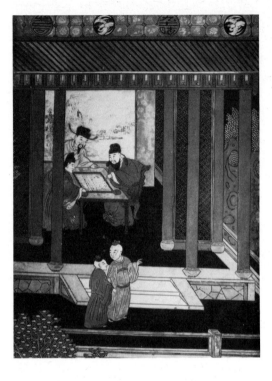

124 Detail of a Coromandel screen. Sir William Chambers's comments on the architecture are on pp. 143–4.

its European imitations unless quoting from some original source. In the seventeenth and eighteenth centuries the word Japan was used both for oriental lacquer and its European imitations.

Various sorts of varnishes had been applied to wood since the sixteenth century with varying effects. The substance usually used was the gum deposited on trees by an insect, *Coccus lacca*, in the various forms of gumlac or shell-lac dissolved in spirits of wine. But there were as many recipes as there were practitioners, some more effective than others. In the mid-sixteenth century Venice had been attempting to imitate Islamic lacquer, and by the end of the century there is at least one documented piece that is not only in a form of japanning, but decorated with chinoiseries. This is a table-top from the *Kunstkammer* at Ambras, once in the possession of Ferdinand II of Tyrol, and listed in an inventory of 1596.

125 Japanned table-top probably from Venice. Before 1596. Formerly at Schloss Ambras. The deer are very similar to those on *Kraak porselein*.

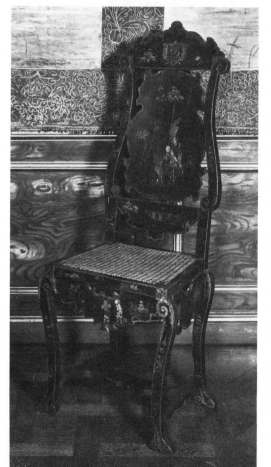

126 **right** A 'black stole with cane bottom, japanned' from Ham House. English, before 1683.

In 1609 William Kick was making japanned ware in Holland 'after the fashion of China'. In 1612 the States General presented a genuine eastern chest, and one made to match it by Kick, to Sultan Ahmed Khan of Turkey. Lacquer was also imitated at Nuremberg, Augsburg, and Hamburg at this time, but neither Kick's nor the German japan can be identified today.

In fact there appears now to be a considerable gap in the history of chinoiserie lacquer. It has recently been shown that the lacquer room at Rosenborg[1] in Denmark is late seventeenth century and should not be dated 1616 as it had erroneously been, and it is difficult to see much chinoiserie in the famous Saddlers' Company ballot box (dated 1619).

Perhaps there really was very little japanning until the 1660s, when it is recorded that Venice was exporting japanned wares. An entry in the *Journal du Garde Meuble* of the French Crown for 12 February 1666 states that 'le sieur Perignon livra un cabinet noir, façon de la Chine, garni d'argent et deux gueridons assortissants, destines pour Versailles'. Whether this is japan or lacquer hinges on how accurate the description 'façon de la Chine' is – should it just be 'de la Chine'? In 1667 the *Manufacture Royales des Meubles de la Couronne* was established at Les Gobelins by Charles Le Brun, and in 1672 the *Ouvrages de la Chine* was begun there.

Charles II of England ordered from Gerreit Jensen, in 1680, for presentation to the Emperor of Morocco, a 'cabinet and frame table-stands and glass all of Japan worke'. In 1683 Jensen was employed at Chatsworth, and paid £41 for wainscoting of 'hollow burnt Japan' (i.e. Coromandel lacquer): 'framing, moulding and cutting of the Japan, and joyning it with panels'. This common practice will be described in Chapter 12. In the same year an inventory of the property of Elizabeth Dysart, Duchess of Lauderdale described 'twelve black stoles (chairs) with cane bottoms, japanned' which are still at Ham House, Surrey.

Japanning was not only fashionable, it became an occupation for young ladies – a hobby. In

1. illus. **194**

127 Designs for 'a 12 Inch Frame for a Looking Glass for Jappan Worke' from Stalker and Parker's *Treatise* published in 1688.

1688 Stalker and Parker published *A Treatise of Japanning and Varnishing*, giving numbers of recipes and instructions for their use, and at the same time some splendidly naïve engravings of chinoiseries suitable to be placed upon the objects to be decorated. In 1689 Edmund Verney wrote to his daughter at school: *'I find you have a desire to learn Jappan, as you call it, and I approve it.'* Such amateurs did not work only on small boxes and so on: the Countess of Bristol in her will (1741) left to her son Lord Hervey 'my cabinet, chest, large screen and small screen being white japan of my own work in confidence that he will preserve them for my sake'. Books such as *The Ladies Amusement or Whole Art of Japanning Made Easy* of 1760 provided better drawn designs to be copied and assured Ladies that although they should be careful about European scenes, 'with Indian or Chinese greater liberties may be taken . . . for in these is often seen a Butterfly supporting an Elephant or things equally absurd: yet from their gay Colouring and easy Disposition they seldom fail to please'.

At the end of the seventeenth century England, Holland and the town of Spa in Belgium were the centres of the japanning industries. But in 1686 Gerard Dagly who had been born in Spa went to work for the Elector Frederick William II of Brandenburg in Berlin. On the Elector's death his successor Elector Frederick III (after 1701, King Frederick I) gave him the retainer of 'lodging, one pot of wine, four pots of beer, two loaves of bread, daily, fodder for two horses, wood and coal' as well as all the raw materials he needed, and 1000 ecus a year. He was an aggressive and energetic man and soon was in charge of all the royal decorations. An engraving of 1696 shows the four great cabinets he made for the Cabinet of Curiosities *in situ*: at least one of these cabinets still exists. In 1694 Christoph Pitzler described a room in the Schloss Oranienburg with blue-and-white japanned cabinets by Dagly. Dagly made harpsichord cases for the Berlin firm of Rost and Michael Miethke, specializing in white backgrounds, and also numerous other japanned articles – even buttons.

In England, in 1701 the japanners of London appealed against the number of imports of lacquer, claiming that it was driving them out of business, and in 1702 the duty was duly increased – but at the same time many japanners were exporting japanned wares to Spain and Portugal.

An idea of the quantity of lacquer imported at this time is given by the contents of the *Fleet Frigate*, which left Canton in February 1702 with a cargo that included thirteen chests of lacquered ware, fourteen small 'scrivetories' and seventy chests of screens (probably Coromandel).

Japanning began in America in about 1700. Some of the best pieces were done by Thomas Johnson, working in Boston, who clearly japanned for many different cabinet-makers (as did the japanners in France). A famous tallboy[1] probably japanned by Johnson has the name Pimm (John Pimm of Boston) scrawled on the back – probably to identify it in the japanner's workshop. Fashions varied in different towns: for instance English japanned longcase clocks were fashionable in Boston, while in Philadelphia locally

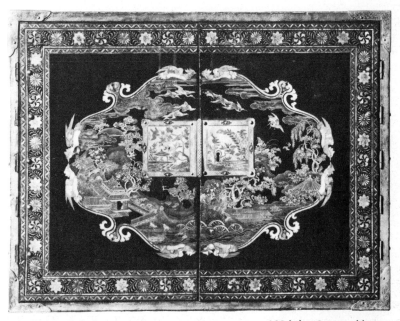

128 above Detail of a cabinet by Gerard Dagly, japanned and inlaid with mother of pearl.

129 below Japanned harpsicord. German, early 18th century – compare with the lacquer in the lower colour plate facing p. 44.

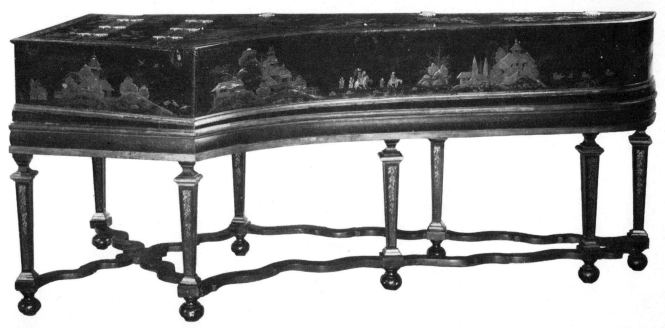

1. plate facing p. 140

japanned ones were preferred. Centres of japanning were Hartford, Connecticut, Newport, Rhode Island, and New York. The '*lacca povera*' technique of using paper cut-outs as a basis for japanned designs became a genteel occupation for ladies all along the East Coast.

In 1710 Martin Schnell left Dagly's workshop to work in Dresden: between 1712 and 1716 he was paid a salary by the Meissen factory for 'lacquering' and decorating the red stoneware. Dagly's workshop closed in 1713, and Gerard Dagly retired – Jacques Dagly, the younger brother, went to Les Gobelins and took Claude III Audran as partner: they seem to have employed Antoine Watteau as a painter of carriage doors.

Around 1730 there seems to be another change in style in the use of lacquer and japan: instead of it forming the furniture – being essential to it and generally controlling its shape – lacquer (in particular) comes to be treated as a veneer or an inlay, as a decorative effect to be used on any piece of furniture. To do this lacquers were ruthlessly cut up and often bent into shape on *bombé* or serpentine fronts of *commodes, encoignures*, or *bureaux à dos de l'âne* – this style began in France. Many of the great cabinet makers of the rococo style – roughly the reign of Louis XV – and of the neo-classical style – approximately the reign of Louis XVI and a little later – used lacquers that were often removed from older and unfashionable pieces.

The Martin family were the best imitators of lacquer in France: in 1744 they took out a patent for japanning 'en relief dans le goût du Japon et de la Chine' and in 1753 another, on a

130 above Meissen black stoneware bottle by Böttger, with japanning by Martin Schnell.

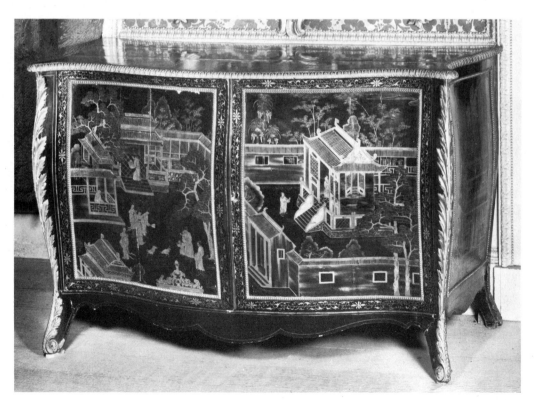

131 English commode *c.* 1770 using panels of Chinese pictorial lacquer bent to fit the serpentine and *bombé* shape.

new type of lacquer – perhaps the basis of the famous *vernis Martin*. This, at its best, is extremely difficult to tell from Japanese lacquer, and at the time was just as highly considered. The Martin family worked for Queen Marie Leczinska at Versailles and also for Mme de Pompadour at Bellevue. In 1747 one of the Martin brothers, Jean Alexandre, went to Berlin to work for Frederick II and in 1753 he decorated the 'flower' room at Sans Souci in natural colours on a yellow ground. (By now lacquer rooms were very fashionable, see Chapter 12).

One of the specialities of the Martins was repairing and refurbishing lacquer. They actually scraped off some surfaces, replacing them with a different colour, added decorative items where they felt the need, and patched holes etc. with japan. What a problem for the modern cataloguer!

In England, japan was also repaired, though not usually so drastically. In 1759 Lord Irwin of Temple Newsam was charged £8 for 'Cleaning and repaireing two Japan Cabinets Inlaid with pearl Cleaning the Copper work and repaireing the pearl', by Robt. Nash, and 5 guineas for 'Cleaning and Repairing and new Drawing an

132 left Writing-table made by Weisweiler for Marie Antoinette at St Cloud in 1784 using panels of Japanese lacquer.

133 above *Encoignure* by Criaerd with a panel of *vernis Martin* forming the door. The painting is in a style partly derived from chinoiserie.

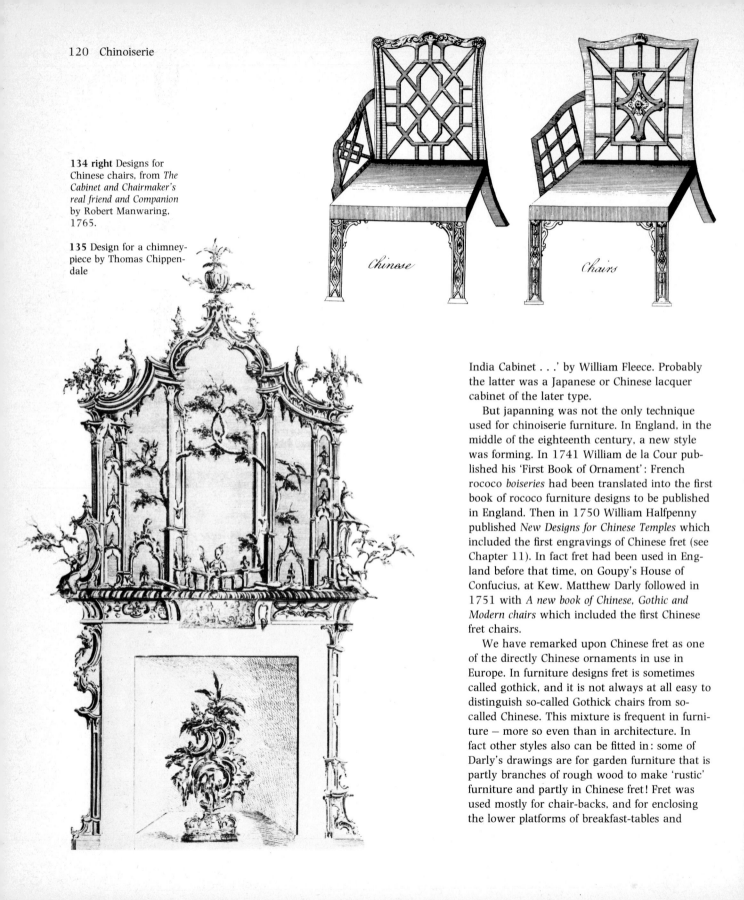

134 right Designs for Chinese chairs, from *The Cabinet and Chairmaker's real friend and Companion* by Robert Manwaring, 1765.

135 Design for a chimney-piece by Thomas Chippendale

Chinese Chairs

India Cabinet . . .' by William Fleece. Probably the latter was a Japanese or Chinese lacquer cabinet of the later type.

But japanning was not the only technique used for chinoiserie furniture. In England, in the middle of the eighteenth century, a new style was forming. In 1741 William de la Cour published his 'First Book of Ornament': French rococo *boiseries* had been translated into the first book of rococo furniture designs to be published in England. Then in 1750 William Halfpenny published *New Designs for Chinese Temples* which included the first engravings of Chinese fret (see Chapter 11). In fact fret had been used in England before that time, on Goupy's House of Confucius, at Kew. Matthew Darly followed in 1751 with *A new book of Chinese, Gothic and Modern chairs* which included the first Chinese fret chairs.

We have remarked upon Chinese fret as one of the directly Chinese ornaments in use in Europe. In furniture designs fret is sometimes called gothick, and it is not always at all easy to distinguish so-called Gothick chairs from so-called Chinese. This mixture is frequent in furniture — more so even than in architecture. In fact other styles also can be fitted in: some of Darly's drawings are for garden furniture that is partly branches of rough wood to make 'rustic' furniture and partly in Chinese fret! Fret was used mostly for chair-backs, and for enclosing the lower platforms of breakfast-tables and

whatnots. It was also used as blind-fret, that is applied to the solid surface, on cabinets, book-cases and so on. Most elaborate of all are the splendid pagoda-roofed 'China-cases' of Chippen-dale and of Ince and Mayhew, which usually have both open fret and blind fret, either japanned or painted.

Lock and Copland's *New Book of Ornaments* of 1752 included the first so-called 'carver's pieces' in chinoiserie style – these are of carved soft-wood, to be gesso-ed and gilded or painted and are usually for attachment to the wall – console tables, mirrors, girandoles etc.

Both these styles are best known today in the work and publications of Thomas Chippendale. It should be emphasized that Chippendale was neither the originator of these or of the many other styles in which he worked, nor was he necessarily the best practitioner – he was a fashionable cabinet-maker and decorator among several other competitors of equal standing. But in 1754 he published the first edition of his celebrated *The Gentleman and Cabinet-maker's*

136 left Design for a candle stand by Thomas Chippendale

137 right Design for a girandole by Thomas Johnson

138 below Designs for Chinese chairs by Thomas Chippendale

Chinese Chairs

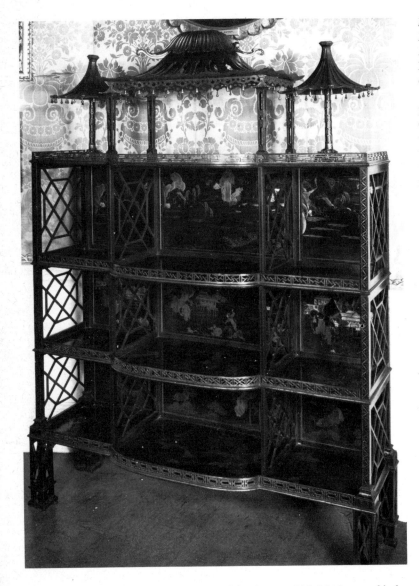

139 above English cabinet using three styles of chinoiserie – japanning with chinoiserie scenes, Chinese fret, and pagoda cresting.

140 right Japanned bed supplied to the Duke of Beaufort by William and John Linnell before 1754

Director: Being a large Collection of the Most Elegant and Useful Designs of Household Furniture, In the Most Fashionable Taste. Matthias Lock and Matthew Darly drew some of the plates, but others are by Chippendale himself.

It is the third edition of the 'Director', finally published in 1764, that is the best source of Chippendale's designs, but the differences between the first and third editions tell us something of the changes in taste of the time. Between these dates, Chinese-taste chairs etc. remained just as fashionable, but the third edition included much more 'carver's work' designs. This was because of Chippendale's rival, Thomas Johnson (not to be confused with his American namesake the 'Japaner at the Golden Lyon in Ann Street, Near the Town Dock, Boston') whose superbly eccentric rococo chinoiseries were published over the years 1756–8, issued in monthly parts at 1s 6d each, plus 1s 6d downpayment upon first subscription.

'Carvers' chinoiserie were partly based on French boiseries, and some were influenced by, if not actually plagiarized from the work of Cuvilliés, Pineau and Hoppenhaupt. But carved, and usually gilt, wood chinoiseries became one of the great successes of English furniture making.

In the 1750s and 60s, japanning seems to have been less fashionable, as Robert Dossie wrote in *The Handmaid to the Arts* of 1758, japanning 'is not at present practised so frequently on chairs, tables, and other furniture of houses, except for tea waiters, as formerly'. Even so, Chippendale maintained a japanning service, for in 1755 the Sun Assurance Company included on its plan of Chippendale's workshop a 'Drying-room with stone floor for charcoals, containing a japanning stove and German stove'. In 1754 Dr R. Pococke writes that the Chinese bedroom at Badminton is 'finished and furnished very elegantly in the Chinese manner'. This suite of furniture, with its superb pagoda-roofed bed, now in the Victoria and Albert Museum, was long attributed to Thomas Chippendale. It has recently been proved by Helena Hayward that the suite was supplied by William and John Linnell, from drawings by

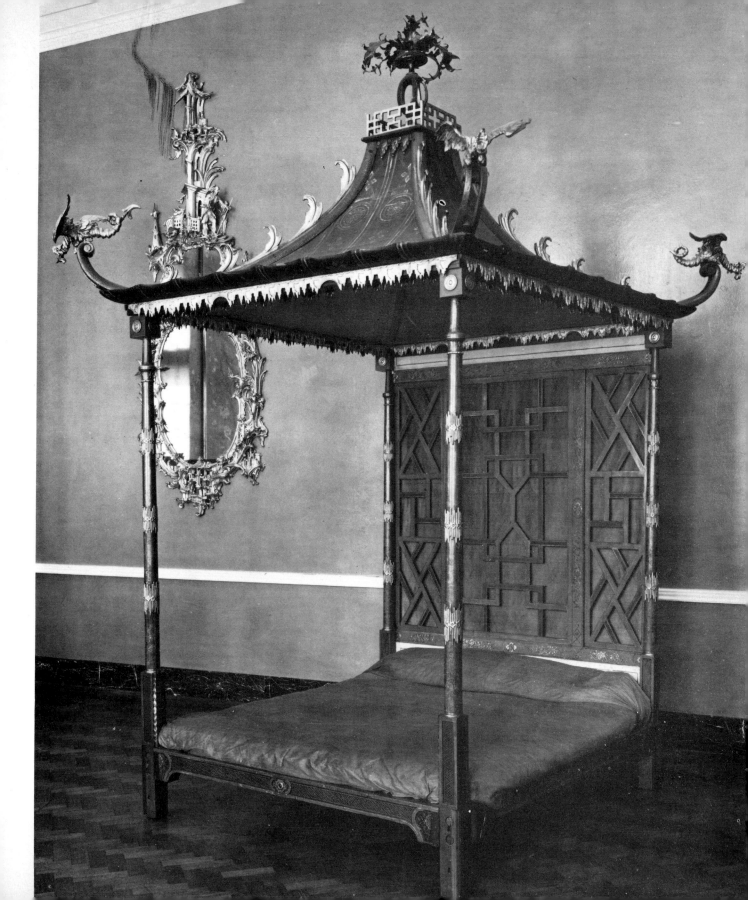

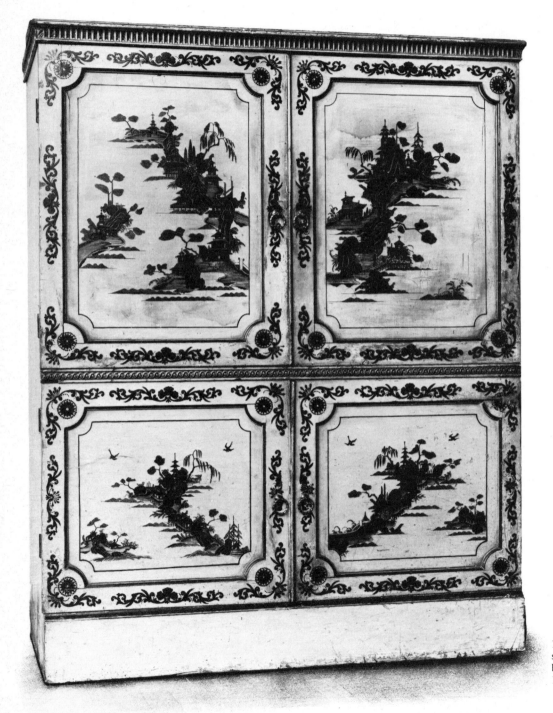

141 Japanned wardrobe supplied to David Garrick by Thomas Chippendale in 1770

John Linnell, shortly before Dr Pococke saw it.

Often, japanned articles were very insignificant: in 1752 or 53 Vile and Cobb charged Anthony Chute of The Vyne 3s 0d 'for a japanned hearth broom'.

Oriental lacquer must have retained some popularity for Horace Walpole gave some panels to Pierre Langlois to make into commodes. They were not finished on 12 March 1766. Making up oriental lacquer into pieces of furniture was almost as common in England as in France. On 12 November 1773 Chippendale charged Edwin Lascelles of Harewood House £30 for 'A large Commode with folding Doors veneer'd with your own Japann with additions Japann'd to match with a dressing Drawers and five locks'.

But in the late 1760s japanning came back into fashion, often associated with the new vogue for the neo-classical that was coming over from France. On 14 October 1767 Chippendale charged Sir Edward Knatchbull £26 'To large Dome Bedstead with Mahogany feet Posts a sacking bottom and Castors and very rich Carv'd Cornices and Vases Iappan'd Blue and White'. In 1772 Chippendale supplied David Garrick, the actor with '12 very neat carv'd Cabreole arm'd Chairs, Japan'd Green & White . . .' at £48. '2 ditto Burjairs [bergeres] . . .' at £10 and a 'large Carv'd Sofa to Match' at £17.

There is, at last, firm evidence that Chippendale supplied the green japanned furniture in the State Bed Chamber and State Dressing Room at Nostell Priory[1] in Yorkshire, where he had hung the 'India paper' in 1769 (see Chapter 12). But first he supplied more 'India paper' (Chinese wallpaper) — it was quite expensive:

21 Feb 1771: 4 sheets of India Paper and
* Border − £2 15s*
April: To 17 sheets fine India Paper − £12 15s

It is interesting that in the third edition of the 'Director' (1762) Chippendale recommends the japanning not only of some of the more far-fetched chinoiserie china-cases and porcelain stands, but also of two almost baroque-looking dressing tables.

Only in Venice did the fashion for japanning last uninterrupted throughout the eighteenth century. In 1754 there were twenty-five lacquer workshops in Venice and in 1773 the number had increased to forty-nine. This increase reflects perhaps the growth in popularity of japan among visitors. Venetian japan of the eighteenth century is not often in chinoiserie style, but in one of great exuberance and brilliant colour, where the idiosyncratic adaptations of the shapes of English and French furniture run riot.

The word japanning also has another meaning. It is used for the 'lacquered' tinware first made by the firm of Thomas Algood in Pontypool, Monmouthshire perhaps in the 1660s.

142 Pontypool japanned
tinware urn

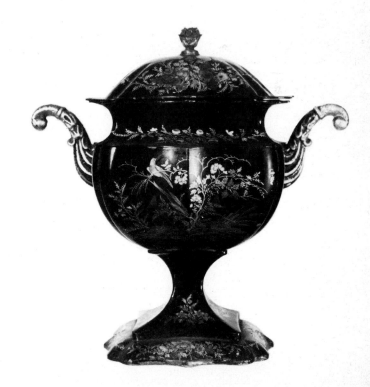

This form of varnishing on tinware or other sheet metal requires stoving to considerable heat (the exact temperature was a secret) up to three times. The resultant wares, usually small pieces, boxes, pin-trays etc. were both strong and cheap. Other rivals started in Birmingham and Bilston, and by the nineteenth century larger pieces, trays and coal-scuttles were made, and often decorated with chinoiseries. Dr R. Pococke, in 1756, wrote that whereas Birmingham wares were usually in bright colours, Pontypool used gilt chinoiseries on a black ground. Later, when chinoiserie went out of fashion, engravings were copied, in bright and realistic colours.

Also in Birmingham the *papier mâché* industry grew up: John Baskerville and then Henry Clay made an extremely strong *papier mâché* that by the 1790s could be used for furniture – beds, tables, sofas and chairs. In 1851 Messrs Jennens and Bettridge even announced they could make piano-cases. Large pieces rarely bore chinoiserie designs – these were usually confined to the smaller pieces such as small boxes.

It is perhaps curious that none of the furniture that we have discussed in this chapter bears any relation to the furniture of Japan (where little furniture is used) or of China. Even the lacquers exported to Europe were, as early as the late sixteenth century, specially made to order and not much used for domestic purposes. Perhaps only screens would have been found of use in China (Japanese screens are of paper and wood and not of lacquer).

Sir William Chambers illustrated one style of bamboo furniture in his *Designs of Chinese Buildings, Furniture etc.* of 1757 and this was later imitated and may even have been made up in Europe of imported component parts: it was also imitated[1] and may even have been made up in furniture enjoyed a brief vogue in England. In France it was uncommon, but Jacob apparently made a set of chairs for the Pagode de Chanteloup. Chinese hardwood domestic furniture was virtually unknown in Europe until well into the nineteenth century.

143 Japanned *papier mâché* tray made by Henry Clay *c.* 1810

1. illus. **199**

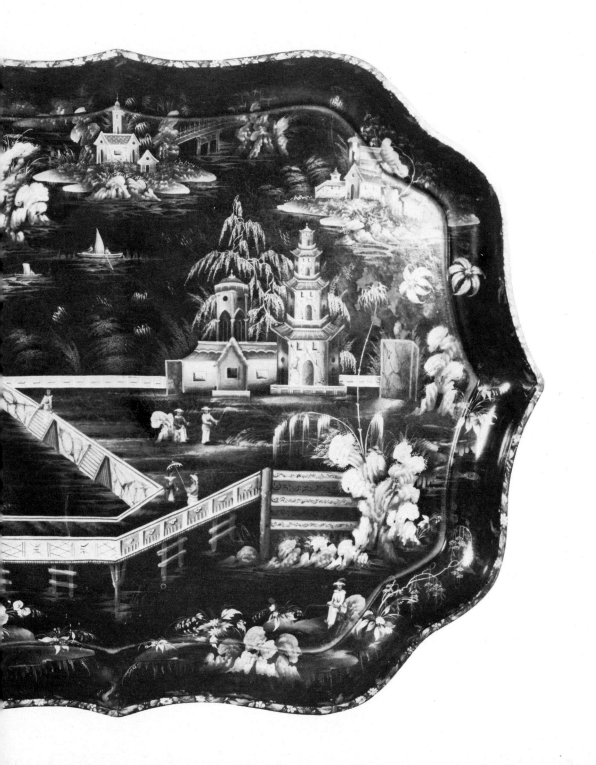

DES JARDINS ANGLO - CHINOIS À LA M

Prix 12.[tt]

À PARIS.

Chez LE ROUGE Ingenieur Géographe du Roi,
Rue des Grands Augustins. 1784.

144 The Chinese garden
and kiosk at Rambouillet
from Le Rouge's *cahiers* on
Jardins anglo-chinois.

Chapter Ten

The so-called Anglo-Chinese Garden

It is a little difficult for the English observer to see just why the English landscape garden or park should have been called, in France, the *jardin anglo-chinois*. Almost the only characteristics these later eighteenth-century European gardens have in common with the Chinese garden is the interest in scenery and the lack of insistence on symmetry. But these were important innovations in Europe. We must therefore look not only at pre-eighteenth-century European gardens, but also at Chinese gardens and see what, if anything, was known of Chinese gardens in Europe by the beginning of the revolution in park design that took place in Britain in the 1730s and '40s, and whether such knowledge could have been influential.

In the seventeenth and early eighteenth centuries, the gardens of all Europe were derived from the Italian gardens of the late Renaissance and the baroque. These were ultimately, if a little vaguely, themselves derived from classical antiquity. The Italian garden was an extension of architecture. It was made up of formal court-yards, sometimes with elaborate *parterres* of clipped low hedges of box surrounding areas of either flowers all of one colour, or, more commonly, coloured stones, marble or sand. Statues, colonnades, fountains, terraces and great hedges symmetrically arranged as background 'walls', canals, and long vistas, lined with huge avenues of trees, extended the garden into a formal park.

In France, this was adapted by Le Nôtre, the great seventeenth-century garden designer, to make the enormous and magnificent gardens of Vaux-le-Vicomte, Versailles, and many other châteaux. The influence of Le Nôtre was profound throughout Europe, and particularly so in Germany, where the French taste was obligatory among the lesser and greater princes. At Potsdam, for instance, the immense gardens of Sans Souci were laid out in the manner of Le Nôtre. The famous *Chinesisches Haus*[1], to which we will refer later was actually built in a 'Dutch garden' (a term for a formal *parterre* of sorts), and the *Englischer Garten* which surrounds it now was a later eighteenth-century novelty.

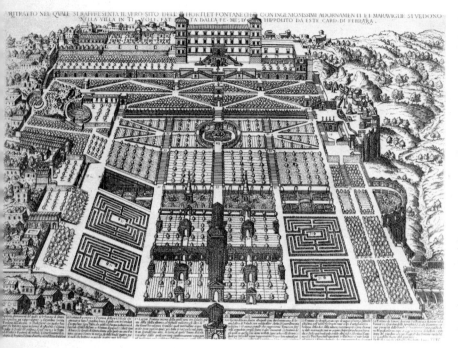

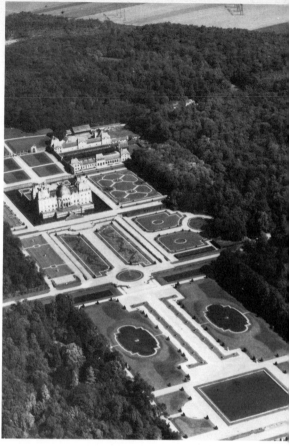

145 above The Italian Garden. The Villa d'Este at Tivoli, an engraving of 1581.

146 right The French formal Garden. Vaux-le-Vicomte from the air: one of the greatest gardens by Le Nôtre.

It was all very grand, pompous, and expensive. Apart from the *parterres*, it was not even a formal garden, but a formal park; it was an invitation to gaze down long views at a distant view or eye-catcher, or to walk down side avenues to sit in a 'temple'. It was not a *garden*. Moreover it was not really visible from ground level: even to see the *parterres* close to the house it was better to be on the first floor than on the *piano nobile*, let alone on the ground.

It seems to have been William Kent, the protegé of Lord Burlington, who, egged on by Alexander Pope, in the 1730s and '40s first 'leaped over the fence' and 'saw all nature as a garden'. What he saw was not a garden, but a park, almost empty of colour and certainly of flowers, but made more visible by the invention of Sir John Vanbrugh and 'Mr Bridgeman', of the Ha-ha, or sunken fence, used at Stowe before 1739. The inspiration is undoubtedly more classical than Chinese, as a walk through the

only intact Kent garden left, Rousham Park, will tell one. Perhaps the influence of another of Burlington's protegés, Robert Castell, who published in 1728 a description of Pliny's villa garden as 'like so many beautiful landskips', was more in evidence than Sir William Temple's or Joseph Addison's vague descriptions of Chinese contrived asymmetry. Certainly the concept of the romantic classical landscapes of Claude and Poussin show in the mixture of ruins and 'nature' a revolt against symmetry that was quite new to Europe.

There seems to have been a period before Kent's 'leap' when the eccentric but unreal was solemnly contemplated, perhaps following the precedent of Chinese irregularity: it would, however, be very difficult to take seriously designs for gardens of such absurdly convoluted pattern as those proposed by Batty Langley in his book of 1728, *New Principles of Gardening, or, the Laying out and Planting of Parterres, Groves,*

147 Drawing by William Kent for the Cascades at Rousham.

148 Romantic lanscape: 'Moses exposed', by Poussin.

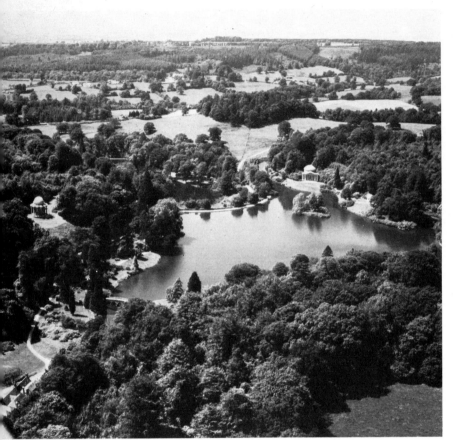

149 Stourhead from the air. A great 18th-century landscape park.

150 right F. M. Piper's plan of Stourhead 1779

Wildernesses, Labyrinths, Avenues, Parks etc. after a more GRAND and RURAL manner than has been done before.

The point is, that the asymmetrical garden was the most obvious reaction to the straight lines and formality of the great French gardens. Such formal gardens do not seem to suit the British character any more than they suit the topography.

Obviously the romantic ideal of nature improved by art was that taken up by William Kent, and then Brown, Chambers, and Repton. It was Lancelot 'Capability' Brown who brought the landscape park to its greatest popularity, and

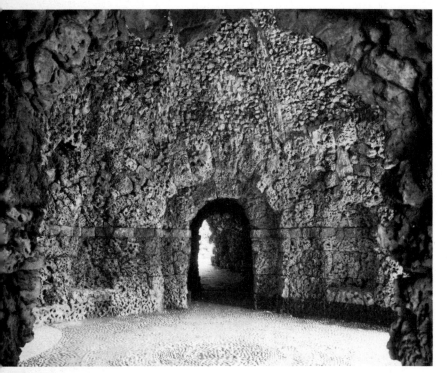

151 The grotto at Stour-head

to study: not only does it still exist in more or less its original state but so do most of its monuments. It was completely equipped with a Temple of Hercules (by Flitcroft, based on the Pantheon), a Temple of the Sun and many other neo-classical seats and monuments; it also had a splendid grotto, a 'River God's cavern' and exotic rock-work 'mountains'. Fortunately these can be seen as they were in 1779 in the many drawings of F. M. Piper, who studied there, and drew a plan of the gardens. There is no Chinese pavilion now at Stourhead, though in 1751 a Mr Harding was paid £39 to design one. Piper shows a 'chinesich alcove' on his plan, but apparently never drew it. He did, however, draw a Chinese Parasol, which not even the most prejudiced eye could detect as Chinese.

Brown's ideas were to make the best use of the features of the landscape as they were. He did not often greatly change the landscape except by the use of dams, and clever tree planting. Colour played no part in his schemes. Chambers, a bitter rival, liked to use grottoes and other artificial devices, hiding his own ideas behind a smokescreen of Chinese scholarship. We shall see that Chambers did know something of Chinese architecture – but he knew remarkably little of Chinese gardens.

Arthur Young, writing in 1787 about the garden of the Petit Trianon, summed up the differences between Chambers and Brown most concisely: *'There is more of Sir William Chambers here than of Mr Brown, more effort than nature, and more expense than taste.'*

The ideas of Brown and his school, and of his rivals, were eagerly taken up on the European continent. The informal garden certainly came to France and Scandinavia from England, and to Germany from France, how ever much the French denied it. If it was asymmetrical it had to be 'Chinese'; this had been known to be true of furnishings since the late seventeenth century, and clearly had to be true of gardening and architecture, too, when neither was rococo. But the landscape garden came to France in the 1750s. This date is important, because it is after

many of his parks still exist today. He was un-doubtedly the greatest influence on his rivals and successors, particularly Sir William Chambers and Humphrey Repton.

Brown used a very limited selection of trees: elm, oak, beech, lime, plane, scots pine and larch, only occasionally using the cedar (intro-duced in the late seventeenth century). Brown never used flowers or flowering shrubs at all, hence, perhaps, his neglect of the lovely horse chestnut (introduced in 1629). The vogue for masses of flowering shrubs – particularly rhodo-dendrons – is a purely nineteenth-century one. The present view of Stourhead, for instance, is not at all as Henry Hoare planned it: it has been filled out with flowering shrubs to a great density, which has obscured the rather more austere beauty that was originally intended. Apart from this, Stourhead is in many ways the ideal garden

the publication in 1749 of the letter written by a French Jesuit in Peking, Frère Attiret, to a correspondent in Paris in 1743, in which he described in glowing terms the great gardens of the Yüan-ming-yüan:

One wanders from one vale to another not, as in Europe, by straight avenues, but by zig-zag winding paths . . . The Canal sometimes widens, sometimes becomes narrower; here it winds, and there it describes a curve, as if actually deflected by the hills and rocks . . . The paths, too, follow a winding course, sometimes following the canals, sometimes leading away from them.

As the only informal gardens to be seen in Europe were those in England, the French immediately grafted the Chinese description on to the English reality, misunderstanding both in the process. In England, where the writings of a popish priest were probably not to be preferred to the 'reliable' descriptions of Nieuhoff (the authority on whom Temple and Addison relied), the confusion did not arise.

In France the classical landscape with ruins (the ruins themselves classical) of Poussin, Claude and Salvator Rosa was less popular than it had been in the seventeenth century, though still practised in a different mode by Hubert Robert. It smelled too much of *Le Roi Soleil*. (In England, where there were no classical ruins, it was still very fashionable and was eagerly collected throughout the eighteenth century.) So in mid-eighteenth-century France, the classical-romantic ideal of landscape had almost given way to the soft and frivolous pastoral scenes of

152 Three aspects of the landscape garden, from Le Rouge: The wilderness, the romantic ruin (possibly a fake) and a chinoiserie swing.

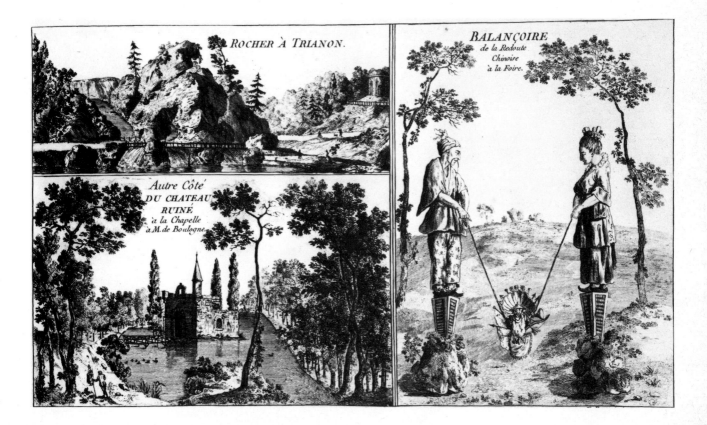

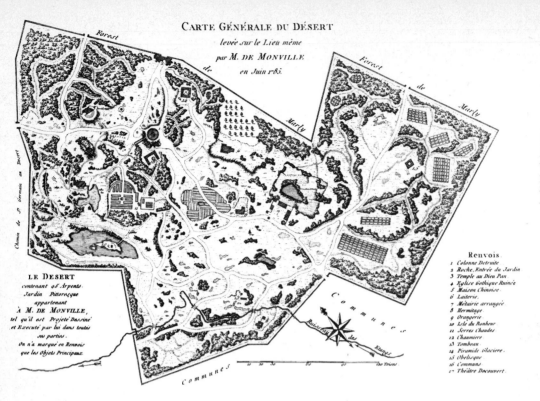

153 The *Désert de M. de Monville*: the over-elaboration can readily be compared to the more simple Stourhead (illus. 150). *See also p. 151*

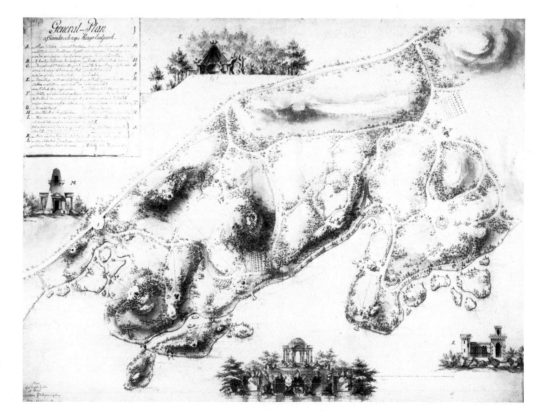

154 F. M. Piper's design for Haga Park, Stockholm, 1786.

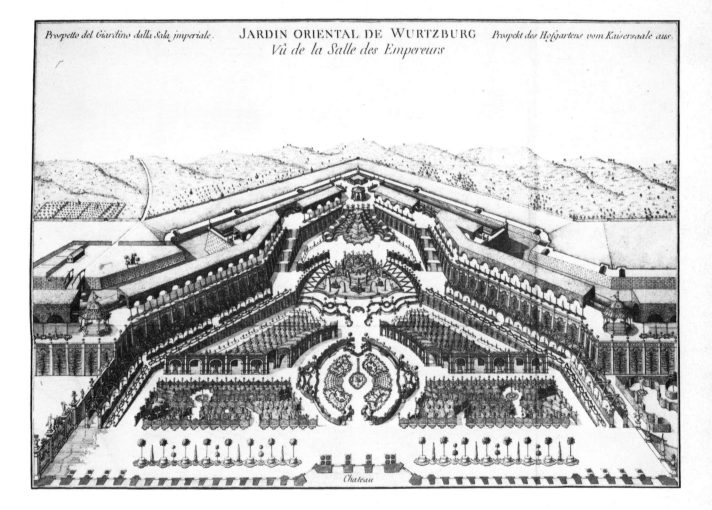

Prospetto del Giardino dalla Sala Imperiale. JARDIN ORIENTAL DE WURTZBURG *Prospekt des Hofgartens vom Kaisersaale aus.*
Vû de la Salle des Empereurs

Chateau

155 Reversion to formality: the so-called oriental garden at Würzburg, from Le Rouge.

Watteau, Boucher, and Fragonard: these might almost be called rococo-romantic and certainly the *jardin anglo-chinois* fitted perfectly into the conception of the pastoral life and the *fête champêtre*. But the name *anglo-chinois* may also have been derived for other reasons. As Horace Walpole wrote in 1771: '*The French have of late years adopted our style in gardens, but, choosing to be fundamentally obliged to more remote rivals, they deny us half the merit or rather the originality of the invention, by ascribing the discovery to the Chinese, and calling our taste in gardening "le goût anglo-chinois".*'

In reality the French landscape garden was not only a reaction against the symmetrical grandeur of Le Nôtre, but also against the stifling formality of the court. The *fermes ornées* and dairies were to bring back the simple life to a jaded aristocracy – obviously impossible in a Le Nôtre setting.

As we shall see, the French embraced the *jardin anglo-chinois* with fervour, and graced it

with innumerable 'Chinese' buildings, though
few of these bear more than the remotest sem-
blance to Chinese architecture, as we shall see
in Chapter 11. These parks were not only English
in origin, but the designers had often studied in
England; Joseph Bélanger, the greatest of them,
was in England in 1766.

But if they were to suit the mood for the
rococo-romantic, they could not conform to
English canons of good taste, which still harked
back to the 'pictorial' of William Kent as trans-
lated by Brown. They had to be less solemn and
less grand, and they became overcontrived, and
too full of buildings of all styles. Young's remarks
about the Petit Trianon were pejorative, and

157 and 158 Possible in-
spiration for the landscape
park?
Above Chinese blue-and-
white dish, Transitional
style, mid-17th century.
Below Chinese *famille verte*
dish, 18th century.

156 A Chinese kiosk at
Veitshöchheim

could equally well have applied to many of the other great landscape-parks of France, Rambouillet, the Désert de Monville, Bagatelle or the Parc Monçeau. (The Archpriest of all of this was the Prince de Ligne, whose park at Beloeil even had a 'model' village where the wretched farm labourers had to join in the make-believe of the simple life, wearing costume and singing and dancing.)

In England, where Chambers' advocation of excessive 'improvement' of nature never really found favour, it was not until very late in the century that such criticism was justified. In fact the worst excesses may have been at Alton Towers in the early nineteenth century.

In both Sweden and Germany the landscape garden, often filled with the by now almost obligatory pavilions, grottoes, cascades, temples and pagodas in a splendid miscellany of styles, became the rage. Under Scheffer's guidance and Chambers' tuition, F. M. Piper laid out the two great gardens of Haga and Drottningholm in Sweden for Gustaf III, while in Germany the great formal garden of Schwetzingen was converted into an *englischer Garten* by Friedrich Ludwig von Sckell only twenty years after its completion. Both Piper and von Sckell had studied in England. On almost every great estate throughout Europe, even if the formal garden was not completely destroyed, a *jardin anglo-chinois* or an *englischer Garten* was usually fitted in somewhere, a 'wilderness'.

But these were English landscape gardens, ultimately inspired by neo-classical romantic painting, and touched-in here and there with chinoiserie ideas, and they should never have been confused with anything really Chinese.

Except for the great Imperial Parks, such as the garden of the Yüan-ming-yüan, the Chinese garden is in some ways more comparable to the Italian garden than to the *jardin anglo-chinois*. As the Chinese house is built up on a series of interconnecting courtyards, often with water flowing through, the effect is of a series of rooms, each with its garden. Like the Italian garden, in many cases the only trees or shrubs would be in

tubs, and there would be statues on marble plinths, though these would be of lion-dogs rather than of the Muses. In some Chinese court-yards the effect of a grotto of exaggerated proportions is sought, and in many there is a pleasing and carefully contrived asymmetry, but it cannot be said remotely to resemble an English park.

Certain features of the Chinese garden do, however, creep into European decorative schemes. You do not need to have an accurate verbal description of a Chinese garden, sent by a Jesuit, if you can see it yourself perfectly well on a Coromandel screen, or a *famille verte* dish. These often depict garden scenes and show the essential formality of the Chinese garden to be broken only by a slight and understated use of asymmetry.

Why the later landscape gardeners, particularly in France, may have sought Chinese 'authority' for their landscape gardens was because of their familiarity with Chinese landscape painting as shown so often on blue-and-white plates. It was the landscape, not the garden that was the influence, if we have to find one at all.

The Chinese 'landscape' garden was a miniature version of nature: a microcosm of natural scenery in a small area, though the size of this small area could vary from a few square yards to several acres. It reaches its apogee in the Zen gardens of sixteenth-century Japan. This garden could be built anywhere; as the Yüan Yeh, a garden treatise of 1634 says: '*A single "mountain" may give rise to many effects, a small stone may evoke many feelings . . . if one can find stillness in the midst of the city turmoil, why should one then forego such an easily accessible spot and seek a more distant one?*'

The English landscape garden — in itself a misnomer, park is the correct word — was never a miniature form of nature. Chambers, perhaps, tried to make part of it so with his transitions from the 'pretty' to the 'horrid', but Brown and Repton did not. Improve nature, yes, and of course make the best of what you have, but make a miniature of it, no.

Japanned highboy. American, early 18th century. Probably made by John Pimm of Boston and japanned by Thomas Johnson. *See p. 117*

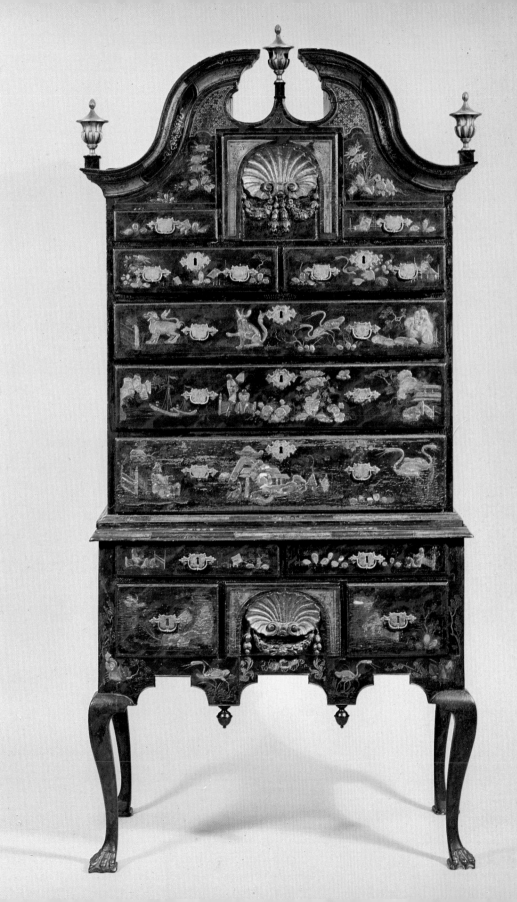

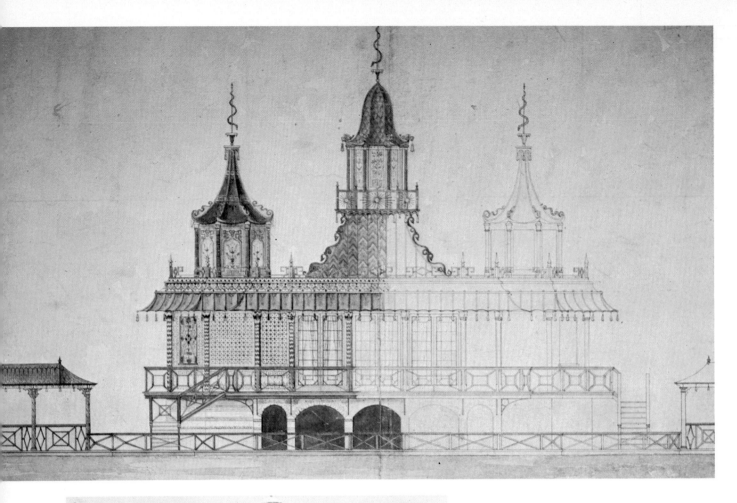

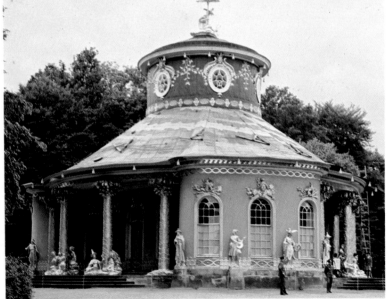

We have seen that there is but one real similarity between the Chinese garden and the *jardin anglo-chinois*, and that is the possibility of the use of an asymmetrical layout. That this relies in Europe on Chinese models is debatable, it being more of a classical-romantic notion, but it brings with it, willy-nilly, one important feature. This is the use of the garden pavilion.

Garden pavilions occur in almost every Chinese garden, but are not at all common in European gardens (especially English ones) before the eighteenth century. Then they were enthusiastically erected all over Europe, and I venture to suggest that the lesson of a garden building both beautiful (or at least pretty) and utilitarian was learned more from the Chinese than from Claude, and here again, was probably learned from the landscapes painted on blue-and-white porcelain, which almost invariably include some sort of pavilion. Of course, once the fashion began, every conceivable, and even almost inconceivable style of architecture was used from Classical through chinoiserie to 'Hindoo'. But this is the subject of Chapter 11.

Drawing by Samuel Tevlon of the Chinese Fishing Temple at Virginia Water built by Wyatville and decorated by Frederick Crace in the 1820s.

The *Chinesisches Haus* at Sans Souci, Potsdam by J. G. Büring 1754–7 for Frederick the Great. *See p. 149*

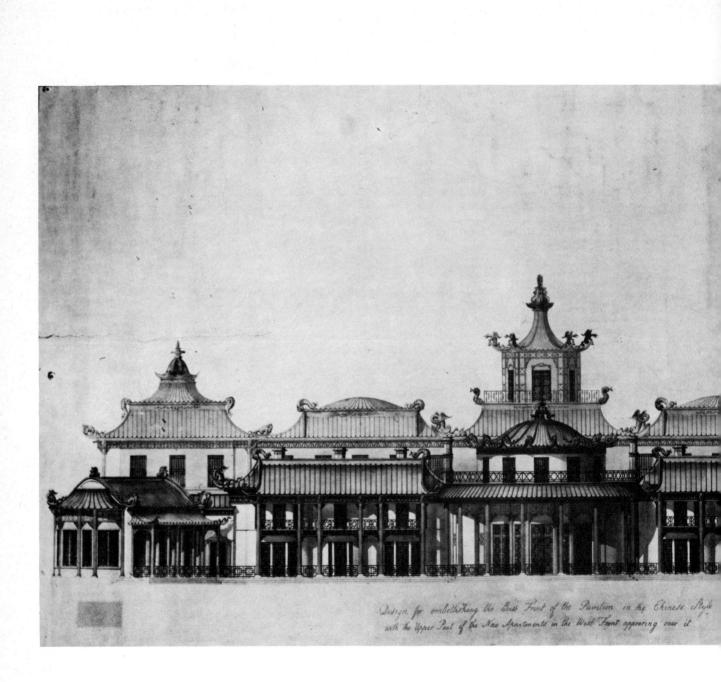

Design for embellishing the East Front of the Pavilion in the Chinese Style with the Upper Part of the New Apartments in the West Front, appearing over it

Chapter Eleven

Architecture

159 Project for the east front of Brighton Pavilion by William Porden, 1803.

Although chinoiserie styles had been used in Europe for centuries, apparently no attempt was made to build any form of chinoiserie building until near the end of the seventeenth century. Partly, of course, this is inherent in the subject-matter of the style; if you are used to chinoiserie illustrations of buildings, bridges and so on that are evidently in imminent danger of collapse, then you can hardly be expected to use them as architectural inspiration. Again, it was partly due to the revival of the classical canons of architecture that had made classical proportions virtually inescapable. But more than anything the cause was probably the essential frivolity of seventeenth-century chinoiserie as seen on silks, japanning and other decorative features. What had been seen of real Chinese architecture was only that depicted on porcelain or lacquer.

The Jesuits in China in the seventeenth century had written disparagingly of Chinese architecture: *'very unpleasing to foreigners, and must needs offend anyone that has the least notion of true architecture'* wrote Père Louis Le Comte in 1690. Even du Halde as late as 1735 wrote: *'The Houses of the Nobility and rich People do not deserve to be mention'd, in comparision of ours; it would be an Abuse of the Term to call them Palaces, they being nothing but a Ground-Floor, raised something higher than common Houses . . . It must be confessed, however, that the Palaces of the chief Mandarins, and the Princes . . . are surprizing for their vast Extent.'* But this was by then out of date: for early in the eighteenth century it was realized that there were several similarities between Chinese and European styles of building, and even of basic constructional ideas. The use of the pillar, the peristyle, the open arcade were common to both; so was a liking for symmetry based on a central feature with flanking subsidiary features. These similarities were seized upon by architects so that merely by dressing up a normally classical building in 'Chinese' trappings it could be made into an Oriental Palace — such was Pillnitz in Saxony. In 1757, long after the first successful excursion into the style, Sir William Chambers wrote: *'In both the antique and*

143

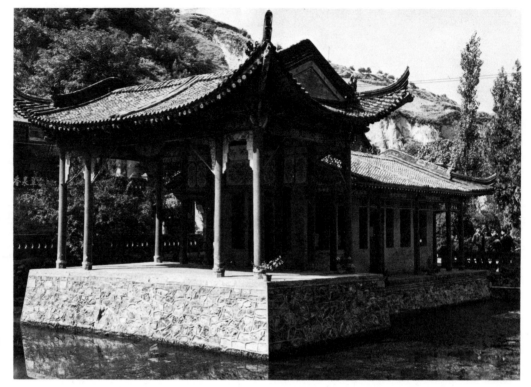

160 A real Chinese pavilion at Sian, showing the use of column, arcade and peristyle.

Chinese architecture the general form of almost every composition has a tendency toward the pyramidal figure; In both, columns are employed for support; and in both, these columns have diminution and bases . . .; fretwork, so common in the buildings of the ancients [does Chambers mean Greek key and the Vitruvian scroll?], *is likewise very frequent in those of the Chinese; the Disposition of the Ting* [explained as a Great Hall] *is not much different from that in the Peripteros of the Greeks . . .'* and so on.

It was probably not what Chambers intended – he tried to be so academic about it all – but what this meant to his readers was that Chinese architecture was not only respectable, but that it could be easily assimilated into the European sense of proportion, and of suitability. It was therefore considered suitable for light, airy,

colourful buildings where its 'frivolity' was an asset, not a liability. And what could have been more perfect than this combination of features for garden pavilions? Clearly chinoiserie styles could never replace the classical or even the gothick, even in garden architecture, but could be allowed as subsidiary features. And this is just what they became in the mid-eighteenth century, even that severe critic of chinoiserie and champion of gothick, Horace Walpole, conceding that chinoiserie pavilions might add 'a whimsical air of novelty that is very pleasing'.

It was Chambers who first introduced a touch of realism into chinoiserie. Chambers had visited Canton in his youth, and laid claims to some knowledge of all things Chinese. In 1757 he published a magnificent volume entitled *Designs of Chinese Buildings, Furniture, Dresses, Machines*

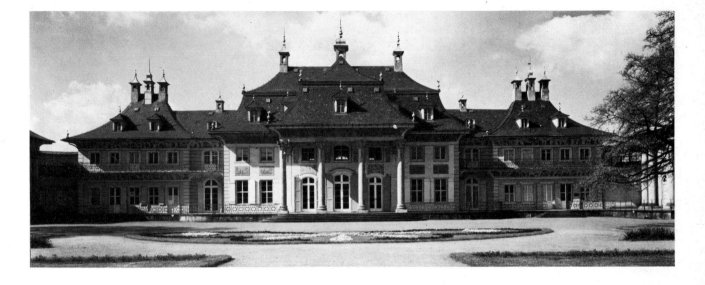

and *Utensils* full of didactic remarks about
Chinese architecture and dismissive remarks
about chinoiserie buildings – 'toys in architec-
ture'. He was promptly commissioned by Augusta,
Princess Dowager of Wales, to build a series of
Chinese, Moorish etc. buildings in Kew Gardens.
Many of these, including the Aviary, the Pheas-
antry, and the Moorish Pavilion, have since
perished, but the most famous of all, the great
Pagoda, still stands, though no longer quite so
richly embellished as before. In fact the Pagoda
is the nearest thing to Chinese architecture
eighteenth-century Europe seems to have
achieved: strictly it is not entirely accurate either
in proportion or in constructional method, but
there were no rules to which to adhere and
Chambers could not have built a 'correct' build-
ing without exactly copying a Chinese proto-
type. Its nearest equivalents in China are the
Southern style brick pagodas with wooden eaves
and balconies, and intricate wooden bracketing

In China, Chambers never went outside Can-
ton, though he is confident that Canton is
sufficiently representative of Chinese architecture
that he need not have bothered to travel! In his
1757 book there is no pagoda remotely like the

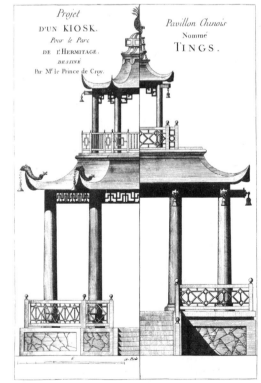

161 above The *Indianisches
Lustschloss* at Pillnitz built
by M. D. Pöppelmann
1720–32 for Augustus the
Strong – a dressed-up
European building. *See
p. 147 and illus. 1*

162 A comparison between
Chinese architecture
(right) and fanciful Euro-
pean architecture (left),
from Le Rouge.

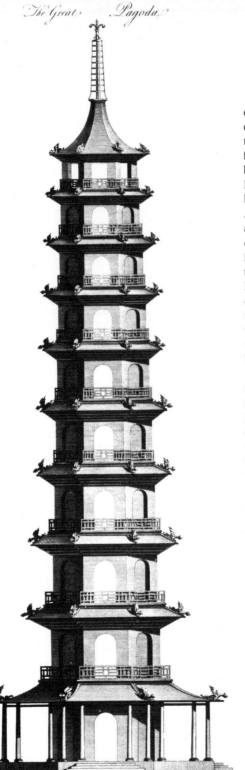

The Great Pagoda

163 The Great Pagoda at Kew. From Sir William Chambers's *Gardens and Buildings at Kew*, 1763.

one he designed for Kew, only an affair of diminishing stepped stages with little resemblance to reality. A somewhat similar pagoda was in fact erected at Sans Souci (the Dragon House, by Gontard) and another was planned for Drottningholm by C. F. Adelcrantz, though never built. In Nieuhoff's book (*An embassy . . . to the . . . Emperor of China*, English edition 1673) there are engravings (by Wenceslaus Hollar and others) of various Chinese scenes, one of which is of 'Kanton' and shows a pagoda in the distance which is probably ancestral to the Kew Pagoda, for Chambers would have seen it. Most of the pagodas illustrated in Nieuhoff are drawn without tapering to the top, as if the sides were vertical, and a pagoda not unlike these is illustrated by Krafft (1809–10) as being at Montbéliard.

Just as Chambers' determination to outdo nature in landscape gardening fell somewhat flat – he never seriously rivalled Capability Brown – so his chinoiserie buildings, also dressed up in scholarly robes, never made more than a passing impression on contemporary taste. People knew exactly what they wanted a 'Chinese' building to be, light, frivolous, immediately pretty and gaily coloured, and they had no use for Chambers' solemn pronouncements on inaccuracy. If a building had Chinese fret or a conical or concave roof, if it had upturned eaves and was hung with bells it was Chinese (or Indian, as you liked) and bother Sir William.

So chinoiserie continued as a valid, if muddled style, long after its supposed authenticity had been questioned and refuted. It was indeed towards the end of the eighteenth and into the beginning of the nineteenth century that many of the best examples of chinoiserie were created.

The earliest attempt at a chinoiserie building appears to have been the *Trianon de Porcelain*, built in 1670 by Louis XIV for Mme de Montespan at Versailles, and designed by Louis Le Vau. Although supposed to imitate Chinese buildings even in the layout of the courtyard, it was, in

fact, merely a semi-classical building heavily overdecorated with blue-and-white faïence. It was the colour-scheme rather than the architecture that was 'Chinese'. Faïence is of course wildly unsuitable for the northern European winter and by 1687 the Trianon was pulled down. But it may be considered the father of the many 'Chinese' follies, garden pavilions, bridges and temples that were to become so common in the succeeding century.

The idea of the *Trianon de Porcelain* — that is the covering of it in blue and white — probably came from a description of the 'porcelain' pagoda at Nankin, perhaps that of Nieuhoff who visited it in 1635. In Nieuhoff's book there is also an engraving of an Imperial Palace at Peking, showing the disposition of the building to be very approximately that of the Trianon (to judge from Perelle's engravings). Perhaps Le Vau made the best of both worlds and had a more acceptably shaped series of buildings covered in faïence. Nieuhoff wrote that the pagoda is: *'a high Steeple or Tower made of Porcelane, which far exceed all other Workmanship of the Chineses in cost and skill . . . This Tower has nine Rounds, and a hundred and eighty four steps to the top; each Round is adorn'd with a Gallery full of Images and Pictures, and with very handsom Lights: the outside is all Glaz'd over and painted several Colours, as Green, Red, and Yellow . . .'* In other words, it was covered in coloured pottery tiles and tile-work figures — not the blue and white of the Trianon, a purely European conceit.

After the Trianon the next chinoiserie buildings seem to have been those of Augustus the Strong in and near Dresden. Augustus had a magnificent collection of Chinese and Japanese porcelain, and was the patron of the Meissen Factory (see Chapter 8), and to house these collections he converted his 'Dutch Palace' which he had bought in 1717 into a *japanisches Palais*. Apart from a vaguely oriental roofline, the main 'oriental' effect was the substitution of baroque 'chinese' caryatids for the pilasters of the main courtyard.

This is the beginning of the 'dressing' of a building to transform it into another style that became standard practice later in the eighteenth century. In chinoiserie it was possible because of the similarities already noted between Chinese and European post-Renaissance architecture: it was, however, rarely used — few large buildings were made oriental.

More oriental in conception was the *Indianisches Lustschloss* of Pillnitz (built 1720–32), but even here it is only in the decoration of the columns of the portico, the concave cornice painted with chinoiserie figures, and the doubly concave roof that it differs from a neo-classical building. The Chinese House at Drottningholm[1], in Sweden, built in the 1760s, has much the same characteristics, though the scale is more intimate and the effect perhaps more charming than at

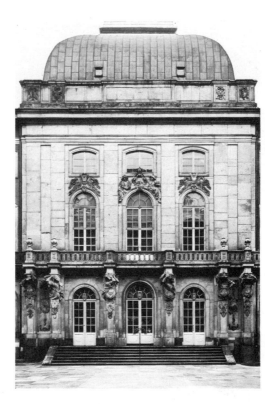

1. illus. 1

164 The *Japanisches Palais* at Dresden and detail of a caryatid

165 One of the gilded figures by Benkert and Heymüller outside the *Chinesisches Haus* at Sans Souci, Potsdam. *See also lower colour plate facing p. 141*

Pillnitz. The Chinese Tea House at Sans Souci[1], Potsdam, of the 1750s, went considerably further than this, but the trefoil plan and the conical roof do not disguise the neo-classical basis of the design. Here the surface decoration is fanciful in the extreme, and splendid 'Chinese' figures grace not only the pinnacle of the roof (arousing hoots of contemporary derision) but also sit and stand around the outside, gilded, in the shade of the palm-tree columns. Astonishingly, the building was originally erected in a formal garden, and the *Englischer Garten* was only laid out late in the eighteenth century.

In England there can have been few chinoiserie buildings before the 1740s. Chinese fret (see Chapter 9) had appeared before then, but apparently not commonly. One of the earliest designs for a chinoiserie building is that of the House of Confucius at Kew, designed by J. Goupy *c.* 1745. According to Vertue there was a 'Chinese house painted by Mr Slauter' at Stowe in 1745, and an engraving by Bickman of 1750 shows it to have been almost adjacent to the famous Palladian Bridge, which seems rather surprising, and not particularly oriental in aspect. In the little garden pavilion at Shugborough Park, Staffordshire, built around 1747, the Chinese fret of the windows hardly conceals the European proportions of the windows and door. This is probably the earliest extant chinoiserie building in Britain: by a curious irony, commented upon by Hugh Honour, it was built for the brother of one of the men who first aroused suspicions in Europe that China was not, after all, the paradise of justice so often claimed. Captain Anson had experienced the corruption and inefficiency of Chinese local government when he had landed at Canton. The pavilion was built shortly after his return home.

In the 1740s and 1750s chinoiserie buildings in gardens became widespread throughout England and indeed throughout Europe. Men of taste often preferred the new gothick, especially when it had pretensions to scholarship, and men of less taste mixed chinoiserie, rococo, and gothick with an enthusiasm that is as charming

as it is absurd. Mostly this mixture of styles was applied to furniture – even by Thomas Chippendale – but some architects were also guilty. Batty Langley, among others, tried to formulate the gothick so that it could be used (or judged) as easily as could the classical orders: first published in 1742, his book was re-issued (probably in 1747) as *Gothic Architecture improved by rules and proportions in many grand designs of columns, doors, windows*

In spite of Langley's well-meaning nonsense it is astonishing how often a 'gothick' design had panels of chinese fret, or a chinoiserie one, crockets! So gothick and chinoiserie pavilions flourished and bred. Clearly it was, in the mid-eighteenth century, difficult at times not only to keep the styles apart, but even to tell them apart: some of the pattern-books describing their illustrations as one or the other in fact illustrate objects that could be either or neither – particularly is this true of furniture designs. Though gothic had never really stopped for ecclesiastical or collegiate buildings, the new gothick was domestic, and was much used in

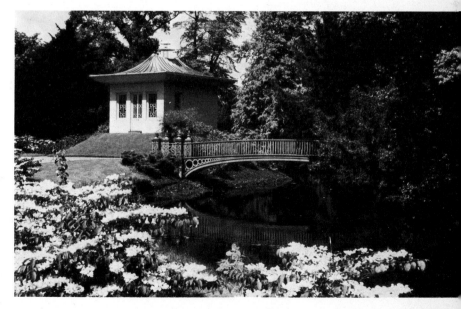

166 The Chinese garden pavilion at Shugborough *c.* 1747

parks, parallel to chinoiserie, or mixed with it, coming into its own in the eye-catchers and sham castles of Sanderson Miller. Notes of realism do, however, creep into the most unlikely places. The charming Chinese Pavilion at Harmstown House, County Kildare (formerly at Wotton House, Buckinghamshire), built *c.* 1750, has painted exterior panels and lattice windows (not particularly Chinese in aspect) under an almost correctly shaped Japanese roof.

Most chinoiserie garden buildings seem to have been more or less temporary structures, and it is a wonder that so many have survived. Many have not, and are known only from contemporary descriptions, engravings or drawings. Some, of course, were never even built, but were suggestions and plans published by architects (and furniture-makers) in pattern-books. Many of these are delightful, and some absurd. One of the best sources of such engravings of the eighteenth century is the great series of books by Le Rouge, in twenty-one volumes,

begun in 1773, most of which are entitled *Jardins anglo-chinois*. Several splendid chinoiserie buildings still exist in France from among the many to be seen in Le Rouge's engravings — but how we miss the absurd pavilion at Bonnelles perched on a grotto and hung with bells. Among the best is the pavilion at Cassan, near L'isle Adame, of *c.* 1778. This gives a remarkably good impression of a Chinese garden pavilion — it has a double roof over an octagonal room surrounded by a latticed peristyle — but its base is solidly European. A handsome stone-built arched affair, vaulted within, and with Tuscan columns, it covers a small bathing pool. Somehow the marriage of these two styles works and the effect is surprising but quite acceptable: it is a splendid example of the Chinese use of pillars conforming to European usage. Less Chinese — much more neo-classical — is the great stone-built *Pagode de Chanteloup*, where the superimposition of storey upon storey is clearly inspired by the pagoda, but almost the only other

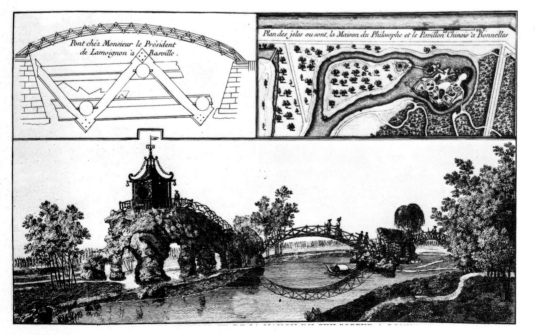

167 *La maison du philosophe et le pavilion chinois à Bonnelles*, from Le Rouge.

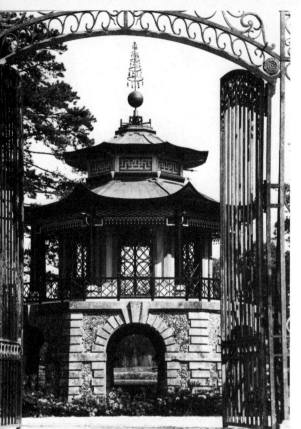

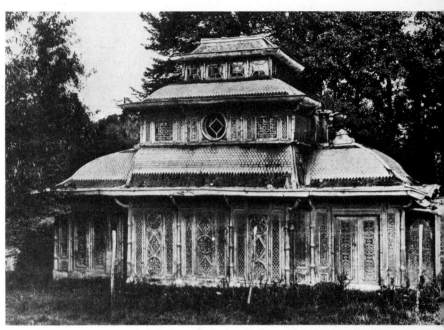

indications of chinoiserie are the slightly con-
cave outlines of the eaves, the pseudo-Chinese
characters inscribed on the lowest storey, and
the iron fret balustrades.

A principal attraction in one of the greatest
of all follies, the *Désert de Monsieur de Monville*, was
the *Maison Chinoise*. The *Désert* was a *jardin*[1]
anglo-chinois, said to have been influenced by
Hubert Robert and begun in 1771: it is now
called the *Désert de Retz*. Here even the main
house is a folly – it is in the form of a broken-
off gigantic column, with windows in the flut-
ings, and a jagged skyline, to look like a break –
it was even planted with weeds. Unlike other
features of the park, the *Maison Chinoise* was not
designed as a ruin, and it has very little of the
East about it. True it has curved roofs – but they
are ogee shaped – and *treillage*; it has a fret-
balcony and it has figures of 'mandarins' with
conical hats and parasols. Most ingeniously of all,
the symmetrical chimney pots are shaped as urns
or vases, to give the effect of incense burners,

1. illus. **153**

168 above left The pavilion
at Cassan

169 above right The decay-
ing *Maison Chinoise* in the
*Désert de M. de Monville.
See also illus. 153*

170 right *The Pagode de
Chanteloup* at Amboise, by
Le Camus 1775–8. Built
by the exiled Duc de
Choiseul as a mark of
thanks for the loyalty of
his friends.

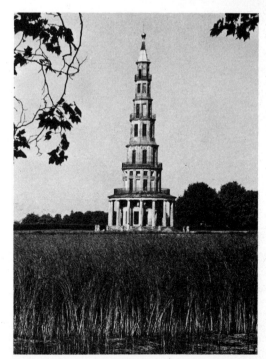

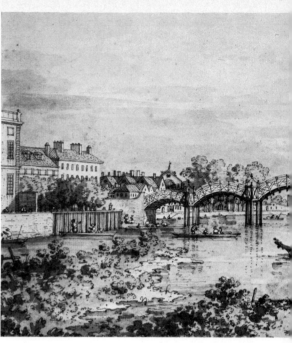

but as Sirén points out, its character is more French than Chinese.

The Prince de Ligne has been mentioned, in Chapter 10, as a chinoiserie fanatic, who even had a chinoiserie village in his park at Beloeil. He was not unique. At Tsarskoe Selo Catherine the Great of Russia had a Chinese village of eighteen houses built around a temple and a pagoda. The work was begun in 1784 – the architect was the Scotsman Charles Cameron – but the pagoda was not finished when Catherine died in 1796. (It was finished, simpler and smaller, by Stassow in 1818.) In Germany the Landgraf Friedrich II of Hessen-Cassel built a model village (called Mulang) by the side of the lake at Wilhelmshöhe. Begun in 1781, and finished in 1797, it was perhaps the last great chinoiserie folly outside England. There was a pagoda (only on one storey) with a red-painted roof, and many farms, dairies, stables and houses for the workers. To add a touch of the exotic, negro women were employed there, presumably because no Chinese were available!

A lost piece of chinoiserie is the bridge that crossed the Thames at Hampton Court: of this we have an engraving of 1753 by Canaletto. This was a Chinese fret bridge, perhaps the ancestor of the innumerable fret bridges that have been built and are indeed still built today,

all over Europe. Curiously enough, they were not thought of originally as particularly Chinese. Chinese fret[1], one of the few hallmarks of chinoiserie to be genuinely and directly Chinese, was another god-send to the park planner and architect. Chinese rails were considered particularly suitable for bridges and also for railings, balustrades and balconies, and could without question be used in conjunction with other styles – see, for instance, the campus of the University of Virginia, by Thomas Jefferson.

Related to Chinese fret is *treillage* in which either a false perspective may be given, or else a false image of a building created. This had been advocated by Batty Langley, and his *New Principles of Gardening* of 1728 included as its frontispiece 'Temples of Trelliss work after the grand manner at Versailles'. It reaches its peak at Dropmore, in Buckinghamshire, which has a Chinese aviary as well as Tuscan doorways: but this is much later, probably mid-nineteenth century.

In accordance with real Chinese usage, fret bridges would normally be arched, and sometimes would have a pavilion in the centre. The pagoda built by Nash for the Prince Regent in 1814 in St James's Park was on the centre of a chinoiserie bridge. *'Unfortunately'*, says Hugh Honour, *'it made its* début *as the centre-piece in a*

171 **left** The Chinese village at Tsarskoe Selo, near Lenningrad, a gouache by Quarenghi.

172 **above** The chinoiserie bridge at Hampton Court; engraving by Canaletto, 1753.

173 **above right** Chinese fret at Monticello, by Thomas Jefferson.

1. p. 120

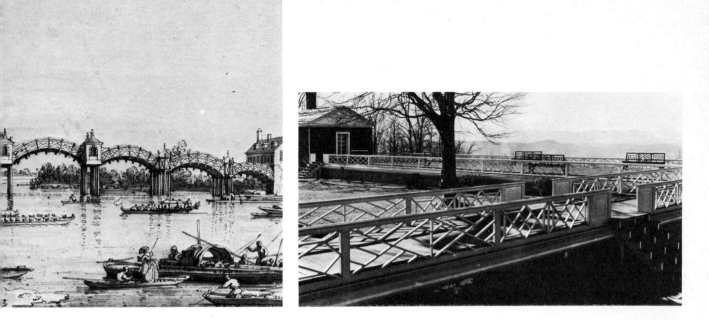

174 above The Campus of the University of Virginia, Charlottesville, by Thomas Jefferson. Engraving by B. Tanner, 1826. Chinese fret and Greek temples.

175 right *Treillage*. The Chinese aviary at Dropmore, 19th century.

firework display when rockets were let off with such gay abandon that the upper storeys caught fire, burst into flames and fell, popping and sizzling, into the water'. Fireworks themselves gave a particularly Chinese flavour: as Frère Attiret had written in 1734: *'in pyrotechnics and illuminations the Chinese leave us far behind. The few that I have seen infinitely surpass anything of the sort that I have witnessed in Italy and France . . .'*

If a Chinese pavilion was not set in the middle of a bridge, it could also be placed suitably, it was considered, on a rockwork grotto or 'mountain'. These were particularly popular in France, and were once to be found at Bonnelles,

Bagatelle, La Folie Saint-James, and Rambouillet to mention but a few of those that can be seen engraved in the great books of Le Rouge. Pavilions on boats are less common, and the Duke of Cumberland's preposterous yacht on Virginia Water decorated with a winged dragon on the hull, and with a gaily painted, fretted and gilded pavilion with a striped roof as its cabin, may well have been the most exotic of its type in northern Europe. In Venice, carnival barges of elaborate chinoiserie design can be seen in the engravings of Andrea Zucchi[1].

In the Chinese garden, where the garden itself was really a device to show off to best

176 The Duke of Cumberland's yacht, *The Mandarine*, on Virginia Water. Engraving by Haynes.

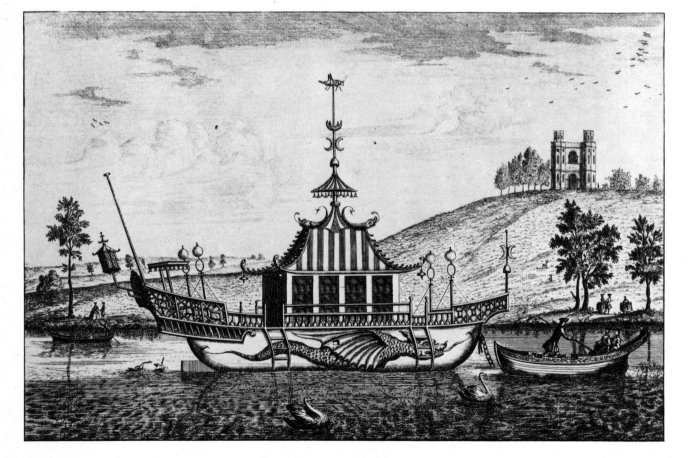

1. illus. **62**

advantage the innumerable buildings in it, water was an essential. So it was in Europe, and most of the buildings we have described were on or near water. Two particularly attractive buildings at the water's edge – both of which survive – were Holland's Chinese Dairy at Woburn, and a pavilion now called 'The Quarters' at Arlesford Hall in Essex. The Dairy is one of those buildings that it is difficult to identify as chinoiserie, though it has fret-work and an octagonal lantern; 'The Quarters' is an attractive double-roofed affair used, in the eighteenth century, for picnics by the lake and for angling: John Constable painted it in 1816.

Only the major buildings of the earlier part of the century had been far from water – Pillnitz, Brühl, and the Tea House at Sans Souci. Later there were Drottningholm and the Pagoda at Kew, but in the early nineteenth century some new major buildings were built in or converted to chinoiserie styles, regardless of the fact that they were not close to water.

Two of these are in England. Sezincote, in Gloucestershire, and the Royal Pavilion at Brighton. Sezincote is one of the most extraordinary buildings of chinoiserie – in the 'Hindoo' style. Actually it is a European house dressed in Mogul architectural features. It was built c. 1805

177 right The Chinese Dairy at Woburn, built by Henry Holland in 1787 for the Duke of Bedford.

178 below 'The Quarters', Arlesford. Detail of a painting by Constable, 1816.

179 below right Thomas Daniell's drawing for a 'Hindoo' temple at Sezincote

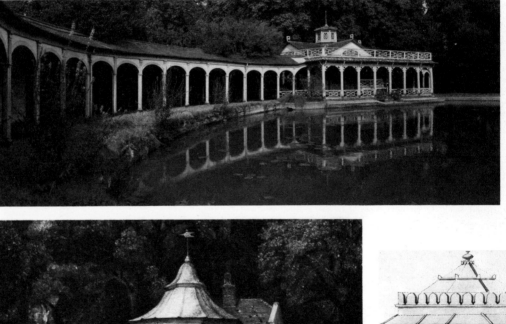

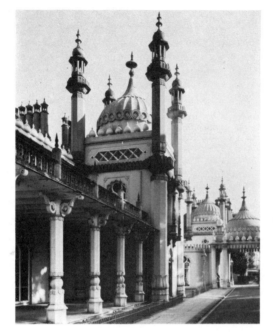

180 Brighton Pavilion: the Hindoo style as completed by Nash.

181 Section of the Brighton Pavilion – engraving by Nash.

by Samuel Pepys Cockerell for his brother, a retired Indian 'nabob', with the active help of Humphrey Repton, and possibly of William and Thomas Daniell. It was, according to Repton, based on the drawings of the Daniells, though these were not published until 1809, 'I gave my opinion, even assisted in selecting from from Mr. T. Daniell's collection of drawings.' In other words, it took elements from the drawings and adapted them to dress a basically European house: the disposition of the windows, for instance, even on the south front is purely classical, and this cannot be hidden by scalloped arches. It is the detail, the Mogul cornice (*chujja*) and bracketing, the dome, and the pinnacles that give it its undeniable eastern air.

Brighton is even odder: not the product of a single-minded client, nor the work of one sole architect. Holland's basic enlargements to the existing house were adapted successively by Robinson, Porden and Nash. (Repton had supplied a splendid chinoiserie design that was not

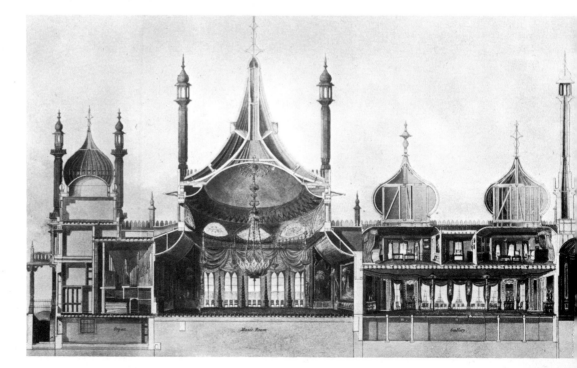

used.) The style was 'Hindoo', and was certainly
partly based on Sezincote, which the Prince
Regent visited in 1807. Outside, it is Hindoo, or
partly so: inside it is 'Chinese' — the Prince had
changed his taste by 1815.

A third is the Palazzo Favorita at Palermo
begun late in 1799 for Ferdinand IV, King of the
Two Sicilies. Outside it has various features that
stamp it as chinoiserie — fret railings, and an
octagonal pagoda roof — while the whole was
painted in brilliant colours. Two splendid fea-
tures were the spiral staircase built into an
open-sided minaret, and the stables imitating a
sort of tent.

But on the continent of Europe in general, the
early nineteenth century brought with it a
lessening in the fervour for chinoiserie: not only
did it remind one of the *ancien régime*, but
Napoleon had imported the new style, the
Egyptian style, so readily adaptable to classical
notions.

In England, however, chinoiserie continued —

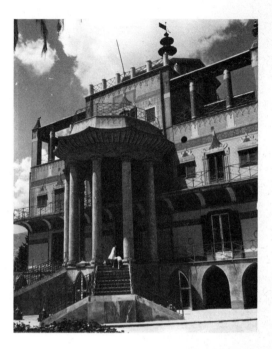

182 Palazzo Favorita,
Palermo, built by Guiseppe
Patricola, *c.* 1800 for
Ferdinand IV.

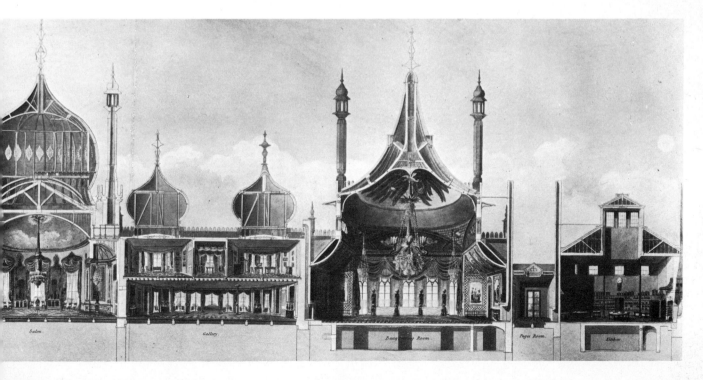

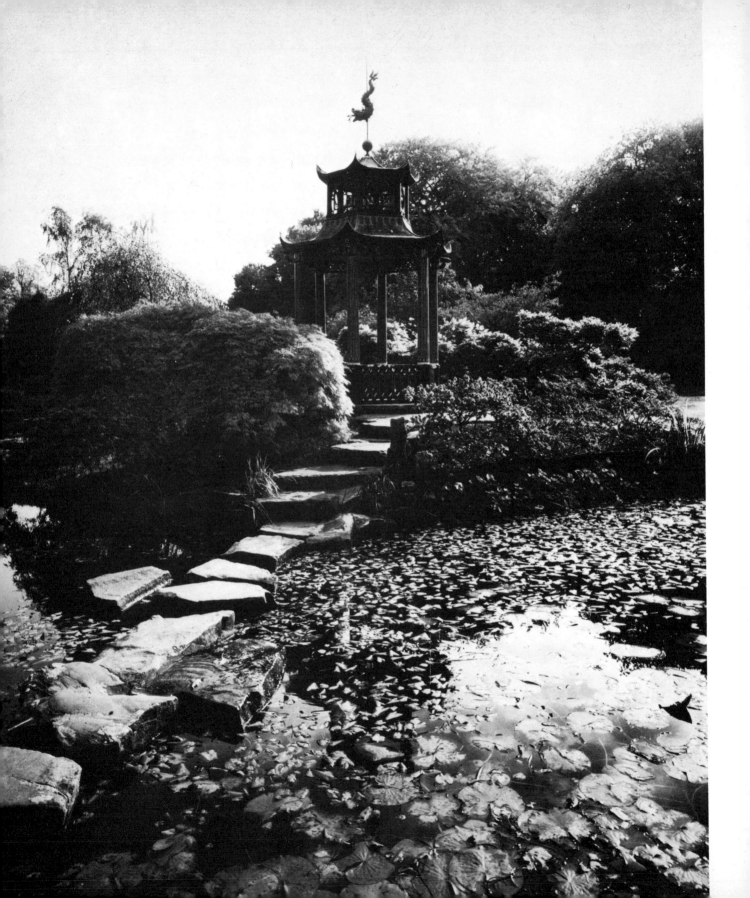

not particularly enhanced in favour by the example of the Prince Regent — but it continued. The gardens of Alton Towers in Staffordshire were laid out, and its Pagoda built in the 1820s, and in spite of the new craving for mediaevalism and the Jacobean revival of the early Victorian years, there was even a Chinese pavilion (made of iron) in the Great Exhibition of 1851. It is now at Cliveden, Buckinghamshire.

As an amusing corollary to a chapter on chinoiserie building, it is interesting to see the process in reverse. In the 1750s the Ch'ing Emperor Ch'ien Lung had built in the north eastern corner of the great Yüan-ming-yüan a series of palaces in European style. These were not so much a 'copy' of Versailles as is sometimes claimed, but more a version of Italian baroque: *baroquerie* one is almost tempted to call it. These buildings have not survived, but excellent engravings demonstrate their curious mixed character, and some details can be discerned from the photographs of the ruins taken in 1922 by Osvald Sirén.

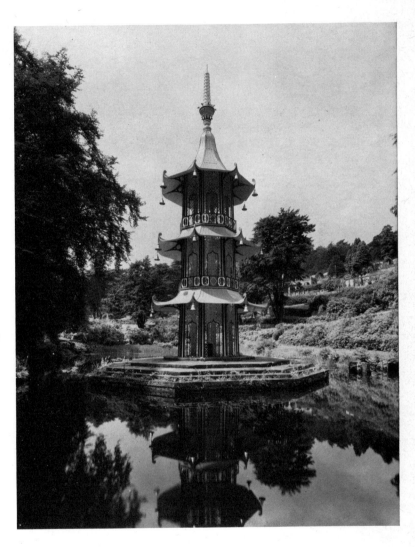

183 left The Chinese pavilion made for the Great Exhibition of 1851, now at Cliveden, and set in a 'Japanese' garden.

184 above The pagoda at Alton Towers: it is reminiscent of Chambers's design of 1757 (*see p. 146*) but was actually built after 1820.

Chapter Twelve

Interior Decoration

In many ways it is the interior decoration of a room that most displays the taste of its time. When it has lasted unchanged, it can tell us more than can, say, furniture or porcelain, or even pictures, for we know how it was intended to look *in situ*: pictures, porcelain and furniture can be moved from place to place in a room, from room to room, or can be broken, sold, replaced. Rooms, even when moved entire to a museum, still retain their complete spatial arrangement.

A number of chinoiserie rooms of several differing types have remained virtually unchanged since the eighteenth century, and it seems worth while to examine them in some detail.

In pre-Renaissance Europe there was little comfort in the way of window-glass, floor-covering, or heating, and the smoke-laden atmosphere produced by the open fire precluded the use of almost all fabrics save tapestry. With the Renaissance came the demand for comfort in the house: the fireplace and chimney, covered walls, turkey foot-carpets, even window-glass. Wood-panelled walls, chairs, sometimes even covered in a cushion, and curtained beds became widespread. Tapestry and painted leather provided an even warmer effect than panelling, but both were extremely expensive.

Tapestry and painted, japanned or gilded leather could, of course, be decorated with chinoiseries. But in this chapter I want to discuss the overall effect of the room rather than the details of any chinoiserie decorations. And so I shall be describing mainly wall-coverings (some of which have themselves been discussed individually in other chapters).

Not until the seventeenth century was the room designed as an entity, perhaps by the architect. No longer were there tapestries or wall hangings arranged arbitrarily – instead, the wall coverings were specially made for and fitted to the room. Even the furniture could be made for the room, and by the end of the century was arranged in a formal way around the walls, with little furniture being used in the middle of rooms.

Chairs had cushions, or were even upholstered; carpets were used less for table covers and more on floors. Wall covering included silk panels and, later, silk-covered walls: the material used for the bed curtains and chairs was often the same as that on the walls. Window curtains were in use in France in the mid-seventeenth century, but not in England until the early eighteenth: then they too were often *en suite*.

The Italian silk industry had been able to provide silks, damasks and velvets for Europe since the thirteenth century. In the seventeenth century the French silks of Tours and Lyons replaced the Italian silks, save for the rich figured velvets of Genoa, with which the French could never compete. From that time on, almost all European silk designs were based on French patterns. That these French designs depended ultimately on Sasanian, Byzantine and Chinese patterns (among others) we have already seen in Chapter 5. In the seventeenth and eighteenth centuries the patterns are further and further removed from these origins, under the constant pressure for new designs each year, for novelty. Between 1700 and 1730 the 'bizarre' silk patterns are more markedly non-oriental and were followed in turn by such patterns as the realistic floral patterns, the neo-classical ribbon patterns and the chinoiseries. Patterns based on the designs of Huet, Pillement[1] and others of the more frivolous styles of chinoiserie enjoyed a vogue for the latter half of the eighteenth century, while the flowered and sprigged silks of the end of the century reflected patterns of Indian chintz.

In the sixteenth century a cheaper substitute for silk materials had begun to appear in Europe. This was the painted or printed cottons, for use as furnishing or dress materials, imported from India first by the Portuguese, who called them pintados (spotted cloth) and later by the Dutch and English, who called them chintz.

We have seen how these were influenced by European demands as early as 1643. By the 1680s ready-made suites for bed-hangings, curtains, and vallances were being ordered by the

1. plate facing p. 20

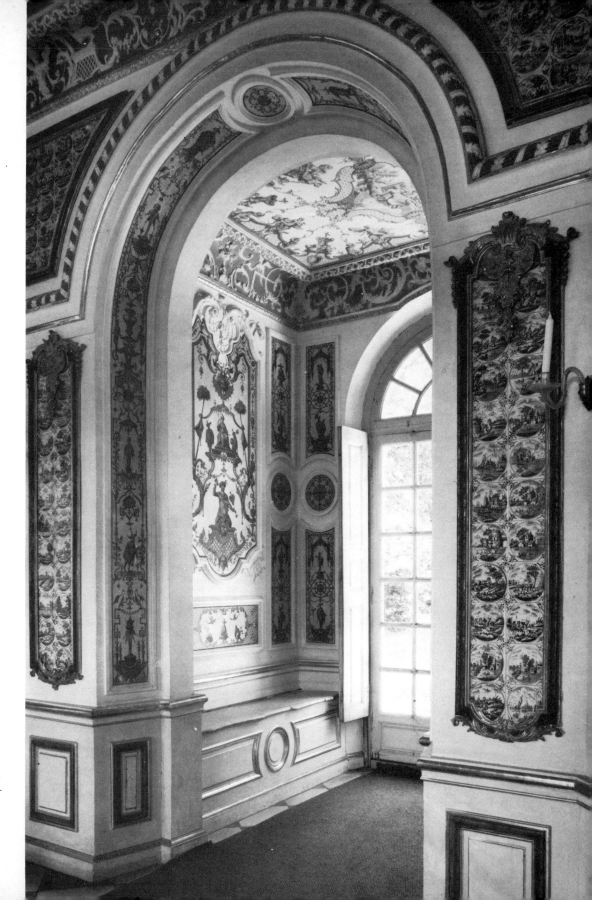

185 Blue-and-white. Delft tiles and chinoiserie painting on the landing of the Pagodenburg. *See p. 165*

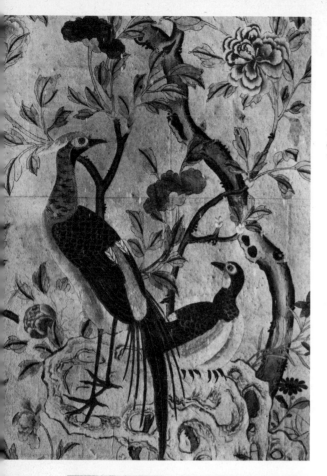

186 'Indian' paper – detail of an 18th-century Chinese wallpaper.

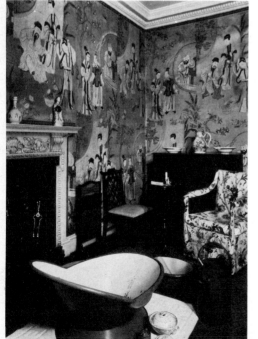

187 The Chinese dressing-room at Saltram House with incorrectly hung Chinese wallpaper.

hundred. Chintz was also used for wall covering. On 5 September 1663 Pepys wrote: 'Creed, my wife, and I to Cornhill and after many tryalls bought my wife a Chinkse; that is, a paynted Indian Callico for to line her new study, which is very pretty.' This shows that not only was there a considerable choice but also that it was easily available. It was in fact imported in such great amounts that by 1701 a heavy duty was imposed on its import, to assist the struggling Spitalfields silk industry. It remained a source of dress material, however, in spite of regulations prohibiting its use, and patterns derived from chintz are still much used today.

Chintz patterns, especially of the flowering-tree type, were also obviously very influential on the cheapest type of wall covering, wallpaper. Painted wallpapers had been in use in England since the early sixteenth century, but were not common until the seventeenth century. By the mid-seventeenth century, Chinese painted wallpaper was being imported into Europe (it was often called Indian, of course) and by the 1680s it was being imitated in England and by the 1700s in America.

The Chinese wallpaper imported into England seems to have been of two major types, the repeating bird and flower and the non-repetitive landscape. In the former, one big tree-like plant extends in sinuous line upwards, with many branches to either side on which are a multitude of exotic, if somewhat crudely drawn, flowers and birds, highly reminiscent of chintz patterns. Such panels can be seen in many rooms in England today, and the wallpaper hung by Thomas Chippendale in Nostell Priory[1] in 1771 (see Chapter 9) is of this type. More uncommon, and much more difficult to use not only because of its size, but also because of its dominance, was the landscape extending across several panels. The designs of these are similar to those found on Coromandel screens[2] of earlier or contemporary date, and on *famille verte* porcelain; presumably they are all based on Chinese wood-block-printed pattern-books. A splendid example of the latter style is to be found in the 'Colopies'

1. plate facing p. 93 2. illus. 123

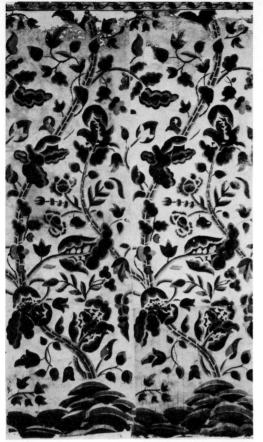

188 left An early 18th-century English wallpaper strongly influenced by chintz design.

189 right Eighteenth-century English flock wallpaper with a more Chinese-style chinoiserie design.

190 Mahogany fire-screen with fragments of Chinese wallpaper: English, mid-18th century.

room at Saltram House in Devon, which also has three other rooms hung with 'India' paper.

In the late seventeenth century Chinese wallpaper was imitated by innumerable wallpaper makers, notably Thomas Bromwich. Wallpaper from China was not cheap and so English substitutes found a ready market. Usually they were as much influenced by Indian calico as by Chinese wallpaper, but as we have seen, Chinese wallpaper itself often owes much to Indian textile design. We have also seen that Indian printed and painted chintzes were adapted to conform to European tastes, so we have here as fine a muddle of oriental and chinoiserie styles as we met in porcelain! An example of Indian-influenced design is visible on the trade-card of Edward Butling about 1690, though he does not advertise, as does George Minnikin (c. 1680), that he 'makes and sells all sorts of Japan and other coloured papᵣ hangings both in sheets and yards . . .' Another advertisement of 21 August 1693 lists 'strong paperhangings with fine India figures in pieces about 12 yards long and half an ell broad'.

There were various taxes put upon paper-making and paper-painting so that not all wallpaper was cheap, and it was often hung on canvas upon a wall, so that it could be moved, rather than upon the bare wall. Some papers of about 1700 seem to have cost only 2d or 3d for pieces of 12 yards length, though more expensive papers were sold by the yard: in 1754 the Duke of Bedford paid the large price of 4s per yard to Messrs Crompton and Spinnage, but this was probably for an elaborately embossed paper and not for an 'Indian' paper.

Chinese wallpaper was expensive enough, and well enough liked for it to be used for smaller decorative effects[1]. In 1758 Vile and Cobb charged Sir Charles Hanbury-Williams £1 10s 'for a mahog. 2 leav. screen wᵗʰ frett at bottom, cover'd with India paper'. This would have been made of sheets cut from other larger pieces. This was a common practice even on walls, where it did not seem to matter much whether a pattern corresponded exactly — it was the effect that

counted. Crace and Son's work at the Royal Pavilion, Brighton included bamboo-patterned wallpaper cut in strips so as to form a framework for other patterns.

Chintz and Chinese wallpaper made a pretty effect, but could not really be used for very grand rooms; they were considered suitable only for bedrooms and private sitting rooms. It was the brilliant colours and glossy surface of porcelain and lacquer that provided the possibility of the formal 'Chinese' room.

Perhaps the earliest *Porzellanzimmer* was the incredible room built for Friedrich III of Brandenburg by Andreas Schlüter, presumably with the help of Gerard Dagly (p. 116), at the Oranienburg, just outside Berlin. An engraving of 1733 by J. B. Broebes shows the very walls and pillars to be encrusted with cups, plates and so on: 160 cups to each flute of the Corinthian columns! Specially made stands, wall brackets, shelves and cornices were layers deep in vases, and innumerable plates were attached to the walls. On the ceilings were painted allegories of Asia presenting porcelain to Europe: some of the porcelain is clearly identifiable. As if the Oranienburg was not big enough, Friedrich also built the Charlottenburg, west of Berlin, in which were two *Porzellanzimmer*, one designed by Eosander von Göthe and with mirrors behind the wall brackets. These rooms had nothing to do with the display of porcelain: it was the effect that was required.

Several such rooms were built by various German princes, and Princess Mary of Orange had one at Hunsslardiek, probably designed by Daniel Marot. In 1687 Nicodemus Tessin described this room as: '*very richly furnished with Chinese work and pictures. The ceiling was covered with mirrors . . . with the most beautiful effect imaginable, . . . The chimney piece was full of precious porcelain, part standing half inside it, and so fitted together that one piece supported another.*' When William and Mary later came to England, they determined to build a porcelain room at Hampton Court. Among the artists employed by Wren for the improvements to the Water

The Music Room, the Royal Pavilion, Brighton. Decoration by Crace and Sons for the Prince Regent.

1. illus. **190**

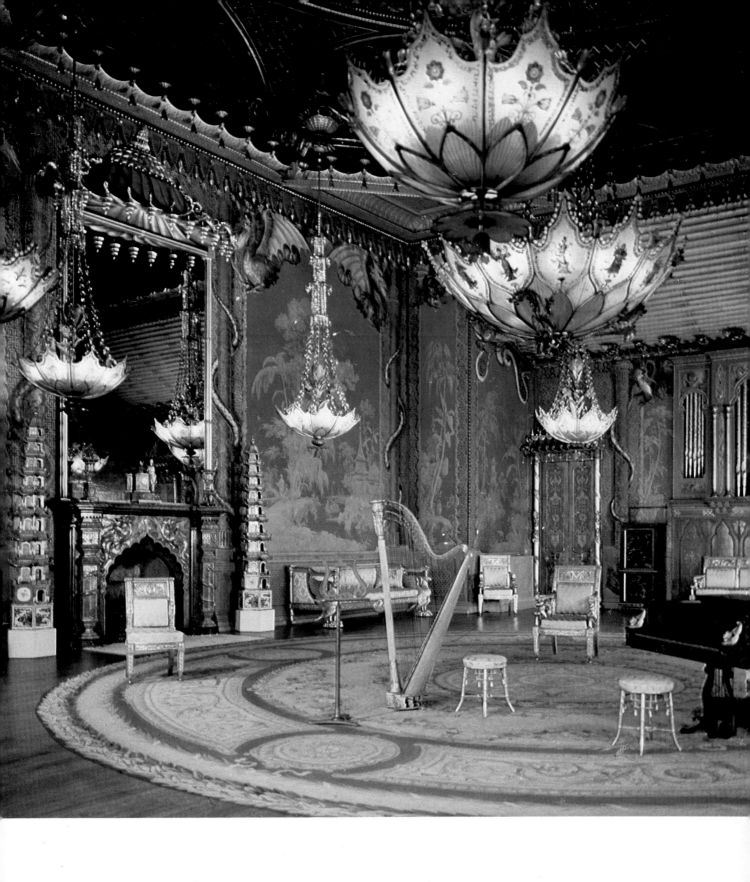

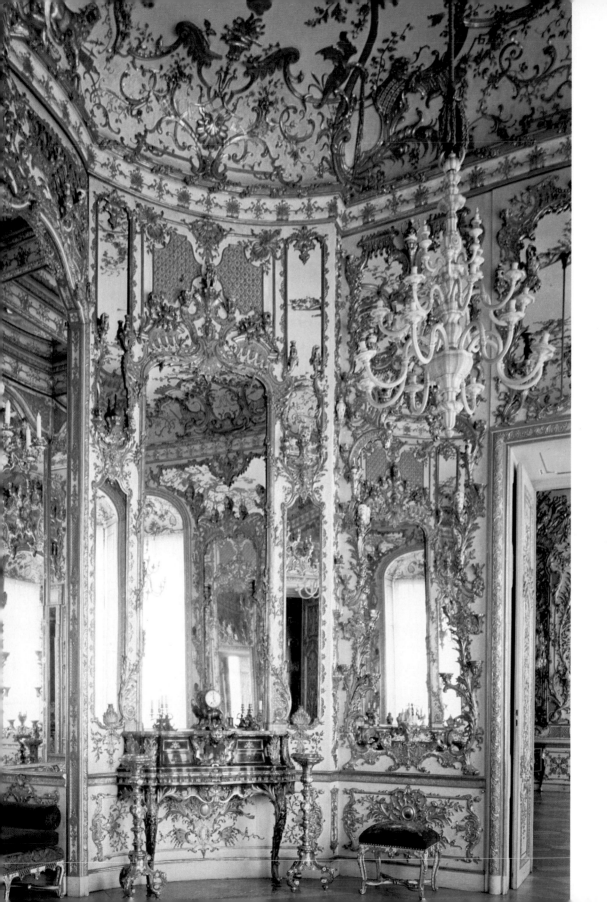

Gallery was Grinling Gibbons, and his drawing for a chimney-piece with special arrangements for the display of porcelain still exists.

In general, however, collections were not so enormous, and while many great houses of Europe had a *Porzellanzimmer* with brackets and shelves of porcelain, few were so crowded as the examples cited above. They were intended for the display of porcelain as much as for the glittering surface and bright colours.

In the late 1720s Augustus the Strong planned for Pillnitz a room, or rooms, to house his huge collections of porcelain, that would be made of porcelain, walls and all. Logically this is an extension of tile-work as much as an extension of the *Porzellanzimmer*. Tile work was an obvious choice for kitchens and bathrooms (the latter were rare!), and was used for some time for closed-stoves and fire-surrounds. But blue-and-white tiles particularly had a Chinese flavour, in spite of their often domestic Dutch detail, and some sets of tiles were specially made with chinoiserie scenes. In the Amalienburg at Nymphenburg, the kitchen is tiled throughout and included a Chinese type scene composed of many tiles. These had been in store in the Residenz for some years, and by the time Cuvilliés installed them, many were missing and the whole scene has been jumbled up like an incorrectly assembled jig-saw. In the Pagodenburg, blue-and-white delft tiles decorate the landing and window embrasures of the staircase.

The room at Pillnitz was never built, but three porcelain rooms, partly or incompletely panelled or fitted with interlocking pieces specially made for them, still exist. The Du Pacquier porcelain fittings in the Dubskychen Palais near Vienna, built in the 1730s, were confined to mouldings and architectural and decorative features, and did not include the background. The wall-lights, chandeliers and chimney-piece also were all elaborately modelled in porcelain.

For the Portici palace near Naples the Capodimonte factory made the first entire room of porcelain: 3,000-odd pieces. On the white ground, panels of Chinese figures stand among trophies and flowers of rococo style. Large wall mirrors set into the porcelain enhance the brilliance of the room even more. A similar room at Aranjuez was made by Capodimonte artists transported to Buen Retiro (the chandeliers may be from the same set of moulds), but the figures show so much distinction, and similarity to the figures in the Villa Valmarana frescoes[1], that they may have been designed by Gian Domenico Tiepolo, who was in Spain at that time (1761).

If a wall covered in porcelain provided a splendid effect, so did one panelled in lacquer or japan. The Chinese screens imported to Europe in the seventeenth century were not always preserved intact. Sometimes they were cut up and made into cabinets, but they could also be used as wall-panelling or wainscoting. They were relatively easy to split so that both sides could be used, and where they did not fit, then a cabinet maker and a japanner would be called in to make up the necessary pieces. Thus in 1683 Gerreit Jensen was paid £41 for work in the 'Japan Closet' at Chatsworth, which according to Celia Fiennes was wainscoted in 'hollow burnt Japan' (Coromandel). He was paid for 'framing moulding, and cutting of the Japan, and joyning it into panels'. As with many lacquer rooms of Europe, it was later dismantled, and the panels used for furniture.

The year before, John Evelyn had written of his 'neighbour Mr Bohun, whose whole house is a cabinet of all elegancies, especially Indian; in the hall are contrivances of Japan screens instead of wainscot'. Naturally we cannot tell from Evelyn's description whether the japan was oriental or English. If it was panelled in European japan, it must have been one of the earliest of its type, and would likely have been commented upon more fully by Evelyn, whereas oriental wainscoting was already becoming fashionable. An early — if not the earliest — still existing japanned room is that in Rosenborg Castle, Denmark. This has been erroneously dated to 1616, but recent work has shown it to be the work of a Dutch japanner of the 1690s, while much of it was redone or restored in

The rococo porcelain room at Schloss Nymphenburg, Munich, by Cuvilliés and Zimmermann.

1. p. 170

191 The *Porzellanzimmer* at Oranienburg (*see p. 164*), an engraving by J.B. Broebes, 1733.

1716: many of the motifs illustrated in the walls are taken from Nieuhoff's book of 1635 and Stalker and Parker's of 1688. All the same, it is ancestral to many later japanned or partly japanned rooms in England, France, Italy, Russia, Moravia, Portugal, and, above all, Germany.

A lacquer room in Prague built for Count von Sternberg in 1709 is of double interest to us here firstly as an early japanned room, and secondly because it was also intended for the display of porcelain on brackets etc. to which the japanning was to provide a background. At Ludwigsburg, the Nürnberg japanner Johann Jacob Sänger built a room for Duke Eberhard Ludwig of Württemberg in 1717, where chinoiserie panels in colours on a dark ground are surrounded by gilded rococo woodwork on a red and brown ground; here also there were a few brackets for porcelain.

In the great baroque library of the University of Coimbra in Portugal even the book-cases are japanned green and red, and have discreet gilt chinoiseries. For many of these japanned rooms, it was not the detail of the chinoiseries that mattered — they were, so to speak, so much

192 The tiled kitchen of the Amalienburg, Schloss Nymphenburg — polychrome and blue-and-white tiles.

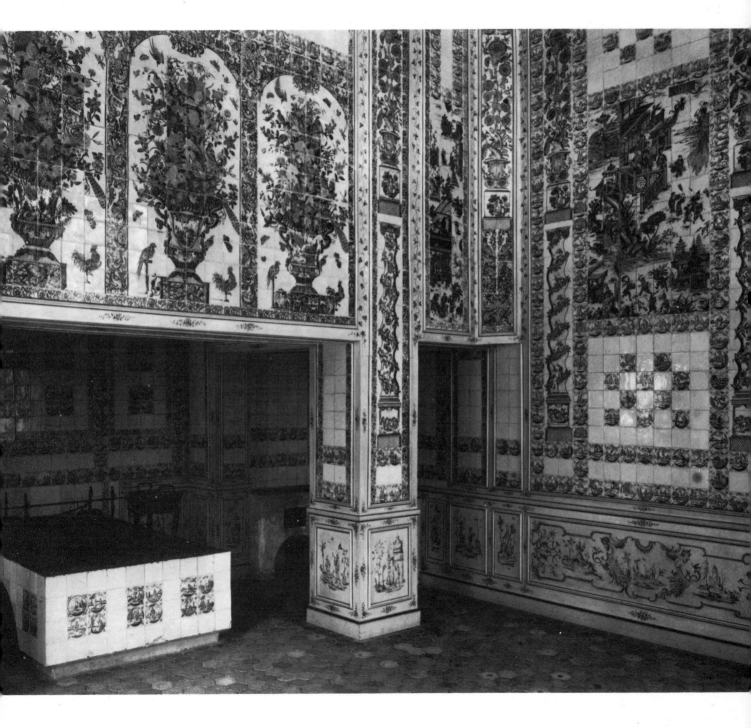

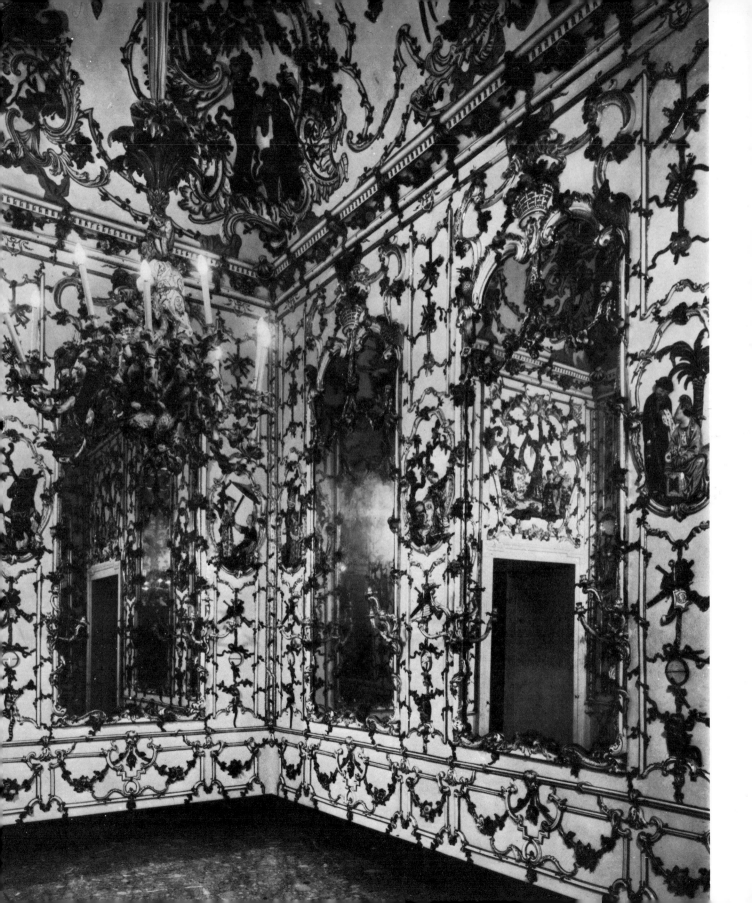

wallpaper – what mattered was the glowing colour and shining surface of the japan. This is even true of some cases where oriental lacquer is used, for instance in the Palazzo Reale in Turin. Here Filippo Juvarra designed a room for some panels of Chinese lacquer, which were augmented by some japanned panels by Pietro Massa, to form an interior of great magnificence, but where the chinoiserie is hardly of importance.

Lacquered and japanned rooms continued in favour throughout Europe until the 1760s, though there are a few even after then. Among the better rooms of the forties and fifties are, or were, those at the *Eremitage* near Bayreuth, at Tsarskoe Selo near Leningrad, at Potsdam, Schloss Nymphenburg, Schloss Brühl and Drottningholm, near Stockholm. In many of these rooms, lacquer and japan were mixed: in 1763 William Vile was paid £572 12s for 'making out all the old japan brought from the Queen's House, new drawing and securing it, and making a quantity of new japan to make out the old to fit the different wall' in St James's Palace. Pyne (1819) calls the room 'the Queen's Breakfast Parlour'. This must have been nearly at the end of the fashion in England, though in Holland the *Huis Ten Bosch*, the summer palace near the Hague, had a 'Japanese' room with inset lacquer panels installed as late as 1785.

Not all the chinoiseries used to decorate rooms were done on japanned backgrounds; many were on plain paintwork. In France in particular, where japanned rooms were not common (though two interiors by the Martin brothers are mentioned on pp. 118–9), chinoiserie wall paintings in the grotesque style were fashionable in the first half of the eighteenth century, often in that curious variation of the style called *singerie*, where monkeys act the part of people[1]. Why exactly monkeys were considered oriental is difficult to assess, but they had appeared in the more chaste work of Bérain and were used almost throughout the eighteenth century. These rooms were nearly always panelled, so that the paintings did not run riot over the walls, but were enclosed within some sort of framework –

193 left The room of Capodimonte porcelain from the Portici Palace, Naples, 1757–9.

194 right The green japanned room at Rosenborg Castle. Copenhagen. The lower panels (see detail) copied after Nieuhoff.

often gilded woodwork. Huet's *Grande Singerie* in the Château de Chantilly, painted in 1735, was among the most delightful of the genre. The smaller room at Chantilly (on the ground floor) is perhaps even more attractive than its more famous companion; shaped panels of grotesque *petites singeries* over a moulded wainscot in similar style give a beautifully delicate effect. Even the reverse of the shutters are painted to match. The figures in the chinoiseries by Huet

at the Château de Champs are proportionately somewhat larger, and this development was followed elsewhere.

A house in England, Kirtlington Park Oxfordshire, has a good example of a *grande singerie* ceiling and ceiling cove, painted in 1745 by J. F. Clermont (at a cost of £70); Clermont, a Frenchman, worked in England for several years. At Kirtlington the monkeys are engaged in various sporting activities: one, riding a greyhound, is shooting at a hare, but will almost certainly miss, and hit one of his own mastiffs instead.

All these chinoiserie paintings we have seen have been relatively discreet. None have had the dominating effect of large scale designs, such as were used for the frescoed Venetian villas. In fact, one of the most famous of all chinoiserie interiors must be that of the Villa Valmarana at Nani, near Venice, with its great frescoes by Gian Domenico Tiepolo. Anyone familiar with the work of Giambattista Tiepolo, the father of Domenico, might be excused surprise on first view of these grim figures. There is none of the lightness so superbly captured by Giambattista, whose ceiling on the grand staircase at the Würzburg Residenz has touches of chinoiserie for the 'Continent of Asia', and whose style is so suitable for the more frivolous aspects of chinoiserie that it is sad that there are no examples. Domenico's figures at Villa Valmarana have none of that; indeed they have a solidity and an almost evil look that belies their fancy dress. One character exhibits a roll of chintz or wallpaper as if it were the stolen plans of the Bruce-Partington submarine, before the arrival of Sherlock Holmes. The Villa Valmarana frescoes were painted in 1757 and almost immediately afterwards Domenico went to Spain with his father, where he seems to have had a considerable influence over the decoration of the room of

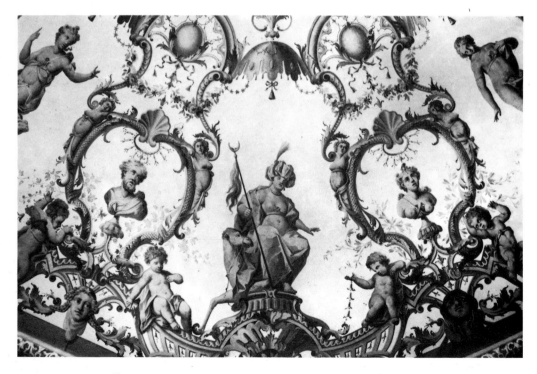

195 Asia – detail of ceiling painting from the Pagodenburg, Schloss Nymphenburg.

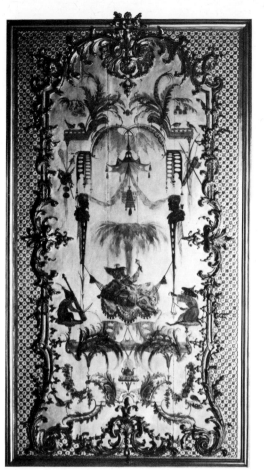

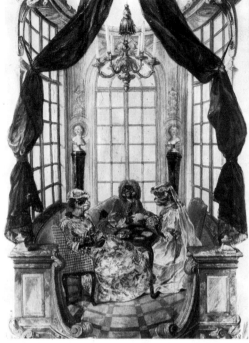

Singerie:
196 right One of Christophe Huet's *grande singerie* panels for Chantilly, *c.* 1735.
197 far right *Petite singerie* from the lower rooms at Chantilly, by Huet.

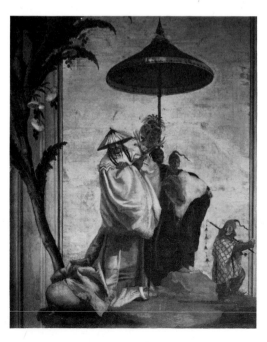

198 Chinese figures from the Villa Valmarana frescoes by Gian Domenico Tiepolo, 1757.

Buen Retiro porcelain at the Palacio Real, Aranjuez.

Curiously, few other Venetian villas seem to have had chinoiserie frescoed rooms. One, the Villa Grimani-Vendramin Calergi at Noventa Padovana, has a first-floor room decorated by Andrea Urbani in a soft and toy-like style, in the late 1770s. Here all the figures appear to be dancing – even those not actually doing so – save for the almost obligatory dwarf weighed down by a vast porcelain jar.

Wall painting and fresco was not often used in England: there were no rococo followers of Verrio or Thornhill. In fact, apart from furniture and some excellent plaster work, rococo was very cautiously used in England. There is virtually no rococo architecture. There are few great rococo interiors and there is not even any rococo woodwork panelling. It must be remembered, though, that the rococo and chinoiserie 'carvers'

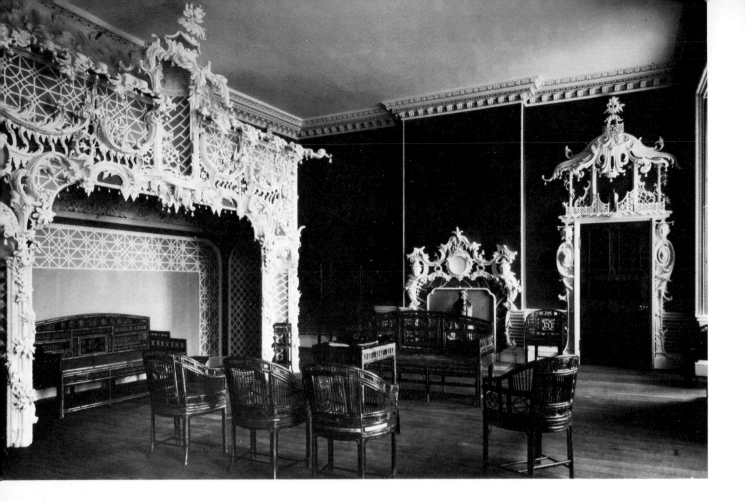

works' by such designers as Thomas Johnson, Chippendale, and Ince and Mayhew were meant to be fixed to the wall, and not to hang. Nowadays fashion decrees that all such carved work must be gilded, but original accounts show that often these carvings were painted or japanned.

From such 'carvers' work' descends the oddest of all European chinoiserie interiors, the Chinese Room at Claydon House, Buckinghamshire. Much of the room is decorated in fantastic high relief wood carvings, painted to imitate plaster, of chinoiserie scenes and figures. Carved by the otherwise almost unknown Mr Lightfoot, and finished in 1769, they have a naïve but vigorous quality that is as far removed from China as chinoiserie could get. Clearly much influence can be traced to the work of Thomas Johnson, but the Claydon House carvings are exceptional, and appear to have provoked no imitations.

Mr Lightfoot had wanted a rococo balustrade to the staircase at Claydon, but his designs were

not accepted. It seems a little surprising, perhaps, that he did not suggest Chinese fret. At Boughton House there is a 'Chinese staircase' which Christopher Hussey dates to about 1740 (which would make it the earliest use of Chinese fret in England) while after the period of Claydon, there are but few others, examples being the iron staircase balustrade at the Pagode de Chanteloup and a staircase at Battersea, near Petersburg, Virginia. Clearly, Chinese fret was suitable for out-of-doors, but not for interior decoration (it was, of course, an important feature on furniture, see Chapter 9).

I said at the beginning of this chapter that we would be concerned with the chinoiserie interior, that is, with the whole decoration of a room. And so we have been, but it must be remembered that in the seventeenth and eighteenth centuries it was virtually impossible for the decorator to be consistent. Chinoiserie schemes could hardly avoid being mixed with rococo, neo-classicism,

or gothick. Chinese wallpapers were hung in ordinary European rooms, lacquer panels were set in rococo gilded woodwork, *singeries* might be painted on pale-coloured neo-classical panelling. The complete chinoiserie interior was a rarity, and because of fluctuating fashions, is an even greater rarity today. The Chinese House at Drottningholm, outside Stockholm, is one of these survivors, but it pales by comparison with the interiors of the Royal Pavilion at Brighton.

The interior of the Pavilion is one of the most thorough of all chinoiserie interiors. Curiously enough, enamoured though the Prince Regent was of exotic styles, as he had shown in the chinese room at Carlton House, it had originally been intended that the interior of the Pavilion should have been neo-classical. The gift of some fine Chinese wallpapers in 1802 changed the Regent's mind, and the Pavilion became the most exotic oriental building in Europe. The chinoiserie furniture by Holland from Carlton House was brought in; the Music Room columns were painted with dragons: imitation bamboo and bamboo wallpaper proliferated. Although Crace and Sons were the decorators, in the first four years of the century, many oriental things were supplied – it was only later, after 1815, that much more of it was chinoiserie. So it was not until the Regent's return to the Chinese taste in 1815 after his long flirtation with the 'Hindoo' that the interiors of Brighton were finally decorated, throughout, in chinoiseries. The Yellow Drawing Room (now the North Drawing Room) was decorated with brilliant painted chinoiserie panels and lit by rows of tasselled Chinese lanterns. Most fantastic of all was the Banqueting Room by Robert Jones and Frederick Crace. The ceiling is domed and painted as the sky in which sits a gigantic banana-like treetop. Suspended from this is a dragon which carries a huge chandelier upon which sit more dragons. All the furniture was similarly ornamented with dragons, and there was even a dragon in the huge Axminster carpet. Wall paintings of 'Chinese' scenes by Robert Jones, in panels on a silvered ground were

framed in blind-fret in red and yellow. Brayley, describing the room in 1838, wrote: '*no verbal description, however elaborate, can convey to the mind or the imagination of the reader an appropriate idea of the magnificence of this apartment . . . Yet luxuriously resplendent and costly as the adornments are, they are so intimately blended with the refinements of an elegant taste that everything appears in keeping and in harmony*'. Little less magnificent is the Music Room, with its huge panels of gilt chinoiserie scenes on a red japanned ground, that are derived partly from the drawings of William Alexander. It was all finished by 1822, and recent restorations, and the return of much of the original furniture, shows it to have been a high point in chinoiserie decoration. Unfortunately the Music Room was damaged by fire in 1975.

Chinoiserie could go no further, and the Regent's example was not much followed. Mediaevalism became the rage and only the rediscovery of Japan revived the chinoiserie interior in the second half of the nineteenth century.

199 left The Chinese room at Claydon House, by Lightfoot, finished in 1769. The detail shows the hoho bird (*see also illus. 8*), in the style of Thomas Johnson (*p. 122*). The cane furniture is similar to that drawn by Sir William Chambers (*see p. 126*).

200 The Long or Chinese Gallery, Brighton Pavilion. Aquatint by Nash.

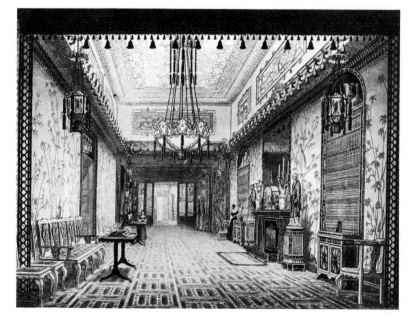

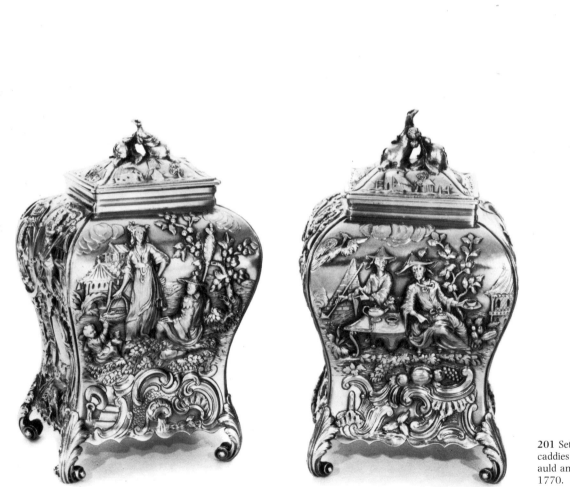

201 Set of three silver tea caddies by Louisa Court-auld and George Cowles, 1770.

Chapter Thirteen
Metalwork

In 1254, William de Rubruck[1] was guest of Mangu Khan at a great banquet held at Karakorum, when the centre-piece was a wine-fountain, made by Guillaume Boucher, a French craftsman who had been captured in Hungary by the Mongols in 1242.

'*Mangu had at Caracorum a great palace*', wrote Friar William, '*. . . where he has his drinkings twice a year . . . In the entry of this great palace, it being unseemly to bring in there skins of milk and other drinks, Master William the Parisian had made for him a silver tree, and at its roots are four lions of silver, each with a conduit through it, and all belching forth white milk of mares. And four conduits are led inside the tree to its tops, which are bent downward, and on each of these is a gilded serpent, whose tail twines round the tree. And from one of these pipes flows wine, from another cara-cosmos, or clarified mare's milk, from another* bal, *a drink made with honey, and from another rice mead, which is called* terracina; *and for each liquor there is a special silver bowl at the foot of the tree to receive it. Between these four conduits in the top, he made an angel holding a trumpet, and underneath the tree he made a vault in which a man can be hid. And pipes go up through the heart of the tree to the angel. In the first place he made bellows, but they did not give enough wind. Outside the palace is a cellar in which the liquors are stored, and there are servants all ready to pour them out when they hear the angel trumpeting. And there are branches of silver on the tree, and leaves and fruit. When the drink is wanted, the head butler cries to the angel to blow his trumpet. Then he who is concealed in the vault, hearing this blows with all his might in the pipe leading to the angel, and the angel places the trumpet to his mouth, and blows the trumpet right loudly. Then the servants who are in the cellar, hearing this, pour the different liquors into the proper conduits, and the conduits lead them down into the bowls prepared for that, and then the butlers draw it and carry it to the palace to the men and women.*'

This fantastic device was surely in a mixture of western and eastern styles. It sounds as though it had a romanesque flavour, and yet it

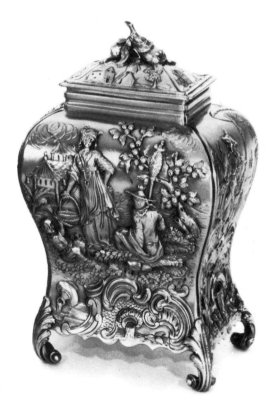

probably depended on Persian prototypes, which were also copied in Constantinople. Luitprand of Cremona saw a similar contrivance in Constantinople at an audience granted to him (as ambassador of the Lombard King Berengarius II) by the Emperor Constantine Porphyrogenitus in 946.

Goldsmiths' work was always prized in Europe, not only for its intrinsic worth, but for the skill of the smith and the luxury of the effect. The reliquary[1], a valuable container for holding a Holy Relic, was often a masterpiece of gold craftsmanship. Often the relic contained was, say, an arm of a saint, when the reliquary might be made in the shape of an arm. From reliquaries, the craft was extended to curiosities and rarities. Objects from the East or from Africa were given elaborate mounts: bezoar stones (concretions found in the intestines of some Asian animals), Nautilus shells, ostrich eggs, coconuts and so on were thus treated. Antique objects from Egypt or Rome were similarly treated. The famous porphyry vase[2] mounted in gold in the shape of an eagle of distinctly Byzantine aspect, in the Treasury of St Denis was just such a piece. Abbot Suger wrote in about 1144 of the 'porphyry vase, made admirable by the hand of the sculptor and polisher, after it had lain idly in a chest for many years, converting it from a flagon into the shape of an eagle'. Pieces as well documented as this are very rare.

When porcelain appeared in Europe it was mounted not only to enhance its value and to make it more elaborate and conspicuous, but also to protect it from damage. The most famous of early mounted porcelains was the Fonthill Vase, mounted in 1381, described in Chapter 7.

The mounting of porcelain was quite common by the sixteenth century: a piece of mounted Chinese blue-and-white is seen in the Bellini/Titian 'Feast of the Gods', painted about 1514[3] (see Chapter 7). Turkish Isnik wares, European salt-glaze mugs — all could be embellished with gold or silver and enamelled mounts.

In eighteenth-century France, this reached a peak of elegance when rococo and, later, neoclassical ormolu mounts were fitted to Chinese monochrome wares. Sometimes several pieces, some oriental, some European, were mounted together, and with ormolu and Vincennes[4] porcelain flowers: this was considered especially suitable for *blanc de Chine, pagods, famille-verte* biscuit figures and for Imari figures.

Such mounts were usually fitted to exotic oriental objects, be they beautiful pearl-shells, or Ming porcelain. It is only after the beginning of the sixteenth century that exotic animals and oriental-type motifs appear as objects in their own right; that is, without a 'curiosity'. Of course such things often had a function as well as being decorative — table-centres, salt-cellars, table-fountains and so on. The famous salt-cellar made by Benvenuto Cellini for François I some time before 1544, which has a sea god and a sea goddess as main decoration, has, under the god, sea horses, but under the goddess, an elephant. A particularly spectacular elephant was made as a table-fountain in silver-gilt by Christoph Jamnitzer of Nuremberg, about 1600. It is in the form of one of Hannibal's elephants, with a castle on its back full of ferocious-looking Carthaginians repelling Scipio's attackers who are conspicuously absent. The *mahout* is a moor, and on the elephant's rump sits a monkey. Quite possibly the model is derived from an engraving by Martin Schongauer, taken when an (African) 'helffandt' was led round Germany by a certain Hans Filshover in 1482–3.

Such exotic and lavish displays of goldsmiths' work were much admired in the seventeenth and eighteenth centuries. One such admirer was Augustus the Strong, King of Poland and Elector of Saxony. It is inevitable that the name of Augustus the Strong should occur frequently in a book on chinoiserie: his passion for oriental porcelain and other objects had resulted in not only the formation of perhaps the greatest collection of Chinese and Japanese porcelain in Europe, but also in the genesis of the Meissen porcelain factory. Augustus also employed one of the greatest of all goldsmiths and jewellers, Johann Melchior Dinglinger.

Chinoiserie and Japanese lacquer snuff-boxes and an *aide-mémoire*. French 18th century.

Overleaf 'The Birthday of the Grand Mogul' by Johann Melchior Dinglinger, after 1702, for Augustus the Strong.

1. illus. **40** 2. illus. **202** 3. illus. **83** 4. illus. **91**

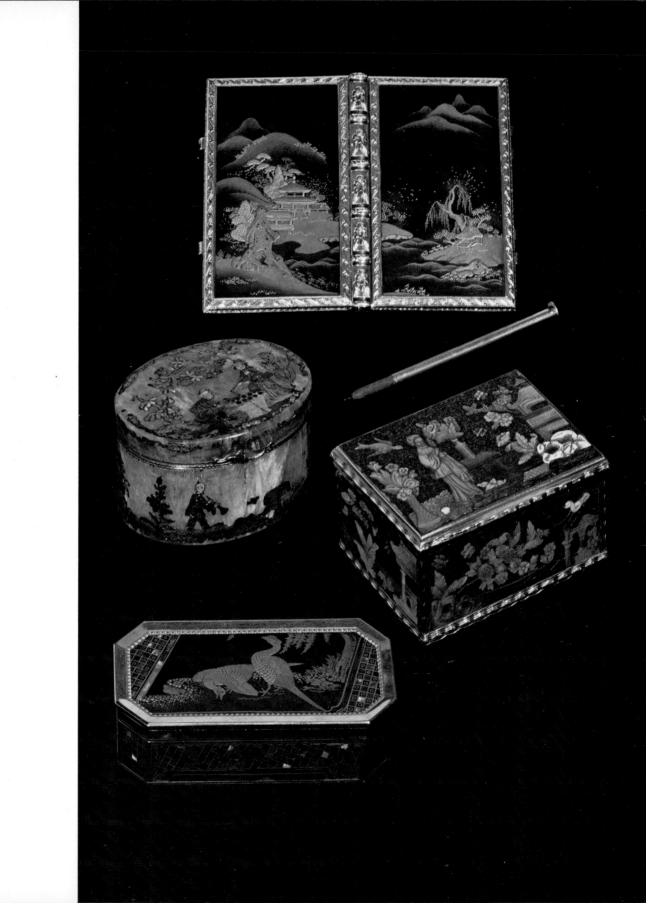

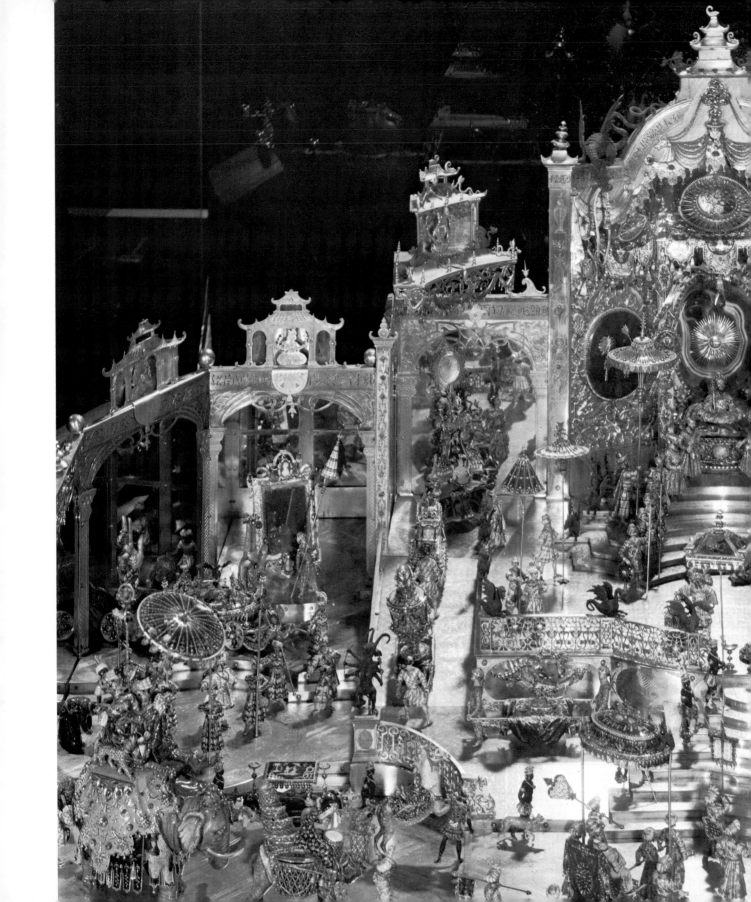

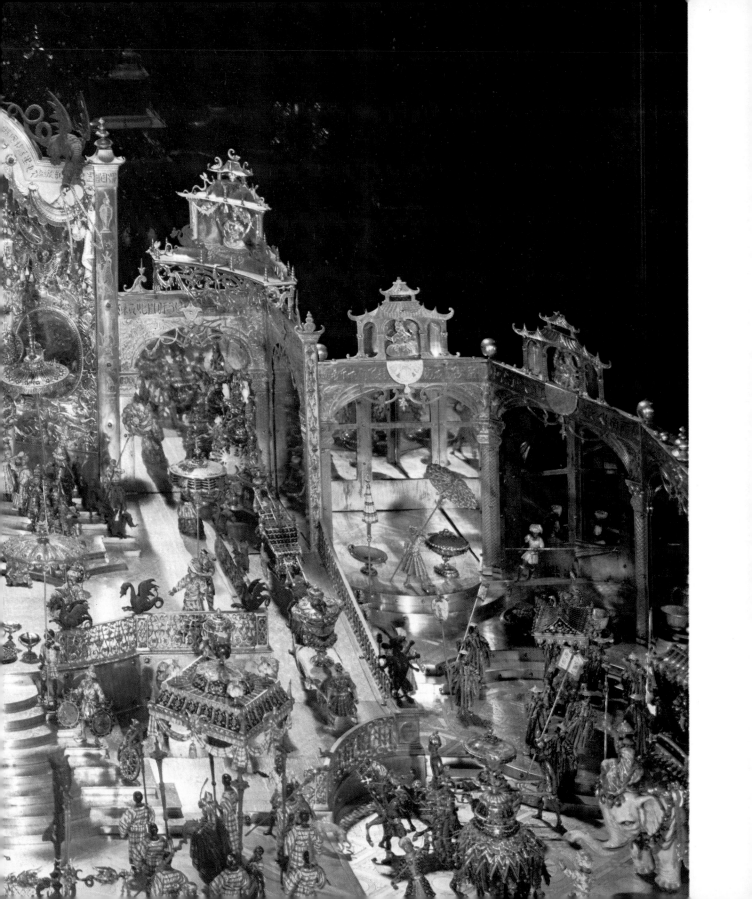

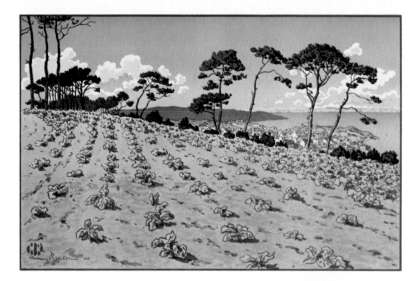

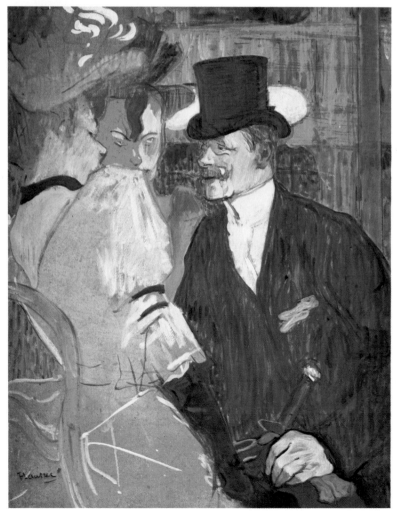

'The Path'. Print in the Japanese manner by Benjamin (Henri) Rivière. *Compare with illus. 221*

The Englishman at the Moulin Rouge by Henri de Toulouse-Lautrec. Coloured drawing. In the prints, the colour areas are evenly coloured, as in a Japanese print.

In 1702 Dinglinger began for Augustus the great centre piece called 'The Birthday of the Grand Mogul'. This model[1] in gold, silver, enamels, pearls, and precious and semi-precious stones, is almost a square metre in area, and depicts over a hundred and thirty men and animals gathering at a terraced pavilion with gifts for the Emperor's birthday. It is interesting to see how Dinglinger has taken his details from a wide variety of sources: certain figures and objects are clearly derived from the published engravings of Nieuhoff (1669), Montanus (1670), Dapper (1681), de Vries (1682), Stefano della Bella (1683) and others. It is tempting to call this one work the high point of chinoiserie: a glorious celebration of all that is fantastic, exotic and lavish of a partly imaginary East based on intermingled elements of Indian, Chinese, Japanese, Near Eastern, and European styles. It is at once a summing-up of the vague knowledge of the East, and a prophecy of things to come.

Small objects were always, throughout the eighteenth century, considered a suitable medium for chinoiserie decorations. Of all the small objects made in Europe, none are so fine, nor so skilfully made or beautifully decorated as the snuff-box. Snuff-boxes (and patch-boxes and other personal effects that were to be used in public) became some of the most extravagant of all displays of skill. In France, in particular, the gold snuff-box, usually with a concealed hinge and decorated in many different techniques of varying elaboration, became an object for competitive display among connoisseurs. Chinoiserie subjects are to be found in most techniques: enamel on gold, repoussé gold, gold outline on hard stone, inlay and relief, and the inlay of panels of Japanese lacquer.

Several designs for boxes exist, and pattern books were issued by many artists and craftsmen (often plagiarising other artists and craftsmen) for the use or choice of collectors and patrons. One of the earliest of chinoiserie subjects must be the chinoiserie grotesque designs by Daniel Marot, while some of the prettiest derive from Huet or Pillement.

Silver, too, was an obvious choice for chinoiserie decoration. In general, it can be said that in the seventeenth and eighteenth centuries chinoiserie silver both flat-chased and, later, cast and embossed, while relatively common in England, was much less common on the continent.

When chinoiserie appears in the form I have described as rococo-chinoiserie (but it begins, of course, earlier), it took the form of engraving on the surface of silver — flat-chasing. This pictorial style derives from the decoration of Chinese and Japanese porcelain and lacquer, and also owes something to the engravings in such books as Nieuhoff's *Embassy* (English edition 1673). The flat-chasing of chinoiserie scenes on silver begins, in England, probably in the late 1670s: it is dangerous to give too precise a date, as it cannot always be determined whether a piece of silver was chased when newly made, or later.

In the 1680s, chinoiserie scenes bearing a marked resemblance to one another appear on objects by different makers, and Charles Oman believes that they were sent by the makers to a specialist engraver, perhaps a specialist in chinoiserie scenes. This would parallel the practice in japanning, where the wood carcase of a piece of furniture might be sent to a japanner for decoration.

Some pieces of silver decorated with chinoiseries are considerably earlier than their decoration; as chinoiserie became fashionable, it was easy to bring slightly out-of-date pieces back into fashion by having them chased. (This was a common practice in the nineteenth century, too, though chinoiseries were not used.) A well-known example of this is a set of wall-sconces hall-marked 1665, but with later chinoiseries totally alien to the rest of the decoration.

Any piece of silver might be decorated with the flat-chased chinoiserie designs, but it is most common on smaller and more intimate objects, notably toilet sets. The latter, usually consisting of a mirror and a varying number of boxes and other accessories, are not uncommonly decorated in this style: a particularly fine set probably

1. plate between pp. 176–7

202 far left The mounted porphyry vase described by Abbot Suger, before 1144. *See p. 176*

203 centre A table-fountain, silver-gilt and enamel, French, 14th century.

204 left Gold salt-cellar made by Benvenuto Cellini *c.* 1544 for Francois I.

Mounted porcelain:
207 *Blanc de Chine* group of 'Admiral Duff' (*see p. 107*) mounted bronze and with European porcelain flowers.

205 far left Silver-gilt table-fountain by Christoph Jamnitzer *c.* 1600.

Mounted porcelain:
206 left Two Meissen stags with ormolu mounts, early 18th century.

208 below Cresting of a silver toilet mirror *c.* 1680 by Robert Smythier with pre-rococo-chinoiserie scenes.

209 right Larger-scale chinoiseries on a silver casket of 1683

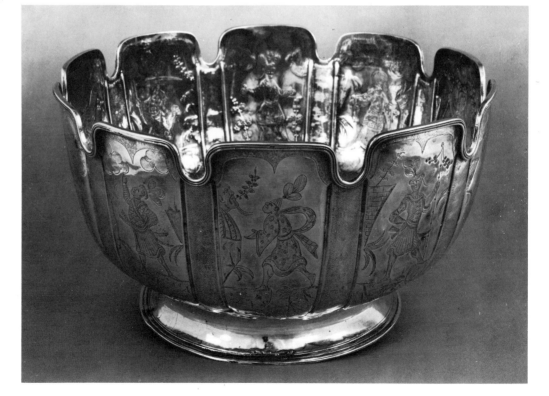

210 Silver monteith *c.* 1800 with chinoiserie figures

by Robert Smythier of about 1680 is in the Victoria and Albert Museum. The design on one of the boxes of this set is markedly similar to one in Huntington Art Gallery, by another maker.

More curious is the jar of 1685 belonging to the Duke of Rutland in a shape clearly imitated from a contemporary Imari jar. Here the chasing is on a bigger scale, but some of the motifs are the same as on the boxes and they may all come from the one workshop. Chinoiserie flat-chasing is even to be found on a communion cup, which shows, perhaps, how little the users of the style cared about its content – it was the effect that was sought.

Flat-chasing was less fashionable by the end of the century and chinoiserie scenes are rare in the eighteenth century. Imitations of oriental shapes are not uncommon, however. Perhaps the most obvious is the teapot. Tea, coffee, and chocolate all appeared in Europe at about the same time. The earliest known English teapot was made in 1670 (it resembled a coffee pot in shape), the earliest coffee pot in 1681. Teapots in the 1680s are based on the shape of Chinese porcelain wine-pots: Chinese teapots often had an overhead handle. Sugar bowls, which appear after 1700, are also based on Chinese and Japanese porcelain shapes. The lid sometimes has a small rim at the centre, which can act as a foot for the lid when it is used as a saucer. One sugar bowl of 1704 even has the gadrooned lid fitting within the similarly gadrooned body, just as in some pieces of Japanese porcelain.

With the arrival of the rococo style in England in the 1730s, silver shapes and styles of decoration became much more exuberant. The leader of the style in England was Paul de Lamerie as it was J-A Meissonnier in France. Chinoiseries begin in the 1740s either cast, sometimes in the solid, or in high relief. Dragons appear as handles to sauce-boats, figures of Chinamen support candlesticks, and chinoiserie figures and landscapes appear on all shapes and sizes of silver.

Naturally it is in the apparatus to do with tea that it is commonest. Tea caddies, often in sets of two caddies (one for green tea, one for bohea) and a sugar-box (later a mixing bowl) were enclosed in boxes so that they could be locked against pilfering by servants. These caddies[1] are often in a wild chinoiserie style, which remained fashionable well into the 1760s. Tea-urns, tea-kettles with stands and coffee pots were cast, chased and worked in repoussé with oriental scenes of extravagant character. Teapots, however, were less popular in silver after the 1730s because of the advent of the readily available and very fashionable porcelain teapots.

Many silversmiths worked in this style in England, including those in the employ of de Lamerie, Nicholas Sprimont, Thomas Whipham and Paul Crespin. In France it was less common, though the mark of F. T. Germain appears on a pair of tea-kettles and stands of splendidly chinoiserie style in 1762.

211 Tea-kettle by F. T. Germain: this outlandish design bears some relation to a more extreme form of modelled Imari 'Kendi'.

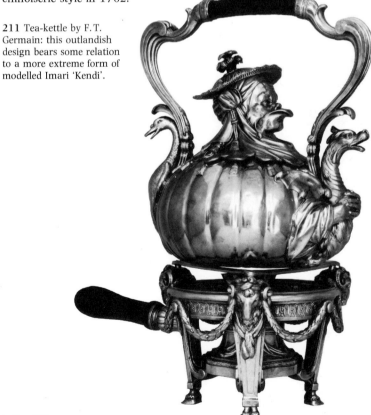

1. illus. **201**

Also popular was a gesture towards the Chinese, without too much commitment. William Grundy, for instance, was responsible for some soup tureens that have the upturned look of the Chinese roof-line so popular in architecture, furniture and clock cases. Chinese fret, also, was used, mostly for baskets for fruit or sweetmeats.

Most exotic of all, and reminiscent of the wildest chinoiserie fancies by the furniture makers, are épergnes, or table centre-pieces. While never on the scale of continental centre-pieces (*surtout-de-table* in French; where does the 'English' word come from?) they have a whimsy all their own.

In the nineteenth century the Moorish style was fashionable for a time – Albert, the Prince Consort, favoured it – and Paul Storr and Robert Garrard made some impressive centre-pieces in the style. Later the vogue descended into one for indiscriminate exotic effects, and innumerable plated centre-pieces modelled with camels, palm trees and so forth appeared.

Silver-covered furniture was to be found in both France and England in the middle of the seventeenth century: indeed Louis XIV had some furniture of solid silver. This was melted down for his increasing military expenses and replaced with lacquer and japan. Some silver furniture still remains at Rosenborg in Denmark. In England, wooden furniture was covered in embossed silver, but little even of this more economical variety survives. This is a pity, for it is probable that some of it was decorated with chinoiseries.

The habit of mounting furniture with metal, for decoration rather than just for use, was continued in both France and England in gilt-bronze – ormolu. But whereas in England ormolu was usually used relatively discreetly, in France it was used as a major element of the decoration of case-furniture, in particular the commode.

Ormolu is bronze that has been coated with gold (*or-moulu*) by the mercury amalgam method. As the fumes given off by the heated mercury were so poisonous, repeated efforts were made to find another technique, but in vain. Ormolu

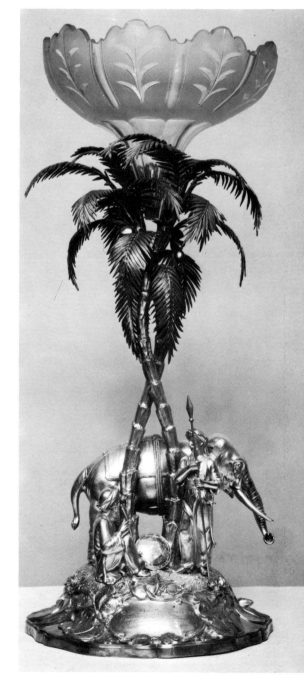

212 Silver *épergne* made in London by the Barnards in 1869 for a surgeon in the Bengal army.

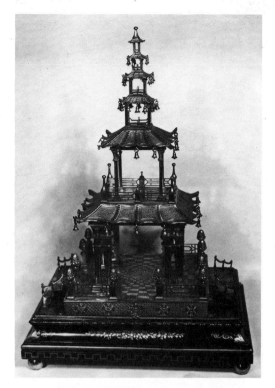

213 Ormolu watch-stand, probably by James Cox, *c.* 1780.

mounts on furniture were at first key-plates, corner-protectors and other useful adjuncts: in the reign of Louis XIV they became decorative elements in their own right and sometimes formed the major part of the decorative effect of a piece of furniture. There were separate guilds of *fondeurs* and *doreurs* to whom furniture was sent to be mounted by the makers. An exception to this rule was Charles Cressent, who sometimes made his own furniture-mounts: these are sometimes in chinoiserie style.

Smaller objects were also made in chinoiserie style — a favourite subject was a pair of *chenets* (fire-dogs) featuring figures of Chinese men and women, usually only recognizable by their hats: pagoda-roof-shaped of course. Chinese figures also appear on wall-lights, rather as they do on silver candlesticks, holding up branches for the candles.

English ormolu, at its best in the work of the Soho factory (in Birmingham) of Matthew Boulton, is very rarely in chinoiserie style.

214 Pagoda clock, ormolu, by Henry Borell.

Japonisme and Modern Chinoiserie

Although it is true to say that the opulent chinoiserie of the Royal Pavilion at Brighton fathered few successors, the taste for chinoiserie did not completely die out in the early nineteenth century. True, it suffered an eclipse in favour of the mediaevalism of Sir Walter Scott, and the Gothic Revival, but a renewal of interest in eighteenth-century taste brought with it a revival of chinoiserie. No longer the prerogative of eccentrics, it spread again, stimulated by a real interest in China and Japan. Eccentricity in the nineteenth century provided one excellent chinoiserie building in America, and several lesser buildings, including, of all things, railway stations: the only legitimate offspring of the Brighton Pavilion was Iranistan built by the great showman Barnum, near Bridgeport, Connecticut. The copy of the Imperial Palace at Peking, planned by the greatest builder of them all, Ludwig III of Bavaria, was to have been of a very different nature, for it was planned to be an accurate copy, where even the plans were drawn on silk.

This desire for pedantic accuracy of detail becomes an important theme in nineteenth-century chinoiserie – and indeed in other nineteenth-century styles, too. Naturally this was rarely possible, and nineteenth-century copies are usually easy enough to distinguish from the real thing. Partly this failure in accuracy may be due to the industrialization of the arts, resulting in the 'too many, too much' effect. In the joy of being able to produce well-made things cheaply (for much Victorian furniture, for instance, is excellently made), the designer could not resist over-ornamentation. And it was to this, and to excessive eclecticism, that the Aesthetic Movement was a reaction.

The Aesthetic Movement was a conscious attempt to educate the public at large to beauty. All things were to be considered as potential 'art objects'. The term 'art furniture' is perhaps the easiest to understand: it derives from C. L. Eastlake's *Hints on Household Taste* of 1867, and means furniture of essentially simple design, suited to its purpose, relatively easy of construc-

tion and with a minimum of decoration which must be suited to the object decorated. Such furniture should be used in rooms decorated in the subdued colours popularized by William Morris and others, and filled with the blue-and-white porcelain, the Japanese fans and the peacock feathers that became the hallmark of the Aesthetic Movement.

An important stimulus to the rise of the Aesthetic Movement was the arrival in Europe of Japanese objects, made possible by the new trade agreements with Japan. Japan had retained its system of closure to the outside world, established in the early seventeenth century, allowing only the most limited access of a few ships each year, to one port in Japan. In the 1850s this voluntary withdrawal from world affairs was shattered by the American commodore Matthew Perry, who in 1857 finally forced trading concessions from the reluctant Japanese, provoking a civil war in Japan that resulted in the overthrow of the hereditary dictators, the Shōgun, in favour of the Emperor.

Japanese goods had been exported since the sixteenth century and had contributed to the great influence on European arts that we have seen in earlier chapters. This had mostly been in the form of porcelain and lacquer, though other things had also been shipped. The new trade agreements caused a new flood of Japanese goods to reach Europe. This caused a craze for Japanese knick-knacks. Naturally these could be expensive, especially if they were the superb quality small objects in which Japanese workmanship excelled, lacquer *inro* (medicine boxes) and their *netsuke* (toggle-buttons) carved in marvellous shapes in ivory or wood, *tsuba*, metal sword-guards, and other sword-furniture, in which many collectors absorbed themselves. More usually it was imitations that were more easily available. In Japan it was quickly realized that what the West wanted was cheap rubbish, but rubbish that looked exotic and oriental: it is thus that Japan, where craftsmanship has been so superb for so long, and where, almost uniquely in the world, the craftsman is as highly

215 Portrait of Emile Zola, by Manet. Note the Japanese screen, print and inkwell, and the obligatory peacock feathers.

NEW YORK AND NEW HAVEN RAILROAD STATION, NEW HAVEN.

IRANISTAN, THE RESIDENCE OF MR. BARNUM. 1851

216 top The New York and
New Haven Railroad
station at New Haven – a
rare example of public-
works chinoiserie.

217 above Iranistan, one
of the last great chinoi-
serie buildings (Moorish-
cum-Mogul) built by the
showman Barnum.

considered as the artist, earned a reputation for
the manufacture of cheap and shoddy goods
which it is only now losing. For the Japanese
rapidly began to cater for occidental taste, just as
they had in earlier times over lacquer and
porcelain.

Ivory carvings of great intricacy, gaudy fans
and appalling pottery and porcelain were shipped
by the boat-load. Worst of all perhaps, are the
ceramics: Satsuma ware and its innumerable
(Japanese) imitations, encrusted with dirty red
and ochre warriors picked out in gilt, in a taste
which was unthinkable for the domestic market,
were considered, in the West, as old Japanese
wares. Of the almost equally nasty Nagasaki
wares Brinkley wrote, as early as 1904: *'Great
quantities of the ''Nagasaki ware'' were exported,
and many an American or European amateur
flatters himself that in the big, obtrusive vases
which disfigure his vestibule he has genuine speci-
mens of Japanese art, whereas he has, in truth,
nothing more than a Japanese estimate of his own
bad taste.'*

Yet when Longfellow wrote his poem *Keramos*
in 1877, it was not of Ching-tê Chên that he
thought, but of Imari, on whose wares were
painted

the counterfeit and counterpart
Of Nature reproduced in Art.

The 1854 exhibition of Japanese applied art
at the Old Water Colour Society's premises pro-
vided a stimulus for the consequent craze for
Japanese objects. That these tawdry Japanese
imports (E. W. Godwin reported them as 'im-
pregnated with the crudeness of the European's
sense of colour, and . . . immeasurably beneath
the older examples' as early as 1876) should
have become such a craze is only understandable
in the context of the new consciousness of beauty
urged by the Aesthetes.

Most curious of all influences is the Japanese
influence on furniture. Japanese houses contain
almost no furniture, so that while the furniture
of Thomas Jekyll, Godwin and, later, Charles
Rennie Mackintosh, was a real extrapolation of

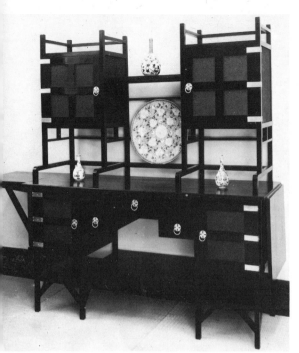

218 left Sideboard designed by E. W. Godwin.

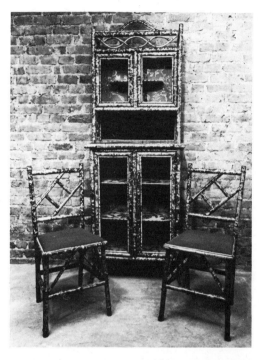

219 right Group of bamboo furniture of the type often inset with cheap Japanese lacquer panels. Japonaiserie for the masses.

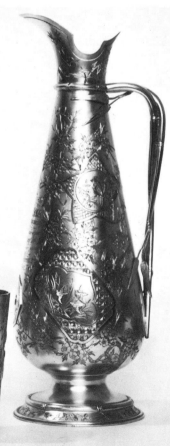

220 left Jug and beakers in silver by Elkington, 1882. A demonstration of the unerring choice of all the worst aspects of Japanese design grafted onto a quasi-Moorish shape.

221 above Japanese woodblock colour print by Hiroshige – compare with the upper colour plate facing p. 177.

so-called Japanese principles, and not a mere apeing of Japanese design, the bamboo-and-lacquer furniture that became so common was almost totally unrelated to Japan. This had a bamboo or imitation bamboo structure while the flat surfaces were poor-quality, basically red-coloured lacquer panels, cut to fit. This bore a closer relationship to Chambers' Chinese bamboo furniture[1] of the mid-eighteenth century than to anything else. Elaborate whatnots, cupboards, 'canterburys' (paper racks) and tables were made in this bamboo, sometimes also with the use of rush-matting door panels (in place of the lacquer) and even with art nouveau tiles — especially on wash-stands.

Factory-produced porcelain with Japanese-style patterns, usually based on the fan and utilizing the bold asymmetry that was now so fashionable, became commonplace, even at the big factories such as Worcester and Minton, while some of Doulton's saltglaze stoneware, although of basically seventeenth-century shape, had elements of Japanese decorative designs.

Silver was less Japanese in shape, for few Japanese shapes were particularly suited to European use, but it provided a surface on which to engrave or apply Japanese ornament. As with the early rococo-chinoiserie it went through the stages first of engraving and then of having shaped handles: in the nineteenth century the handles were usually in a shape derived from bamboo, and were the only concession to 'oriental' modelling.

Much of the silver-ware, by Elkington in particular, was enamelled. It is worth pointing out that it was only late in the nineteenth century that the Japanese used enamel for more than very slight decorative effects. The later Japanese enamel covered the whole of the surface of the copper form in cloisonné or painted enamel. But really, as we have seen on earlier similar occasions, the Japanese wares are chinoiserie themselves.

It was the woodblock prints of Japan that, of all Japanese things, had the most profound and lasting effect on European art, and taste in

general. Japanese prints were startling to western eyes for several reasons, but most of all for the unconventional approach to the viewpoint and composition of the picture, and for the use of areas of flat colour without chiaroscuro. Prints are by no means representative of Japanese art; they were made by a late, plebian school that was not considered by the Japanese as anything but vulgar. Moreover the school was past its prime, having been seriously harmed by the introduction of harsh western pigments.

Fortunately, among the prints that first appeared in Europe were not only the later, poorer examples, but also some of the late eighteenth-century examples that were, perhaps, the high point of the genre. Obviously, the later prints were the more common: van Gogh made copies of indifferent prints by Hiroshige, while in Manet's portrait of Emile Zola, painted in Manet's studio in 1868, there is a Japanese print of a *sumo* wrestler on the wall in the background (beside a drawing for 'Olympia') which is by Kuniaki II, who was working at that time, and scarcely rates a mention in standard books on Ukiyo-e.

But Whistler, in 'La Princesse du Pays de Porcelaine', the first European picture with a definite Japanese flavour, used a pose for the girl which is highly reminiscent of a print by Utamaro, one of the greatest of Ukiyo-e print-makers. Apart from this, there is little else Japanese in the picture: an obviously European girl dressed in a vaguely Japanese costume standing on a Chinese carpet before a made-up screen, holding a Japanese fan. It is the stance that matters, and the angular relationship of the carpet to the screen: it is in this sort of thing that the contribution of Ukiyo-e was to be most important.

Japanese prints were not entirely unknown in Europe before the 1850s, for examples had been illustrated by Titsingh in 1822 and by von Siebold in 1831. In 1856 the printmaker Felix Bracquemond discovered by accident a copy of the printed book of Hokusai sketches called the *Manga* (literally, random sketches, and in fact

222 'La Princesse du Pays de Porcelaine' by Whistler, 1864: a very influential picture.

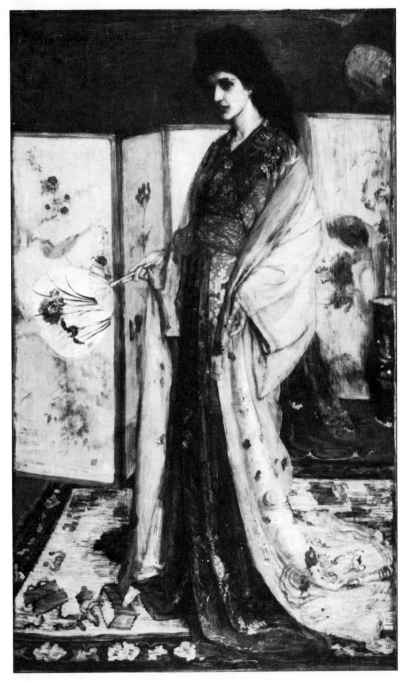

the sweepings of Hokusai's studio floor compiled by a group of Nagoya admirers). Showing this to Baudelaire, the Goncourts and others, and copying from it in his own prints, Bracquemond helped to spread the knowledge of Japanese prints in Paris. By 1862 there were three shops selling Japanese objects in Paris, of which one was called *La Porte Chinoise*.

Interest in Japanese prints appeared in England and France at about the same time, but whereas in England prints were not often taken very seriously by artists (though they were soon to be by collectors), in France they had a considerable effect. A group of printmakers and painters formed the *Société Jinglar* which met monthly at the house of M. L. Solon in Sèvres, with the object of furthering the knowledge of Japanese art. The members wore *kimono* and ate with *hashi* (chopsticks) off a specially made service decorated with designs of animals by Bracquemond largely copied from Hokusai.

Lack of familiarity with other aspects of Japanese art led the Goncourts grossly to overpraise Hokusai, comparing his work with that of Rembrandt, while Phillipe Burty claimed that the sketches of Hokusai rivalled 'Watteau in their grace, Daumier in their energy, the fantastic terror of Goya and the spirited animation of Delacroix'. This sort of judgement still colours European opinions of Hokusai. Only Hiroshige and Utamaro and, later, Harunobu, were considered as comparable with Hokusai.

As the craze for Japanese objects caught on, exhibitions of Japanese prints became more common, and Japanese prints could be bought in several shops in Paris and at least one in London, Bouter and Collins in Oxford Street. The effect on the Impressionist painters is too well known to be charted here, but apart from almost direct copies of prints (van Gogh and others) motifs were lifted direct from prints, or the vocabulary of prints repeatedly used either in a somewhat direct way, as in Mary Cassatt's prints in the idiom of Utamaro, or in the less direct one of composition. Bonnard's four-panel lithograph screen of nursemaids and horse-cabs is an

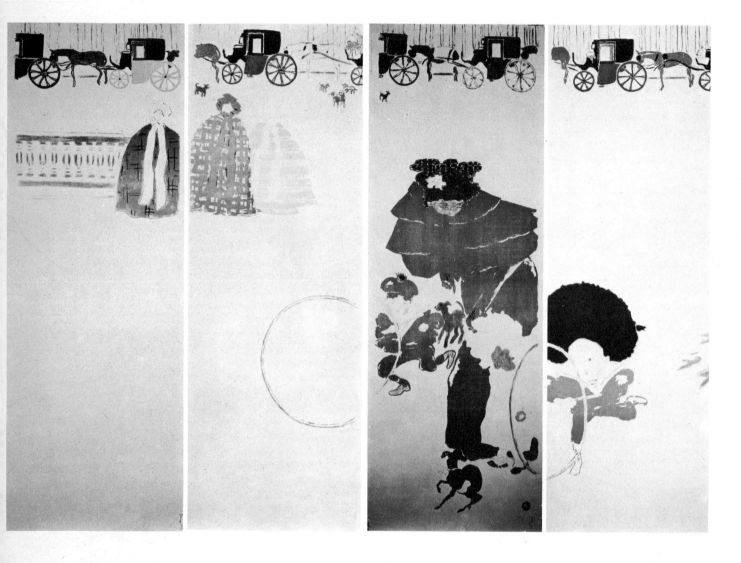

223 Nursemaids and hansom cabs, lithographic four-leaf screen by Bonnard, a brilliant composition in the Japanese manner.

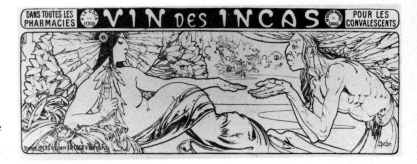

excellent example of a print composed in the more open Japanese style, while the crowded composition of some Ukiyo-e prints, where a figure could be cut across by the frame almost arbitrarily, was clearly influential on Degas and others. Henri de Toulouse-Lautrec and Paul Gaugin both used the effects of flat colour as important features of their work. One of the closest imitators of the general feel of the Japanese print was Benjamin Rivière whose prints use the same compositional tricks as those of Hokusai and Hiroshige: curiously, he foreshadows the later Japanese printmaker Hiroshi Yoshida.

Above all, it was the atmosphere of the print that fired the imagination and coloured the compositions of so many French artists of the end of the century. Thus it was the fact that these painters had seen Japanese prints and had absorbed almost subconsciously some of their visual and pictorial devices, which were then used for the painters' own purposes, rather than any more clearly defined influence, that is important. It is a classic case of one culture or part of a culture influencing another, irreversibly: the grammar has become so infused into western art that it has become totally absorbed. It is no longer chinoiserie.

By the 1880s, more was really known of Japan. Morse wrote on Japanese archaeology in 1879, Franks on pottery in 1880, and Anderson on paintings in 1887. Bing's 'Artistic Japan' was seen to show just one facet of Japanese culture, but it was this that had taken hold of craft-work in Europe: serious Japanese art made little appeal to westerners until the turn of the century, and then only to a few collectors, nearly all American, such as Charles Freer, Ernest Fenollosa and Edwin Morse.

As Japan and Japanese art became better known, the craze for *japonisme* began to fade. But one sector of applied art which notoriously lags behind advanced taste is advertising, and it was in advertisements that much japonaiserie appeared. Mucha's posters for Sarah Bernhardt (the first appeared in 1895 – *Gismonda*) changed the face of advertising, and he and his imitators

were soon using some of the features of the Japanese print. The economic mixture of picture and calligraphy (or typography) had been used by Lautrec, but in such posters as *Vin des Incas*, Mucha set a fashion that at once used *japonisme*, and killed it. It is interesting to see that, to achieve the same purpose, Lautrec and Mucha took two different features from Japanese prints (flat colour, and emphasis on line respectively) and exploited them with such markedly differing results.

Not all the posters were subtle: some were blatantly 'japanese' to the extent of picturing Japanese girls riding bicycles wearing *kimono* (no mean feat), and using the horrible convention of making capital letters a pastiche of Chinese calligraphy. This latter fashion has not died out even today and is often used for book titles or theatre posters.

Parallel to this is the origin of art nouveau. Much has been said of the Japanese influence on art nouveau. In reality it was more the effects of *japonisme* returning to Japan producing a parallel development in Japanese art, than a direct influence. Both *japonisme* and Japanese crafts were changing in the direction of art nouveau. The Japanese pieces that seem influential on the style were, in fact, more or less contemporary with it.

Art nouveau has few characteristics of earlier Japanese art, it has much of the rococo. Alphonse Mucha, who never thought of himself as an art nouveau painter, used the firm, heavy outline to delineate his carefully placed and elaborately

224 Advertisement by Alphonse Mucha: emphasis on line.

225 Advertisement for bicycles by a follower of Mucha; all the worst features of japonaiserie.

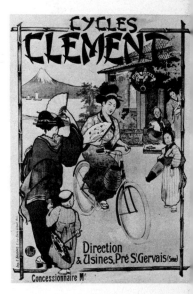

226 and 227 far left and left Two modern textile designs that trace their descent from Indian chintz and formal Sasanian patterns. *See Chapter 4*

228 below left Modern textile design based on the age-old lotus-scroll pattern – for Chinese 14th- and 15th-century examples see illus. 41 and 82.

229 right Modern wallpaper – 18th-century chinoiserie now as 'traditional' design.

posed figures, that is reminiscent of Ukiyo-e: the later sinuousness, based on plant forms, is not oriental, it is merely borrowing the oriental concept of line.

As art nouveau gave way to art deco in the early part of this century, the oriental influence waned even further. Art deco usually has an element of kitsch and sentiment that prevents it from being in any way close to oriental styles.

Japonisme, then, was virtually dead by the 1920s. There are, of course, a few remains to be seen, but on the whole the chinoiserie of today is descended from eighteenth-century taste, and not nineteenth century.

In spite of the broad eclecticism of modern

arts, crafts and design, where influences from all over the world are combined, altered and absorbed, so that little is now national, and where only consciously do national crafts retain their identity, it is surprising how much chinoiserie styles are still used.

Let us take various categories of objects and examine them. Most obvious, perhaps, are textiles. Almost all velvet brocades retain the flavour at least of the Genoese velvets of the seventeenth century that were so firmly based on oriental originals. Apart from chintz, which is so common, and is obviously chinoiserie, many other furnishing fabrics, particularly cottons and linens, have designs based upon sinuous plants

230 Modern Axminster
carpet – close imitation of
Kirman patterns.

with saw-edged leaves and exotic flowers, in which sit elegant and highly-coloured birds. Much wallpaper is of similar design. These are, of course, derived from Indian chintz and Chinese wallpaper (see Chapters 5 and 12).

Persian carpets are still fashionable in Europe and America, and are much imitated, Axminster and other companies using Kashan and Kirman carpets as models.

In ceramics, too, the influence is still obvious. This is not the left-over effects of *japonisme* but the continuation of eighteenth-century wares derived, mostly, from Japanese Imari wares, and Nankin blue-and-white. Willow-pattern, an obviously Nankin-inspired pattern, began in the 1770s and has continued as a popular pattern in transfer-printed blue-and-white ever since: it can be found on any ceramic ware from soup tureens through candlesticks to cow-creamers.

Imari patterns are perhaps even more common. The ironstone wares of Mason's and their competitors are frequently decorated in a harsh-coloured, crudely drawn variation of the Imari style. Other patterns are even copies of Imari; the so-called Old Chelsea, recently revived, is the best example, while that old favourite Indian Tree is a mixture of Imari and chintz patterns.

Another modern effect of oriental influence is in the craft pottery work of England. This is a complex influence, for it depends on the folk-art revival in Japan of the 1920s which was a reaction against western-style industrialization. One of the chief exponents of this reaction was Shoji Hamada, a friend and colleague of Bernard Leach. It is the work of these two men, which owes personal debts to the *sgraffiato* ware of Korea and to English eighteenth-century slip-ware, that has influenced to a great extent the

231 below Adaptation by Coalport of the 18th-century 'willow-pattern', one of the most common of all 'traditional' chinoiserie patterns.

232 right 'Indian tree', a pattern based on chintz and Chinese flowers that has been in production for a century or so.

work of many craft potters in England (and in Japan) today.

Finally, a word on literature. Most chinoiserie literature, whether plays, poems or prose, has been more or less a lampoon. Coleridge's *Kubla Khan* is perhaps the most famous exception:

In Xanadu did Kubla Khan
A stately pleasure-dome decree:
Where Alph, the sacred river, ran
Through caverns measureless to man
 Down to a sunless sea.

So twice five miles of fertile ground
With walls and towers were girdled round:
And there were gardens bright with sinuous rills,
Where blossomed many an incense-bearing tree;
And here were forests ancient as the hills,
Enfolding sunny spots of greenery.

Otherwise, chinoiserie was often used as a weapon with which to chastise the aesthete, particularly by W. S. Gilbert in *Patience*:

A Japanese young man,
A blue-and-white young man,
Francesca di Rimini, miminy, piminy,
Je-ne-sais-quoi young man!

A pallid and thin young man,
A haggard and lank young man,
A greenery-yallery, Grosvenor Gallery,
Foot-in-the-grave young man!

Gilbert also wrote *The Mikado*, also with music by Sir Arthur Sullivan, which has such a confusion of chinoiserie elements derived from China, Japan and elsewhere that it in some ways typifies the earlier phases of chinoiserie rather than that of the nineteenth century. Astoundingly, it drew a dignified protest from the Japanese Ambassador: one is surprised that he recognized that it was supposed to represent Japan.

More recently, the Kai Lung books of Ernest Bramah are a form of chinoiserie in that they are written like a bad translation of a Chinese book. The ponderous, wordy writing, amusing though it may be, is not Chinese. The free translations by Arthur Waley, and even the Chinese stories written by R. H. van Gulik are, to a much

THE SIX-MARK TEA-POT.

Æsthetic Bridegroom. "It is quite Consummate, is it not!"

Intense Bride. "It is, indeed! Oh, Algernon, let us live up to it!"

233 'The beastly aesthete', teased by du Maurier in *'Punch'*, 1880.

greater extent, within the spirit of Chinese literature.

In spite of television and the newspapers, of the package tour and the Nikon camera, the western idea of the East is still partly based on chintz curtains and willow-pattern plates, much as in the eighteenth century it was based on japanned cabinets and Chinese Chippendale.

Select Bibliography
Acknowledgments
Index

Select Bibliography

General

Honour, H. *Chinoiserie: The Vision of Cathay* London, 1961 (pbk 1973); New York (NY), 1962 (pbk 1973)

Lach, D. F. *Asia in the Making of Europe* Vol. I, pts 1 and 2, Chicago (Ill.) and London, 1965; Vol. II, pt 1, Chicago (Ill.) and London, 1970

Reichwein, A. *China and Europe* London and New York (NY), 1925

PART I: THE MEETING OF EAST AND WEST

General

The Hakluyt Society Publications, London

Schafer, E. H. *The Golden Peaches of Samarkand* Berkeley and Los Angeles (Calif.) and London, 1963

1. The Great Silk Road

Hudson, G. F. *Europe and China* Reprint of 1931 edn, London and Boston (Mass.), 1961

The Oxford Classical Dictionary Hammond, N. G. L. & Scullard, H. H. (Eds), 2nd rev. edn, Oxford and New York (NY), 1970

Pirenne, H. *Mohammed and Charlemagne* New edn, London and Scranton (Pa), 1968

Runciman, S. *A History of the Crusades* Vol. 1, London and New York (NY), 1951 (pbk Harmondsworth, 1971); Vol. 2, London and New York (NY), 1952 (pbk Harmondsworth, 1971); Vol. 3, London and New York (NY), 1954 (pbk Harmondsworth, 1971)

Southern, R. W. *The Making of the Middle Ages* New edn, London, 1967; New Haven (Conn.), 1953

2. The Way round Africa

Boxer, C. R. *Fidalgos in the Far East* The Hague, 1948 (reprinted New York, 1968; London, 1969)

Boxer, C. R. *The Christian Century in Japan* Rev. edn, Berkeley and Los Angeles (Calif.), 1967

Boxer, C. R. *The Portuguese Seaborne Empire* London, 1969 (pbk Harmondsworth, 1973); New York (NY), 1970

Parry, J. H. *The Spanish Seaborne Empire* London, 1966 (pbk Harmondsworth, 1973); New York (NY), 1966

Sansom, G. B. *The Western World and Japan* New edn, London, 1966; New York (NY), 1950 (pbk 1974)

3. The Merchant Adventurers

Boxer, C. R. *The Dutch Seaborne Empire* London and New York (NY), 1965

Collis, M. *Siamese White* New impression, London, 1965

Goodman, G. K. *The Dutch Impact on Japan* (T'oung Pao Monograph), Leiden, 1967

Phillips, J. G. *China-trade Porcelain* Cambridge (Mass.), 1956

Rowbotham, A. H. *Missionary and Mandarin: the Jesuits at the Court of China* Reprint of 1942 edn, New York (NY), 1966

PART II: CHINOISERIE

General

Belevitch-Stankevitch, H. *Le Goût chinois en France au temps de Louis XIV* Paris, 1910

Fauchier-Magnan, A. *The Small German Courts in the 18th Century* London, 1958

Jairazbhoy, R. A. *Oriental Influences in Western Art* Bombay and New York (NY), 1965; London, 1966

Jourdain, M. & Jenyns, S. *Chinese Export Art in the 18th Century* Reprint, London and New York (NY), 1968

Lightbown, R. W. 'Oriental Art and the Orient in late Renaissance and Baroque Italy', *Journal of the Warburg and Courtauld Institutes* Vol. XXXII, London, 1969

Sullivan, M. *The Meeting of Eastern and Western Art, from the 16th Century to the Present Day* London and Boston (Mass.), 1973

Watson, W. (Ed.) *The Westward Influence of the Chinese Arts* Percival David Foundation of Chinese Art Colloquy, London, 1973

4. Collecting, and the Cabinet of Curiosities

Born, W. 'Some Eastern Objects from the Hapsburg Collections', *Burlington Magazine* Vol. LXIX (p. 269), London, 1936

Gunther, R. T. *Early Science in Oxford* Vol. 3, reprint of 1925 edn, London and Atlantic Highlands (NJ), 1968

Hermann, F. (Ed.) *The English as Collectors* London and New York (NY), 1972

Shearman, J. 'The Collections of the Younger Branch of the Medici', *Burlington Magazine* Vol. CXVII (p. 12), London, 1975

Taylor, F. H. *The Taste of Angels: A History of Collecting from Rameses to Napoleon*, London and Boston (Mass.), 1948

5. Textiles

Ackerman, P. *Three Early Sixteenth Century Tapestries* New York (NY), 1932

Ciba Review A series of articles by Born, Leix, de Roover, de Francesco, Heichelheim et al., Basle

Erdmann, K. (Ed.) *Seven Hundred Years of Oriental Carpets* Berkeley (Calif.) and London, 1970

Göbel, H. *Die Wandteppiche* 3 vols; Leipzig, Berlin, 1923–34

Irwin, J. & Brett, K. B. *The Origins of Chintz* London, 1970

Kendrick, A. F. *English Needlework* 2nd rev. edn, London and New York (NY), 1967

Kendrick, A. F. & Tattersall, C. E. C. *Handwoven Carpets, Oriental and European* London, 1922; reprint of 1922 edn, New York (NY), 1973, Gloucester (Mass.), 1975

Montgomery, F. M. *Printed Textiles* London and New York (NY), 1970

Tattersall, C. E. C. & Reed, S. *A History of British Carpets* Leigh-on-Sea, 1966; Metuchen (NJ)

Thomson, W. G. *A History of Tapestry* Facsim. of 1930 edn, London, 1973; 3rd edn, Totowa (NJ), 1973

Thornton, P. *Baroque and Rococo Silks* London and New York (NY), 1965

Willetts, W. *Chinese Art* 2 vols, London and Baltimore (Md), 1958

6. Painting, Drawing and Engraving

Archer, M. *British Drawings in the India Office Library* London, 1969

Atil, E. S. 'Ottoman Miniature Painting under Sultan Mehmed II', *Ars Orientalis* Vol. IX (pp. 103–20), Washington (DC), 1973

Benesch, O. 'The Orient as a Source of Inspiration of the Graphic Arts of the Renaissance), in *Festschrift Friedrich Winkler* Berlin, 1959

Goetz, H. 'Oriental Types and Scenes in Renaissance and Baroque Italy', *Burlington Magazine* Vol. LXXIII (pp. 53 and 105), London, 1938

7–8. Ceramics

Catalogues of the Percival David Foundation of Chinese Art, London

Garner, H. *Oriental Blue and White* 2nd edn, London, 1964; New York (NY), 1954

Honey, W. B. *European Ceramic Art* 2 vols, London, 1949 and 1952; 2nd edn, Boston (Mass.)

Honey, W. B. & Lane, A. (Eds) The Faber Monographs on Pottery and Porcelain, London, 1947 et seq.; many of the series have been published in the USA

Jenyns, S. *Japanese Porcelain* London and New York (NY), 1965

Lane, A. 'Queen Mary II's Porcelain at Hampton Court', *Transactions of the Oriental Ceramic Society* 25 (p. 21), London, 1949–50

Lane, A. 'The Gaingnières-Fonthill Vase: a Chinese Porcelain of about 1300', *Burlington Magazine* Vol. CIII (p. 124), London, 1961

Lunsingh Scheurleer, D. F. *Chinese Export Porcelain* London, 1974; New York (NY), 1975

Phillips, J. G. *China-trade Porcelain* Cambridge (Mass.), 1956

Pope, J. A. *14th Century Blue and White* Freer Gallery of Art Occasional Papers 2, Washington (DC), 1952

Pope, J. A. *Chinese Porcelains from the Ardebil Shrine* Washington (DC), 1956

Spriggs, A. I. 'Oriental Porcelain in Western Paintings. 1450–1700', *Transactions of the Oriental Ceramic Society* 36, London, 1965

Volker, T. *Porcelain and the Dutch East India Company* Leiden, 1954

Volker, T. *The Japanese Porcelain Trade of the Dutch East India Company after 1683* Leiden, 1959

9. Furniture, Lacquer and Japan

Coleridge, A. *Chippendale Furniture* London and New York (NY), 1968

Dye, W. S. *A Grammar of Chinese Lattice* Cambridge (Mass.), 1949

Edwards, R. & MacQuiod, P. *The Dictionary of English Furniture* 3 vols, rev. edn, London and New York (NY), 1954

Furniture History Papers by Boynton, Gilbert, Hardy, Hayward, Joy et al., London, 1964 et seq.

Gibbs, F. W. 'Historical Survey of the Japanning Trade', *Annals of Science* VII (p. 401 et seq.), London, 1951

Hayward, H. *Thomas Johnson and the English Rococo* Levittown (NY), 1950; London, 1964

Hayward, H. (Ed.) *World Furniture* New edn, London, 1969; New York (NY), 1965

Huth, H. *Lacquer of the West* Chicago (Ill.), 1971

Stalker, J. & Parker, G. *A Treatise of Japanning and Varnishing* (1688) Reprint, London, 1971; Levittown (NY)

Verlet, P. *French Furniture and Interior Decoration of the 18th Century* London and Rutland (Vt), 1967

Ward-Jackson, P. *English Furniture Design of the 18th Century* London, 1958

10. The so-called Anglo-Chinese Garden

Gorer, R. *The Flower Garden in England* London, 1975

Hyams, E. *A History of Gardens and Gardening* London and New York (NY), 1971

Sirén, O. *Gardens of China* New York (NY), 1949

Sirén, O. *China and Gardens of Europe of the Eighteenth Century* New York (NY), 1950

11. Architecture

Beurdeley, C. & Beurdeley, M. *Giuseppe Castiglione* London and Rutland (Vt), 1972

Blaser, W. *Chinese Pavilion Architecture* Niederteufen (Switzerland), 1974; New York (NY), 1975

Acknowledgments

Hussey, C. (Ed.) *English Country Houses* Vols 1–6, London and New York (NY), 1955–70

Lancaster, C. 'The "European Palaces" of Yüan Ming Yüan', *Gazette des Beaux Arts* (p. 261), Paris, October 1948

Waterman, T. *The Mansions of Virginia* Chapel Hill (N. Car.), 1946; London, 1947

12. Interior Decoration

Entwisle, E. A. *A Literary History of Wallpaper* London, 1960

Entwisle, E. A. *The Book of Wallpaper* Rev. edn, Bath and West Orange (NJ), 1970

Fowler, J. & Cornforth, J. *English Decoration in the 18th Century* London and Princeton, (NJ), 1974

Greysmith, B. *Wallpaper* London and New York (NY), 1976

Huth, H. *Lacquer of the West* Chicago (Ill.), 1971

Musgrave, C. *Royal Pavilion* 2nd edn, London, 1959

Waterer, J. W. *Spanish Leather* London, 1971

Wilhelm, J. 'The Parisian Interior in the Seventeenth and Eighteenth Centuries', *Apollo* Vol. CI, no. 158 (p.283), London, 1975

13. Metalwork

Grimwade, A. *Rococo Silver* London, 1974

Hayward, J. F. *Huguenot Silver in England 1688–1725*, London, 1959

Honour, H. *Goldsmiths and Silversmiths* London and New York (NY), 1971

Oman, C. *Caroline Silver* London, 1971; New York (NY), 1973

Taylor, G. *Silver* Rev. edn, Baltimore, 1964; new edn, London, 1965 (pbk Harmondsworth, 1970)

14. Japonisme and Modern Chinoiserie

Aslin, E. *The Aesthetic Movement* London and New York (NY), 1969

Ives, C. F. *The Great Wave: the Influence of Japanese Woodcuts on French Prints* New York (NY), 1974; Cambridge, 1975

Japonisme: Japanese Influence on French Art, 1854–1910 [Catalogue of an exhibition held in Cleveland, New Brunswick and Baltimore] 1975

Mucha, J. *Alphonse Mucha: his Life and Art* London and New York (NY), 1966

Text

The author and publisher would like to thank the Percival David Foundation of Chinese Art, University of London and the Hakluyt Society, London for granting permission to use extensive quotations from their publications on pages 9 and 175 respectively.

Maps

The maps on pages 18–19 and 38–39 were drawn by John Thompson Associates.

Illustrations

The many museums, art galleries, libraries, firms, individuals and photographers who supplied the illustrations are kindly thanked for their co-operation and are listed below:

Plates

facing page:

20 By courtesy of the Cooper-Hewitt Museum of Decorative Arts and Design, Smithsonian Institution, New York

21 Bodleian Library, Oxford

44 *top* The Warden and Fellows of New College, Oxford

44 *bottom* Private Collection (photo Derrick Witty)

45 Freer Gallery of Art, Washington, D.C.

68 *top* Kunsthistorisches Museum, Vienna

68 *bottom* Cooper-Bridgeman Library

69 *top* Isabella Stewart Gardner Museum, Boston

69 *bottom* Museum Boymans-van Beuningen, Rotterdam

92 Collection Haags Gemeentemuseum, The Hague

93 Cooper-Bridgeman Library

140 By courtesy of The Henry Francis du Pont Winterthur Museum

141 *top* The Royal Institute of British Architects, London

141 *bottom* Camera & Pen International

164 The Royal Pavilion, Brighton (photo John Bethell)

165 John Bethell

176 By courtesy of Wartski, London (photo Derrick Witty)
Centre spread Deutsche Fotothek, Dresden

177 *top* Rutgers University Art Gallery Fine Arts Collection, New Brunswick

177 *bottom* The Metropolitan Museum of Art, New York. Bequest of Miss Adelaide Milton de Groot (1876–1967) 1967

Black-and-White

1 Kungl. Hugerådskammaren, Stockholm
2 By courtesy of Sotheby & Co., London
3 Collection Haags Gemeentemuseum, The Hague
4 Ashmolean Museum, Oxford
5 Author's Collection
6 Victoria and Albert Museum, Crown Copyright, London
7 Corpus Christi College, Cambridge
8 Abbazia di San Pietro, Perugia
9 Victoria and Albert Museum, Crown Copyright, London
10 Robert Harding Associates
11 Bodleian Library, Oxford
12 Ashmolean Museum, Oxford
13 Antikvarisk-Topografiska Arkivet, Stockholm
14 British Museum, London
15 Bibliothèque Nationale, Paris
16 Ashmolean Museum, Oxford
17 New York Public Library
18 The National Maritime Museum, London
19 Museu Nacional de Arte Antiga, Lisbon
20 Academia das Ciências, Lisbon
21 Camera & Pen International
22 Kunsthistorisches Museum, Vienna
23 Mary Evans Picture Library
24 Staatliche Museen Preussicher Kulturbesitz Kupferstichkabinett, West Berlin
25 British Museum, London
26 Kunsthistorisches Museum, Vienna
27 British Museum, London (photo John Freeman)
28 University of Uppsala
29 India Office Library and Records, London
30 Rijksmuseum, Amsterdam
31 By courtesy of Sotheby & Co., London
32 By courtesy of Sotheby & Co., London
33 Author's Collection
34 Author's Collection
35 Victoria and Albert Museum, Crown Copyright, London
36 Mary Evans Picture Library
37 By courtesy of Sotheby & Co., London
38 From *Early Science in Oxford* by Robert T. Gunther, by courtesy of A. E. Gunther, FGS
39 Capitolini Museum, Rome
40 Museum für Kunst und Gewerbe, Hamburg
41 Ashmolean Museum, Oxford
42 National Trust (photo John Bethell)
43 The Administration of the Staatliche Schlösser, Gärten und Seen, Bavaria
44 Kunsthistorisches Museum, Vienna
45 Ashmolean Museum, Oxford
46 By courtesy of the Oxford University Botanic Garden
47 Ashmolean Museum, Oxford
48 British Museum (Natural History), London
49 Ashmolean Museum, Oxford
50 By courtesy of the Cooper-Hewitt Museum of Decorative Arts and Design, Smithsonian Institution, New York
51 Ann Münchow, Aachen
52 National Gallery, London
53 National Gallery, London
54 Victoria and Albert Museum, Crown Copyright, London
55 Royal Ontario Museum, Toronto
56 Victoria and Albert Museum, Crown Copyright, London
57 By courtesy of Sotheby & Co., London
58 National Gallery, London
59 By courtesy of The Duke of Buccleugh and Queensberry, VRD
60 Kunsthistorisches Museum, Vienna
61 John Bethell
62 Civico Museo Correr, Venice
63 Sacro Convento di San Francesco, Assisi
64 By courtesy of Sotheby & Co., London
65 Musée Louvre, Paris
66 By courtesy of the Victoria and Albert Museum, London (photo Derrick Witty)
67 By courtesy of Academy Editions, London (photo Derrick Witty)
68 Metropolitan Museum of Art, New York. Gift of Mr and Mrs Herbert N. Strauss, 1928
69 By courtesy of the Victoria and Albert Museum, London (photo Derrick Witty)
70 Musée Condé, Chantilly (photo Giraudon)
71 Scuola di San Giorgia degli Schiavoni, Venice
72 Musée Louvre, Paris (photo Giraudon)
73 By courtesy of The Leger Galleries, London
74 British Museum, London
75 Galleria Borghese, Rome (photo Giraudon)
76 British Museum, London (photo John Freeman)
77 By courtesy of Sotheby & Co., London
78 By courtesy of Sotheby & Co., London
79 National Gallery of Art, Washington
80 By courtesy of Sotheby & Co., London
81 Ashmolean Museum, Oxford
82 By courtesy of Sotheby & Co., London
83 National Gallery of Art, Washington
84 By courtesy of Christies, London
85 By courtesy of Sotheby & Co., London

86 By courtesy of Sotheby & Co., London
87 By courtesy of Sotheby & Co., London
88 By courtesy of Sotheby & Co., London
89 Ashmolean Museum, Oxford
90 Ashmolean Museum, Oxford
91 John Bethell
92 Ashmolean Museum, Oxford
93 Victoria and Albert Museum, Crown Copyright, London
94 Ashmolean Museum, Oxford
95 By courtesy of Sotheby & Co., London
96 By courtesy of Sotheby & Co., London
97 By courtesy of Sotheby & Co., London
98 The Fitzwilliam Museum, Cambridge
99 Cliché des Musées Nationaux
100 Author's Collection
101 Rijksmuseum, Amsterdam
102 Victoria and Albert Museum, Crown Copyright, London
103 Victoria and Albert Museum, Crown Copyright, London
104 Ashmolean Museum, Oxford
105 Ashmolean Museum, Oxford
106 By courtesy of Sotheby & Co., London
107 Ashmolean Museum, Oxford
108 Ashmolean Museum, Oxford
109 Victoria and Albert Museum, Crown Copyright, London
110 Victoria and Albert Museum, Crown Copyright, London
111 Ashmolean Museum, Oxford
112 By courtesy of Sotheby & Co., London
113 Victoria and Albert Museum, Crown Copyright, London
114 Ashmolean Museum, Oxford
115 Ashmolean Museum, Oxford
116 Victoria and Albert Museum, Crown Copyright, London
117 Rijksmuseum, Amsterdam
118 Rijksmuseum, Amsterdam
119 Ashmolean Museum, Oxford
120 Ashmolean Museum, Oxford
121 Victoria and Albert Museum, Crown Copyright, London
122 Victoria and Albert Museum, Crown Copyright, London
123 By courtesy of Asprey & Co., London
124 Ashmolean Museum, Oxford
125 Kunsthistorisches Museum, Vienna
126 National Trust (photo John Bethell)
127 Academy Editions, London (photo Derrick Witty)
128 Staatliche Museum, East Berlin
129 Staatlichen Schlösser und Gärten, Charlottenburg (photo Jörg P. Anders)
130 Metropolitan Museum of Art, New York; Gift of R. Thornton Wilson 1943, in memory of Florence Ellesworth Wilson
131 National Trust (photo John Bethell)
132 Cliché des Musées Nationaux
133 Cliché des Musées Nationaux
134 By courtesy of the Victoria and Albert Museum, London (photo Derrick Witty)
135 By courtesy of the Victoria and Albert Museum, London (photo Derrick Witty)
136 By courtesy of the Victoria and Albert Museum, London (photo Derrick Witty)
137 By courtesy of the Victoria and Albert Museum, London (photo Derrick Witty)
138 By courtesy of the Victoria and Albert Museum, London (photo Derrick Witty)
139 National Trust (photo John Bethell)
140 Victoria and Albert Museum, Crown Copyright, London
141 Victoria and Albert Museum, Crown Copyright, London
142 By permission of The National Museum of Wales, Cardiff
143 Victoria and Albert Museum, Crown Copyright, London
144 By courtesy of the Victoria and Albert Museum, London (photo Derrick Witty)
145 British Museum, London (photo John Freeman)
146 Aerofilms Ltd
147 By courtesy of T. Cottrell Dormer
148 Ashmolean Museum, Oxford
149 National Trust
150 Kungl. Akademien för de fria Konsterna, Stockholm
151 National Trust (photo John Bethell)
152 By courtesy of the Victoria and Albert Museum, London (photo Derrick Witty)
153 By courtesy of the Victoria and Albert Museum, London (photo Derrick Witty)
154 Kungl. Akademien för de fria Konsterna, Stockholm
155 By courtesy of the Victoria and Albert Museum, London (photo Derrick Witty)
156 Photo Gundermann, Würzburg
157 By courtesy of Sotheby & Co., London
158 Ashmolean Museum, Oxford
159 The Royal Pavilion, Brighton
160 Camera & Pen International

161 Deutsche Fotothek, Dresden
162 By courtesy of the Victoria and Albert Museum, London (photo Derrick Witty)
163 Photo Derrick Witty
164 Deutsche Fotothek, Dresden
165 Camera & Pen International
166 National Trust
167 By courtesy of the Victoria and Albert Museum, London (photo Derrick Witty)
168 J. Alaterre
169 Studio Sud
170 French Government Tourist Office, London
171 Victor Kennett
172 British Museum, London
173 Thomas Jefferson Memorial Foundation, Charlottesville
174 University of Virginia Library
175 *Country Life*
176 The National Maritime Museum, London
177 *Country Life*
178 National Gallery of Victoria, Melbourne
179 The Royal Institute of British Architects, London
180 The Royal Pavilion, Brighton (photo John Bethell)
181 The Royal Pavilion, Brighton
182 Ente Provinciale per il Turismo, Palermo
183 Angelo Hornak
184 *Country Life*
185 John Bethell
186 National Trust (John Bethell)
187 National Trust (John Bethell)
188 Victoria and Albert Museum, Crown Copyright, London
189 Victoria and Albert Museum, Crown Copyright, London
190 Victoria and Albert Museum, Crown Copyright, London
191 By courtesy of the Victoria and Albert Museum, London (photo Derrick Witty)
192 John Bethell
193 SCALA
194 De Danske Kongers Kronologiske Samling paa Rosenborg, Copenhagen
195 John Bethell
196 Musée Condé, Chantilly (photo Giraudon)
197 Musée Condé, Chantilly (photo Giraudon)
198 Archivio E.P.T., Vicenza
199 National Trust (photo John Bethell)
200 The Royal Pavilion, Brighton
201 By courtesy of Sotheby & Co., London
202 Cliché des Musées Nationaux
203 The Cleveland Museum of Art, gift of J. H. Wade
204 Kunsthistorisches Museum, Vienna
205 Staatliche Museen Preussischer Kulturbesitz Kunstgewerbemuseum, West Berlin
206 John Bethell
207 By courtesy of Sotheby & Co., London
208 By courtesy of the Victoria and Albert Museum, London (photo Derrick Witty)
209 By courtesy of the Victoria and Albert Museum, London (photo Derrick Witty)
210 National Trusts (photo John Bethell)
211 Museu Nacional de Arte Antiga, Lisbon
212 By courtesy of the Victoria and Albert Museum, London (photo Derrick Witty)
213 The Royal Pavilion, Brighton
214 National Trust (photo John Bethell)
215 Cliché des Musées Nationaux
216 Connecticut Historical Society
217 Connecticut Historical Society
218 Victoria and Albert Museum, Crown Copyright, London
219 *Antique Collector*
220 By courtesy of the Victoria and Albert Museum, London (photo Derrick Witty)
221 By courtesy of the Victoria and Albert Museum, London (photo Derrick Witty)
222 Freer Gallery of Art, Washington
223 Collection, Museum of Modern Art, New York
224 By arrangement with the Alphonse Maria Mucha Estate
225 Lords Gallery, London
226 Photo Derrick Witty
227 'Emma' by courtesy of Sekers (photo Derrick Witty)
228 'Girland', designed by M.-L. Bjerhagen, by courtesy of Almedahl (photo Derrick Witty)
229 G.P. & J. Baker Ltd
230 Axminster Carpets Ltd
231 Josiah Wedgwood & Sons Ltd
232 Josiah Wedgwood & Sons Ltd
233 Mary Evans Picture Library

Index